Asian Cinema

Tom Vick

A FIELD GUIDE

For Marcia, and for my parents

ASIAN CINEMA. Copyright © 2007 by Tom Vick. All rights reserved. Printed in the United States of America. No part of this book may be used or reproduced in any manner whatsoever without written permission except in the case of brief quotations embodied in critical articles and reviews. For information, address HarperCollins Publishers, 10 East 53rd Street, New York, NY 10022.

HarperCollins books may be purchased for educational, business, or sales promotional use. For information, please write: Special Markets Department, HarperCollins Publishers, 10 East 53rd Street, New York, NY 10022.

FIRST EDITION

The name of the "Smithsonian," "Smithsonian Institution," and the sunburst logo are registered trademarks of the Smithsonian Institution.

DESIGNED BY DEBORAH KERNER

Library of Congress Cataloging-in-Publication Data
Vick, Tom.
 Asian cinema : a field guide / Tom Vick.—
1st ed.
 p. cm.
 Includes bibliographical references and index.
 ISBN 978-0-06-114585-8
 1. Motion pictures—Asia. I. Title.
PN1993.5.A75V53 2007
791.43095—dc22

 2007026648

07 08 09 10 11 ID/QW 10 9 8 7 6 5 4 3 2 1

CONTENTS

In the Mood for Love

INTRODUCTION

CONTRADICTORY TIMES

Among the decorations in my office there are two that never fail to attract attention. One is a poster of Hong Kong director Wong Kar-wai's sumptuously romantic *In the Mood for Love*. The other is a desktop image on my computer from *Spirited Away*, by the great Japanese anime director Hayao Miyazaki. It doesn't matter if it's coworkers, friends, family members, or business associates, nearly everyone remarks on one of these two images, and the reactions are always a variation on "I *love* that movie!"

These two films inspire a remarkable level of devotion from a wide range of people. They are, in a way, *beloved*. That they have found an audience in America is particularly inspiring. It suggests that they speak something like a universal language, each with their own distinct accents. If there's one thing I've learned from being immersed in Asian cinema, it's that there's no such thing as a "foreign" movie. A nation as alien to us as Iran can still appeal to our common humanity through its cinema. Once upon a time we might have laughed at kung fu movies on television, with their clumsily dubbed dialogue and silly sound effects, but now a well-made Hong Kong thriller gives us the same rush as the best Hollywood action film. In Bollywood musicals, we see not kitsch, but a transcendent joyfulness missing from American movies since Gene Kelly hung up his dancing shoes. Asian films offer us windows into other cultures, to be sure, but they also exist within a global web of influences. In Japan, masters such as Akira Kurosawa and Yasujiro Ozu were influenced in part by Hollywood movies and, in turn, made films that have had a huge influence on directors not only in the United States but around the world. The elegant, gravity-defying choreography of Hong Kong martial arts films has become the univeral language of action movies everywhere.

So Asian movies are at once familiar and exotic, and they have never been more popular than they are now. In the 1950s and 1960s, films by international masters like Kurosawa or Satyajit Ray could be seen in small theaters in major

cities. But now *Crouching Tiger, Hidden Dragon* (Ang Lee, 2000), *Lagaan* (Ashitosh Gowariker, 2001) *Hero* (Zhang Yimou, 2002), and *Kung Fu Hustle* (Stephen Chow, 2004) do business at multiplexes, all of Miyazaki's features are distributed on DVD by Disney, and your local art-house theater is as likely to be showing something from Iran, Korea, or China as not. Asian movies are so hot right now that the show business bible *Variety* even launched a Web site in 2006, varietyasiaonline.com, just to keep up.

Asian cinema has seeped into our film culture in other ways as well. Quentin Tarantino's *Kill Bill 1* and *2* (2003 and 2004) were inspired by Hong Kong and Japanese action movies. The Wachowski brothers lifted much style and substance from Hong Kong crime films and Japanese anime for *The Matrix* (1999). Baz Luhrmann's *Moulin Rouge* and Terry Zwigoff's *Ghost World* (both 2001) paid tribute to Bollywood musicals. In her 2004 Academy Award acceptance speech, Sofia Coppola made a point of naming Wong Kar-wai as an influence on her Tokyo-set *Lost in Translation* (2003).

If imitation is indeed the sincerest form of flattery, Hollywood has been paying Asian movies the highest of compliments by remaking them at an unprecedented rate. A slew of recent horror movies, among them *The Ring* (Gore Verbinski, 2002) and *The Grudge* (Takashi Shimizu, 2004), and their respective sequels, as well as *Pulse* (Jim Sonzero, 2006) and *Dark Water* (Walter Salles, 2005), were remakes of successful Japanese horror films. Martin Scorsese's Oscar-winning *The Departed* (2006) is a star-studded retooling of the Hong Kong blockbuster *Infernal Affairs* (Andrew Lau and Alan Mak, 2002). The Korean romance *Il Mare* (Lee Hyun-seung, 2000), found its way to American screens as *The Lake House* (Alejandro Agresti, 2006), starring Keanu Reeves and Sandra Bullock. And many more remakes are in the production pipeline.

Hollywood's interest in Asian popular fare is something of a double-edged sword. For the same reasons that our multiplexes are full of rehashes of 1970s horror flicks, bygone television shows, and comic books, Hollywood producers buy the remake rights to Asian films as a shortcut around the uncertainties of coming up with ideas from scratch. A well-paid team of writers might turn in a dud script no matter what their track record, but simply buying the rights to *Ringu* (the Japanese title of Hideo Nakata's 1998 original)—a highly original horror movie with plenty of chills, and a proven hit in its own country—eliminates that risk.

KIYOSHI KUROSAWA'S *Pulse*

The remake trend can be seen as an acknowledgment of the ascendance of Asian popular cinema as a global cultural and economic force. For the first time in two decades, domestic productions outgrossed Hollywood imports at the Japanese box office in 2006. Even though the Korean government agreed, as a prerequisite to sitting down to trade talks with the United States in 2006, to double the screen time allowed to foreign films, Korean movies continued their long-running trend of topping Korea's own box office as well. These successes attest to the quality of the popular movies being made there. Meanwhile, Hollywood, even at home, hasn't found a way to reliably attract dwindling audiences increasingly turning to television, the Web, and video games for their entertainment.

Why not buy ideas off the rack when they've proven so successful? There are problems with this approach, for the audience at least. One is that the American versions (exceptions such as *The Departed* notwithstanding) tend to be inferior to the originals. Another is that, once they've bought the remake rights, American studios often do everything they can to prevent the originals from reaching our shores. Great Asian films can languish for years waiting to be remade or released. Wisit Sasanatieng's mind-boggling, candy-colored Thai western *Tears of the Black Tiger* (2000) was hidden away for over half a decade by Miramax, its U.S. distributor, until Magnolia Pictures finally bought the rights and released it in 2007. Iranian director Abbas Kiarostami's 1994 masterpiece *Through the Olive Trees*, which Miramax also bought, still isn't available on DVD in the United States. Stephen Chow's *Shaolin Soccer* (2001), a comedy every bit as nutty as his recent hit *Kung Fu Hustle* (2004), and Kiyoshi Kurosawa's indelibly creepy apocalyptic horror film *Pulse* (2001) both languished in studio vaults for years before receiving releases.

The good news is that some of these films do eventually get released. Even better news is that, thanks to the Internet and multiregion DVD players, it takes only a little effort to find them on your own if they don't. Even though the charming Korean comedy *My Sassy Girl* (Kwak Jae-young, 2001) has been stalled in the remake pipeline for some five years, the Korean DVD, with English subtitles, is easy to find on the Web. We live in contradictory times. Even as fewer and fewer foreign films receive theatrical releases in the United States, and Hollywood movies threaten the homegrown industries of other countries, it's now easier than ever for the individual enthusiast to root these treasures out. Not only are foreign DVDs available for a price and a few mouse clicks, but world-class film festivals in

cities such as Toronto, Chicago, San Francisco, and Seattle, and smaller festivals in other cities, regularly screen foreign films that may never see a general stateside release, and smaller distributors catering to niche markets regularly release small gems the majors have passed over.

In addition to their success in the big-business realm of popular cinema, Asian films are permanent mainstays on the global (for lack of a better term) art-film circuit. They routinely win major awards at film festivals all over the world. Even the traditionally America-centric Sundance Film Festival expanded its world cinema offerings recently, in part to take advantage of the strength of Asian films. As Sundance Film Festival director Geoff Gilmore put it in a speech at the 2007 Shanghai Film Festival, "If you ask me where in the last decade and a half the world's greatest filmmakers have come from, there's one simple answer: Asia." More than ever, it is Asian directors such as Iran's Abbas Kiarostami and Taiwan's Hou Hsiao-hsien, to name just two, who are considered masters of our time.

This book, then, is a response to a need. Despite an unprecedented interest in Asian cinema, there is as yet no single guide to what it has to offer. There are scholarly works, aimed at academic audiences, on specific directors or national cinemas for instance, as well as books for aficionados of everything from classic Japanese films to Bollywood to Hong Kong action movies, not to mention Web sites devoted to just about any subset of Asian cinema that you could ask for. This

CINEMA'S BEGINNINGS • French brothers Auguste Marie Louis Nicholas Lumière and Louis Jean Lumière are crediting with mounting the first commercial motion-picture screening on December 28, 1895, at the Salon Indien du Grande Café. Shot on a device patented by inventor Léon Bouly called the *cinématographe*—which could record, develop, and project moving images—these early films were the first documentaries, recording such things as workers leaving a factory or a train arriving in a station. The Lumière brothers and their followers would later travel the world, capturing images of exotic lands. These traveling filmmakers would expose much of the globe, including Asia, to cinema.

book aims to pull together these disparate threads of information to make Asian films less "foreign" by providing the necessary background for enjoying them.

Above all, it is a book for cinephiles. Not so long ago, cinephilia was limited by geography. To see foreign films one had to go to a city with "art house" theaters and independent video stores. Now, for better or worse, cinephilia has migrated to the Internet, and the community is a global one of discussion boards and blogs, where fans tip each other off to great films. It's now almost as easy to keep up with Korean cinema in Des Moines as it is in Seoul.

"The movie seems naturally to exist in a state in which its highest and its most ordinary instances attract the same audience," writes philosopher Stanley Cavell in *The World Viewed*. In other words, the cinephile does not live on art films alone. He or she can also appreciate a great action yarn, slapstick comedy, or musical. In terms of both artistic achievement and pure entertainment, Asia has more to offer these days than any other part of the world. To be interested in world cinema, or Asian cinema in particular, is not a matter of being a "film snob." It's a matter of being open to the world. This book is meant to serve as something like a map for part of it.

OPINIONS AND OTHER HAZARDS

To explore world cinema is to be plunged into a maelstrom of opinions. Cinephiles are a contentious lot. As with pop music, when it comes to film, everyone's a critic. It's a subjective endeavor, no matter whether the writer is on *The New York Times* payroll, blogging in his or her bedroom, or posting a comment on an Internet forum in the heat of the moment. Canons are in flux, subject to the whims and fancies of professionally trained critics and self-taught enthusiasts alike, all of whose thoughts can be valid. For every critic who

JIA ZHANGKE'S *The World*

takes pride in discovering a hitherto ignored great director, there's one ready to take equal pride in proving that the emperor has no clothes. As soon as a region enters the spotlight as the latest hotbed of cinematic activity, a line forms to be the first to declare the trend over. With the proliferation of international film festivals, some directors now stand accused of tailoring their films to a world market rather

than audiences at home. On the other hand, America's independent filmmakers might benefit from engaging the wider world the way that many directors from China, Iran, and Taiwan do.

The Internet can subject us to the full range of opinions on any given film or filmmaker, but it also serves as a natural corrective. I would be angrier with the prominent New York movie reviewer who condescendingly compared the great Iranian director Abbas Kiarostami to a cheeky third-world baggage porter, or the distinguished English critic lamenting the lack of world-cinema masters these days, if the films weren't available for me to judge for myself, or if there weren't an army of equally informed writers willing to challenge them.

I mention all this to show that, yes, I have a few biases of my own, but mainly to make the point that each of us must pick our own way through these thickets of opinion. My goal with this book is to encourage you, the reader, to see the films and make up your own mind.

A NOTE ON HOW THIS BOOK IS ORGANIZED

For organizational purposes, I have divided the Asian continent into four broad categories, starting with the countries with large, long-lived, and influential film industries, and concluding with emerging regions just beginning to take their place on the world cinema stage. Each chapter begins with a brief historical background of each region, to provide context for the films and filmmakers discussed.

Of necessity, the focus will vary from chapter to chapter. Volumes can be—and have been—written, for instance, on Japan's classic-era directors alone, so my coverage of Japanese cinema is necessarily general, presented in a wide shot. For Taiwan, on the other hand, I provide close-ups on the filmmakers of the New Taiwanese Cinema movement, both because of their immense importance in that country's cinematic history and because less information is readily available on them. Also, in general I have tried to focus on films that are relatively easy to see, primarily on DVD, but also at film festivals or in repertory screenings.

Finally, the last chapter includes sources for further investigation—including books, magazines, and Web sites—that can easily fill in whatever I may have left out and provide avenues to more detailed information on the subjects I have touched upon.

THE OLD GUARD

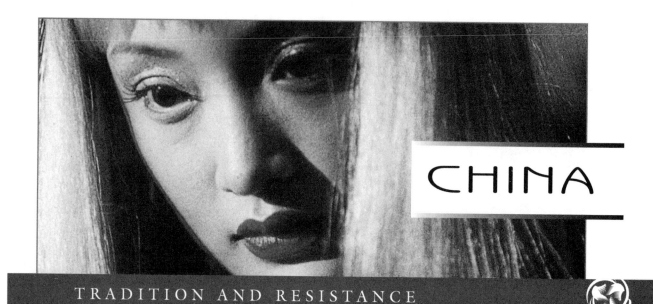

CHINA

TRADITION AND RESISTANCE

HISTORICAL BACKGROUND

China's long evolution of societies and cultures dates back over 3,500 years. Highly sophisticated developments such as philosophy, papermaking, gunpowder, and ironworking precede advancements in the West by centuries. The Silk Road, a trade route that linked China with nations as far away as the Western Mediterranean, was established in the early third century BC, and lasted for thousands of years, contributing to a flowering culture whose achievements are well known.

Two of Asia's most influential philosophies, Taoism and Confucianism, arose in China around the first millennium BC. Taoism's primary text, the Tao te Ching, is still widely read today. Its fundamental tenet is that the natural world operates in a patterned, harmonious manner, called the Way (Tao), and it is our duty as humans to understand and find our place in it. This idea is central to traditional Chinese aesthetics, particularly landscape painting, in which the goal is not to replicate how the natural world looks but to participate in nature's creativity by capturing the spirit of what one sees. The ideals of traditional landscape painting

still inform the work of many filmmakers, from the ravishing landscape shots in the films of Zhang Yimou, Chen Kaige, and Taiwan's Hou Hsiao-hsien, to Jia Zhangke's way of portraying even industrial cityscapes as dynamic, functioning elements of the nature that surrounds them.

Confucianism, with its strict rules of duty to family and society, still has a heavy influence on Chinese culture today. It also spread across East Asia, eventually becoming the state philosophy of both Japan and Korea, where its strict rules of social organization are still felt.

Rapid change came to China in the twentieth century. Thousands of years of dynastic rule ended in 1911 with a rebellion led by Sun Yat-sen, after which two parties, the Kuomintang (KMT) and Mao Tse-tung's Communist Party, vied for control of the nation. Japan invaded China's Manchuria region in 1932, and the two countries remained at war until the end of the World War II. Finally, in 1949, Mao's army overran a ruling KMT party weakened by decades of war. The KMT fled to Taiwan, and on October 1, 1949, the People's Republic of China was born.

Mao's iconic status among twentieth-century political figures stems from both his collectivist ideals and the harsh means by which he tried to institute them, most notoriously the Cultural Revolution, which lasted for the "ten lost years" of 1966–1976 and was designed to crush opposition from within through "reeducation." It wound up destroying the lives of thousands of innocent people. Its effects can be seen in the work of the vaunted fifth generation of Chinese filmmakers, whose work is informed by their memories of growing up during those lost years.

Calls for political reform under Mao's successor, Deng Xiaoping, came to a head in 1989 at Tiananmen Square, where an unknown number of unarmed protesters were killed by army troops in an attempt to squash a huge demonstration. This horrific event, televised around the world, eventually led to an array of reforms, including special economic zones, that kick-started a booming economy that continues to grow. It also spawned a rebellious generation, increasingly influenced by Western culture and more willing to take risks than its predecessors. Witness the sixth generation of Chinese filmmakers, whose underground, sometimes illegal films challenge government authority in unprecedented ways.

Despite undeniable economic and social changes, China remains a one-party state, with strict censorship. While many believe that its increased economic

engagement with the West will eventually lead to democratic reforms, the extent of such changes remains to be seen.

EARLY CHINESE CINEMA:
FROM OLD SHANGHAI TO THE CULTURAL REVOLUTION

Movies have been shown in China almost as long as they've existed. Following in the footsteps of the Lumière brothers, who dazzled Paris with their "moving pictures" in 1895, Spain's Galen Rocca, a traveling showman, included some in a variety show he brought to Shanghai the following year. These new curiosities played to sold-out houses, inspiring a string of fellow entertainment entrepreneurs to tour the country in the ensuing years. Then, in 1905, Ren Qingtai, who ran a Shanghai portrait studio, set up a permanent movie theater in a spare room. Later that year, with equipment bought from a German merchant, he produced China's first motion picture, *The Battle of Dingjunshan* (also known as *Dingjun Mountain*), a series of Peking Opera vignettes performed by one of its biggest stars, Tan Xinpei. By 1916, Shanghai, then the biggest city in the Far East, was home to a growing film industry.

American technicians came to Shanghai to train their Chinese counterparts throughout the 1920s. By the 1930s, China's film industry had entered its golden age. While Chiang Kai-shek's Nationalists and Mao Tse-tung's Communists battled for control of the country, a number of left-leaning directors began making politically pointed, technically sophisticated works that still rank among China's greatest films. Chief among these early auteurs were Sun Yu, whose films—especially *The Big Road* (1935), which is often cited as his masterpiece—critique social injustice with a poet's sensibility; Cheng Bugao, whose *Spring Silkworms* and *Wild Torrents* (both 1933) are still considered classics; and Yuan Muzhi, whose *Street Angel* (1937) is an astonishing blend of American, German, and Soviet stylistic influences.

The 1920s and 1930s also saw the rise of glamorous movie stars, most notably the tragic Ruan Lingyu, a brilliant, emotionally direct actress who has been compared to Greta Garbo. Ruan's brief, meteoric career ended in 1935, when her husband sued her for divorce over an affair and she committed suicide amid intense hounding from the tabloid press of the day. The estimated number of mourners at her funeral topped ten thousand. She was also beautifully memorialized in Hong

Kong director Stanley Kwan's 1992 film *Center Stage* (also known as *The Actress*), which starred Maggie Cheung in one of her most memorable performances.

Japan's encroachment into China in the late 1930s put an end to the golden age. It wasn't until Japan's surrender, at the end of World War II, that film production began to recover, ushering in a brief period of creative activity that rivaled the 1930s in quality. Among the great films of this period are *The Spring River Flows East* (1947), a three-hour epic about the sufferings of the Chinese people under the Japanese occupation, which was a huge hit for director Cai Chusheng; and Fei Mu's innovative and gorgeous drama *Springtime in a Small Town* (1948), which was named the greatest Chinese film of all time in a major poll conducted by the Hong Kong Film Awards in honor of the 2005 centenary of Chinese cinema.

When the Communists gained full control of China in 1949, they unsurprisingly used cinema as a propaganda tool. Content was strictly controlled, which led filmmakers to keep to safe subject matter, such as revolutionary history, literary and opera adaptations, and depictions of ethnic minorities. Scripts were thoroughly scrutinized to ensure that they properly promulgated Party doctrine. The plots had to be simple—linear, and with a clear climax and happy ending—so as to spread the word to the largest possible audience. Even with these tight restrictions on form and content, some great talents emerged during the 1950s, most notably Xie Jin, whose style—a compelling mix of melodrama and politics—was so influential that it became known as the Xie Jin School. Films such as *Woman Basketball Player Number 5* (1956) and *Stage Sisters* (1965) are landmarks for their sensitive portrayals of the lives of women. His epic *Red Detachment of Women* (1959) is considered a Chinese cinema landmark.

In 1966, the Cultural Revolution put an end to whatever progress Chinese cinema was making. During the next ten years many previously approved films were banned, and no new films were produced at all until 1971, when the so-called Eight Model Works began to appear. Personally overseen by Mao's wife, Jiang Qing (an ex-actress herself), these patriotic spectacles featured music, dance, and casts of hundreds, all devoted to extolling the virtues of the Party. The most famous among them, 1971's *The Red Detachment of Women* (a remake of the Xie Jin original) even won fans at international film festivals with its Busby Berkeley–esque parades of young women dancing with rifles. Yang Tin Yuen's 2005 documentary *Yang Ban Xi: The Eight Model Works* reveals that today these films enjoy a certain

kitschy vogue among those Chinese who remember them from their youth, but also that they were made under conditions of very real fear and oppression.

THE FIFTH GENERATION CONQUERS THE WORLD

China's directors are roughly grouped into "generations," based partly on their age and partly on when they graduated from the Beijing Film Academy. The earliest directors are, obviously, considered the first generation. The ones who brought Chinese cinema into its maturity in the 1930s and 1940s are considered the second generation. The third generation were the first active directors after the 1949 revolution. The fourth generation studied film before the dark days of the Cultural Revolution, but were unable to make films until it ended.

The fifth generation of Chinese directors, who graduated from the Beijing Film Academy after 1982, have had, by far, the biggest impact worldwide In addition to receiving the academy's traditionally world-class instruction in film technique, they were also the first generation to have been exposed to the European cinema of the preceding half-century. Having absorbed the stylistic and narrative innovations of Ingmar Bergman, Michelangelo Antonioni, and others, fifth-generation filmmakers were also able to take advantage of relaxed censorship, which allowed them to tackle previously forbidden subjects and move away from the rigidly defined rules of narrative structure that had hampered the ambitions of previous generations.

Zhang Junzhao's *One and Eight* (1983) and Chen Kaige's *Yellow Earth* (1984), both of which feature breathtaking cinematography by Zhang Yimou, mark the start of the fifth generation. They decisively set themselves apart from what came before. *One and Eight*, the story of Chinese POWs during the war

with Japan in 1939, eschews the expected narrative of heroic resistance in favor of a gritty depiction of sometimes cynical, often fallible men at war, and includes radical (for Chinese cinema at the time) devices such as having characters directly address the camera. Also set in the late 1930s, Chen's more elegiac, impressionistic *Yellow Earth* tells the story of a soldier sent to a remote village to record folk songs who finds himself embroiled in a family's struggles with poverty and the sometimes cruel bonds of traditional life. In tone, theme, and style, each were a far cry from the revolutionary operas and stilted patriotic narratives international audiences had come to expect from China.

Zhang Yimou's directorial debut, *Red Sorghum* (1987), announced the arrival of the fifth generation on the world stage, taking home the Golden Bear at the 1988 Berlin International Film Festival and becoming the first Chinese film to receive a commercial release in the United States. The sensuous visual style and sensitivity to the natural landscape that distinguish Zhang's work as a cinematographer are evident in this dramatization of Zhang's grandmother's arranged marriage as a young girl, and her suffering during the war with Japan. It also marked the debut performance of actress Gong Li, who would serve as Zhang's muse for many years to come.

Chen Kaige and Zhang Yimou would go on to become the two most famous members of the fifth generation. Both men came of age during the Cultural Revolution, although their differing personal histories influenced the themes of their subsequent work in film. Chen was born in 1952 to a family of artist-intellectuals. Like many such families, Chen's was forced to work as laborers during the Cultural Revolution. Chen later joined the Red Army, and his time spent at remote outposts inspired the plots and milieu of his early films. As a teenager during the Cultural Revolution, Chen publicly denounced his father, noted filmmaker Chen Huai'ai, at school. He treated the shame he later felt about it allegorically, and quite movingly, in the climax of *Farewell My Concubine* (1993), which won the Palme d'Or at the 1993 Cannes Film Festival.

Zhang's father, on the other hand, was a KMT officer who had fought against the Communists, which made the whole family suspect during the Cultural Revolution. Born in 1950, Zhang was pulled out of school as a teenager and forced to work in a textile factory (as was the main character in his 1990 film *Ju Dou*). It has been reported that such was his poverty—and his dedication to photography—that he sold his own blood to buy his first camera.

Farewell My Concubine

The end of the Cultural Revolution finally allowed Chen and Zhang to enter the Beijing Film Academy, Zhang having been accepted mainly on the strength of the photographs he had taken with that hard-earned camera.

As pioneering Chinese filmmakers, each of them has had to walk a particularly difficult tightrope, attempting to innovate and show previously hidden aspects of Chinese society, on the one hand, while avoiding the wrath of the authorities on the other. The compromises they each have had to make have often led to criticism, and many times to their films being banned in their own country.

Chen's first two features, *Yellow Earth* and *The Big Parade* (1986), owe much of their impact to Zhang Yimou's abundant gifts as a cinematographer, but their stately narrative pacing and treatment of the complex interplay of politics and cultural identity in Chinese society are pure Chen. *Yellow Earth*'s Red Guard soldier is charged with both preserving the village's folk songs and transforming them into patriotic hymns. His contact with a young girl facing an arranged marriage inspires her to rebel and join the army, where women, in her eyes, are free from such cruel constraints. The soldiers in *Parade* resist their strict sergeant's attempts to whip them into shape, as a way of preserving their individuality rather than becoming anonymous cogs in the army's propaganda machine. This idea evidently hit a little too close to home for the government censors, who prevented the film's release for a year. Rebellion and its consequences are also the dominant themes in *King of Children* (1987), in which a rural schoolteacher tosses out his Maoist textbook in order to engage his students in a lesson in critical thinking that ultimately puts him at odds with the authorities.

Music is an ongoing preoccupation of Chen's, from the traditional folk songs that punctuate the narrative of *Yellow Earth* to the skillful playing of the young classical-violin prodigy in *Together* (2002). In 1990's *Life on a String*, the main character's lifelong dedication to music forms the backbone of a philosophical meditation on hope and devotion. The film's protagonist is an elderly, blind master of the *sanxian*, a type of Chinese banjo. As a child, he had been told that when he broke his instrument's thousandth string, he would achieve enlightenment. Now the time is approaching. Meanwhile, he has acquired a blind disciple of his own. As with *Yellow Earth*, *Life* is set in a forbidding yet beautiful landscape, this time central Mongolia. The dialogue and plotting are even more spare, drawing on the meditative aesthetics of traditional Chinese art. Although it failed at the Chinese box office, many now consider it one of Chen's greatest films, or at least the purest

expression of his most experimental impulses. From here on out, Chen would blend those impulses with more conventional narrative forms in an attempt to reach broader audiences and address more sweeping historical themes.

Farewell My Concubine (1993) launched Chen to international renown when it shared the top prize at the Cannes Film Festival with Jane Campion's *The Piano*. Lavish and epic, it follows the relationship between two male Peking Opera stars over the course of some fifty years. The film celebrates the splendor of Peking Opera while exposing the hard lives its performers often led. The main characters, played by Leslie Cheung and Zhang Fengyi, are street orphans rigorously trained from a very young age, and their long relationship—with its subtle homosexual undertones (Cheung's character plays female roles, while Zhang specializes in stout warriors)—is a chronicle of repeated betrayal and reconciliation set against the backdrop of the Cultural Revolution. Also featuring Gong Li in one of her signature performances, *Farewell* is perhaps the defining film of Chen's career, at once critical of his country's history and a gorgeous display of its traditions.

Chen's next two films follow in a similarly sumptuous vein. The intricately plotted *Temptress Moon* (1996) stars Cheung as a heartless gigolo embroiled in the messy betrayals of a wealthy family in prerevolutionary China. Perhaps even more ambitious than *Farewell, The Emperor and the Assassin* (1999) was reputed at the time to be the most expensive film ever produced in China, and it shows. Exploring Chen's favorite theme of betrayal, it features tremendous battle scenes on a scale that even Hollywood rarely dares imagine. In grand cinematic style, it tells the story of Shi Huangdi (called Ying Zheng in the film), the monarch who first united China in the third century BC by brutally defeating the rival states that then ruled various parts of the land. Central to Chen's version of the tale is Ying's descent from idealist to mass murderer, which is prompted by a discovery about his family lineage. The film's over-the-top melodrama and sweeping scale recall the Hollywood of yore, when epics were bombastic and pulled mercilessly at the emotions.

Indeed, Chen's style consistently blends Chinese aesthetic tradition with full-blown Hollywood conventions. This is one of the secrets to his films' appeal. They expose a foreign culture through means that westerners can understand. *Together* (2002), for instance, is a solidly made biographical film about a violin prodigy. Its story—about a young boy from the sticks finally triumphing on the classical music stage—may be conventional. But like the best of classic Hollywood,

it delivers emotional impact, and it does so with solid acting (including that of Chen himself, as a grumpy music professor), a well-wrought script, and Chen's usual high level of craftsmanship. In 2005, Chen entered the big-budget martial arts sweepstakes, making *The Promise*, China's most expensive production to date. An epic fantasy adventure, it features warriors, goddesses, and plenty of battle scenes and special effects.

Chen has had his troubles with the Chinese authorities, but Zhang Yimou's career has been a near-constant parry and dodge, owing in part to his father's KMT activities. Because of his family, Zhang was considered a suspicious character almost from birth. His rebellious nature leads him to challenge authority by slipping criticism of the state into his narratives or arranging for foreign financing under the noses of the Chinese censors, but his desire to continue making films also requires that he perform gestures of reconciliation. It's a difficult balancing act that has made him at once the most famous and the most controversial Chinese director. Besides battling with the state over content, he's been accused, abroad, of pandering to Western tastes for views of the exotic Orient and, in the East, of flaunting morality, thanks to his well-publicized affair with Gong Li, the intense actress who stars in many of his films.

There is one fact about which there can be no argument: Zhang is a supreme visual stylist. He makes brilliant use of color and movement. The signature look of his films is one of gorgeous light playing off shifting surfaces: rippling fabrics, swaying grain—a pulsating world of pure color. Few directors can approach him for sheer lushness.

Establishing a pattern that would continue throughout his career, *Red Sorghum* (1988), his first film as a director, is a product of both rebelliousness and compromise. Its story, about a woman asserting her sexual desire, is embedded in a patriotic depiction of the war with Japan, in order to placate the censors. After it won the Golden Bear at the Berlin International Film Festival, he achieved even more international success with *Ju Dou* (1990). It garnered him the Best Director award at Cannes, and an Oscar nomination for Best Foreign Language Film, over the objections of the Chinese government, which banned it in China, ostensibly for its sexual content. Its narrative is as lurid as the colors of the fabrics in the textile mill around which it is set. Gong Li plays a young woman, married to a sadistic, impotent mill owner, whose affair with her husband's young nephew leads to disastrous consequences.

If *Farewell My Concubine* is Chen's defining film, *Raise the Red Lantern* (1991) is Zhang's. Set in the 1920s, it features Gong in another memorable performance, as the fourth wife of a wealthy, doddering landlord. A damning critique of the traditional patriarchal power structure, it has a claustrophobic, hothouse atmosphere in which the old man's wives compete viciously for supremacy. While it is set safely long before the Communist Revolution, it's not too much of a leap to imagine that a few of its barbs are aimed at those who held power over Zhang's career. Like the faceless bureaucrats charged with banning or censoring his films, the husband who holds the power in *Red Lantern* is rarely seen, exercising his will almost invisibly. Perhaps Zhang's government critics, like others who have studied his work, interpreted his repeated depictions of women suffering at the hands of powerful men as a metaphor for ordinary citizens suffering at the hands of the state. At any rate, the film, like *Ju Dou*, was banned from screening in China. Around the world, however, it garnered awards and nominations from numerous festivals and critics' organizations, as well as another Oscar nomination for Best Foreign Language Film. It is still recognized as one of the greatest films of the 1990s, a perfect blending of Zhang's familiar theme of strong women trapped in patriarchal social structures with the stunning visual design that distinguishes his films, even from those of his talented Chinese contemporaries.

The official Chinese attitude toward the film has changed considerably since it was first made. Zhang has recently adapted it to the stage as a ballet, portions of which were performed at the closing ceremonies of the 2004 Olympic Games in Athens—with the blessings and support of the Chinese government.

Zhang's troubles with the authorities in the early 1990s can be attributed in part to the increasing governmental intolerance following the 1989 Tiananmen Square massacre. With his last two films banned from screening in his own country and under fire in the Chinese media (partly at the instigation of his estranged wife) over his relationship with Gong Li, Zhang must have felt a need to placate his critics. *The Story of Qiu Ju* (1992) is, among other things, an attempt to show that he can play by the rules. This gentle satiric comedy, about a plucky pregnant woman (Gong again) doggedly pursuing justice when a fellow villager kicks her husband in the groin, placated the censors, because its message is that justice ultimately prevails for those who seek it. Stylistically, it is a 180-degree turn from *Raise the Red Lantern*. Instead of the vast interior set of that sumptuous work, Zhang shot primarily on the streets of actual villages and towns, sometimes with a

GONG LI
IN *Raise the Red Lantern*

hidden camera, and used only three professional actors. The rest of the parts were played by average citizens.

The bureaucrats who once hounded Zhang chose to read *The Story of Qiu Ju* as an endorsement of the virtues of contemporary China, even going so far as to view it as a possible propaganda tool. It won several awards in China and prompted the authorities to finally lift the ban on *Ju Dou* and *Raise the Red Lantern*. It was not ignored abroad either, winning the Golden Lion at the Venice Film Festival, and an audience award at the Vancouver International Film Festival, among other accolades.

But Zhang found himself in trouble once again with his next film, 1994's *To Live*. The problems started when Zhang allowed it to be shown in Cannes (where it won the Grand Prize) before Chinese censors had a chance to see it. *To Live* follows the (mis)fortunes of a Chinese family from the 1940s through the 1970s. The father, a gambling addict who loses every good thing he attains, manages to keep the family in dire straits almost constantly, and just when their fortunes seem to be improving, the insanity of the Cultural Revolution arrives, subjecting them to the surreal game of trying to play by rules that are constantly changing.

Zhang tells his tale in a darkly comedic mode. Its critique of the excesses of the Cultural Revolution isn't quite as damning as that of Chen's *Farewell, My Concubine*, but it was certainly seen as a step too far.

The hammer came down just as Zhang was about to start shooting *Shanghai Triad* (1995), which was to be funded by a French production company. In response, Zhang acidly fired off a formal "self-criticism" of the type required of intellectuals during the Cultural Revolution, a subversive gesture meant to remind the authorities that they were in danger of indulging in the authoritarian excesses of the past. After some negotiations, the filming was allowed to commence, but

only after the government received a cut of the money. Despite its production troubles, the film itself is rather innocuous. A gangster movie told from the point of view of a fourteen-year-old boy who befriends a mobster's moll, it evokes 1930s Shanghai with intricate period detail, sharp, high-contrast images, and a more subdued color palette than Zhang usually uses.

Zhang and Gong parted ways, both personally and professionally, after *Shanghai Triad*. And, perhaps worn down from an exhausting years-long cat-and-mouse game with the censors that might have destroyed the career of a less determined director, Zhang has followed a less controversial path over the past decade. He followed *Triad* with 1997's *Keep Cool*, a fast-paced comedy that pokes fun at contemporary Beijing life through the story of a bookseller and a rich man who are vying for the affections of a beautiful woman. Zhang's roving camera (like *Qiu Ju*, it was shot on location, mostly with handheld cameras) relentlessly picks out the absurdities of economically booming Beijing in the 1990s, where a broken laptop can set in motion a revenge plot of ridiculous proportions.

Zhang retained his stripped-down style for *Not One Less* (1999), a gently humorous modern fable about a young girl from an impoverished village who takes it upon herself to travel to the big city to track down a student missing from her school. Its finale is as uplifting as any classic Hollywood movie and, for the authorities, a pleasing affirmation of contemporary Chinese society, even if Zhang dares to realistically depict the hard choices the rural poor are often forced to make. Zhang has claimed that this and his other 1999 release, *The Road Home*, were influenced by recent Iranian cinema, in particular the work of Abbas Kiarostami. One can certainly see the influence in their pared-down narratives and close attention to nature. The difference lies in Zhang's opulent visual style. *The Road Home* switches between a stark tinted black-and-white present to a past filled with lush color, in which the changes of the seasons and of the quality of light throughout the day are depicted with meticulous beauty. If the story is slight—it follows the lifelong love of a married couple, culminating in the wife's stubborn determination to bury her husband according to a tradition that dictates carrying his coffin by hand to the grave—it is enlivened both by Zhang's visual artistry and by its performances, particularly that of Zhang Ziyi, who, like his former muse Gong Li, radiates determination.

Zhang returned to comedy in 2001 for *Happy Times*, in which a middle-aged bachelor and his buddies turn an old bus into a hotel, which they rent out

Hero

to lovers by the hour, all so he can raise money to marry his latest fiancée. The fiancée, unaware of the nature of her beau's business, forces him to hire her blind stepdaughter as a masseuse, and from that point his scheme becomes even more outrageous. Even though some critics have seen it and Zhang's other post–*To Live* films as a slide into complacency, the international awards did not stop coming. *Not One Less* won the Golden Lion in Venice, and *The Road Home* won the Silver Bear in Berlin and an Audience Award at Sundance.

These are small, character-driven films, lacking the lavish sweep of *Raise the Red Lantern*. Zhang's 2002 martial arts film, *Hero*, marks his return to the large-scale moviemaking that made him famous. A big-budget production, it teams Zhang with the great cinematographer Christopher Doyle, that rarest of film artists whose visual gifts rival Zhang's, and stars four of Asia's biggest names, Tony Leung, Jet Li, Maggie Cheung, and Zhang Ziyi. Following in the tracks of Ang Lee's global blockbuster *Crouching Tiger, Hidden Dragon*, *Hero* doesn't

pretend to be anything other than a glorified *wuxia pian*, the popular martial arts movies that decades ago were regarded as lowbrow entertainments, but have since been recognized as marvelously kinetic examples of popular film art. It's *Rashomon*-like plot examines the nature of heroism from different points of view, each of them filmed in a different hue and punctuated by battle scenes that are both awesome in scope and precise in their editing and choreography. The color and the light are nothing short of amazing. At times it seems that every grain of sand is casting its own shadow.

There was some controversy surrounding *Hero* regarding cuts that its American distributor, Miramax (who delayed the film's U.S. release for two years), demanded before the film was even released in China. But such are the ironies of globalization that a filmmaker can be in the position of having to capitulate to both the Chinese government and an American corporation, and that a director's cut DVD is available in China but not in the United States. Zhang was also attacked by critics who remembered his early, more rebellious films for portraying the historical figure of emperor Shi Huangdi in a noncritical way, which was seen as a concession to the official Chinese view. Zhang followed *Hero*'s success with *House of Flying Daggers* (2004). Trading the bright desert light and dark palace interiors of the previous film for lush forests, vast fields, and the Peony Pavilion (which seems to contain every color in the spectrum), this *wuxia* is set in AD 859, when the Tang dynasty is under attack from a rebel group, after whom the film is titled. Andy Lau plays a police investigator who falls for beautiful rebel Zhang Ziyi. Their love/hate adventure ranges through wonderfully staged battle scenes and unreal landscapes, to a climax that is drawn out to over-the-top proportions.

After *House of Flying Daggers*, Zhang returned to a smaller scale with *Riding Alone for Thousands of Miles* (2005), a touching story about an elderly Japanese man who in an attempt to reconcile himself with his estranged son (who

CHINA

17

is dying of cancer), goes on a journey to China in search of a famous opera singer. Once again shifting gears, Zhang followed that with *Curse of the Golden Flower* (2006), an over-the-top, operatic martial arts feast that revels in high melodrama and backstabbing in a Tang dynasty royal family.

Zhang Yimou may have tamed the rebellious nature that first got him noticed, but he's hardly tempered his artistry. He now makes gorgeous pop art on a grand scale. And yet he is still accused of capitulating—either to Western tastes or to his own government. His response: "They say that I'm trying to kiss either the foreigners' asses or the Chinese government's ass. I always jokingly respond that I'm actually kissing my own ass!"

Courage is easy from a distance. European and American critics who attack Chen and Zhang for their compromises with what many see as a repressive regime should try to imagine what it must be like to deal with a government that, not only controls all production, but can make or break a career because of shifts in the political winds, family histories, or the whims of narrow-minded bureaucrats. Consider the fate of Tian Zhuangzhuang, yet another talented fifth-generation director, who was not so adept at playing by the rules.

Tian came from a cinema family. His father, Tian Fang, was a famous actor in the 1930s who eventually became a director at the Beijing Film Studio. His mother, a popular movie star in the 1950s, was later the head of the Children's Film Studio in Beijing. Like Chen, Zhang, and the children of other middle-class families, Tian was sent to the countryside for "reeducation" as a teenager during the Cultural Revolution. He took up photography and developed a love for China's rugged, remote wilderness areas while working in Manchuria, and when the Beijing Film Academy reopened, he enrolled in the directing department, graduating in 1982 along with Chen and Zhang.

After working in television for a few years, Tian made his feature debut with *On the Hunting Ground* (1985), an experimental documentary/narrative hybrid about a traditional hunting society in Inner Mongolia. He traveled to Tibet for his next film, *The Horse Thief* (1986), a stunning piece of cinematic poetry that examines the complex junctures of Buddhism, cultural tradition, and the barren Tibetan landscape through the story of a poor but devout man who is expelled from his tribe for stealing horses. The film's vast, haunting landscapes and minimal dialogue give it the feel of a fable, a legend that transcends its context and reaches toward something primal.

The Horse Thief gave Tian his first international exposure. It was praised by Martin Scorsese and released commercially in the United States. Tian shares with his classmates Chen and Zhang an attraction to the landscapes and people of China's remote areas (and a preference for working there, far from central-government interference), but his style is much more experimental than theirs. Where Chen and Zhang create elegantly crafted narratives highlighted by great visual beauty and detail, Tian challenges his audience's expectations by pushing the boundaries of what narrative cinema can be. He blurs the line between documentary and fiction. He respects the cultures he films to such an extent that their traditions and rituals are often left unexplained, and simply play themselves out in front of the camera. *On the Hunting Ground*, for instance, was made in the Mongolian language. If the landscape is a background for the stories in the films of Chen and Zhang, it at times becomes the very subject for Tian. His long takes emphasize its vastness, its beauty, and its dangers. The people and the stories they enact are secondary in his films, as they are in life, to the awesome power of nature. The failure of his first two films at the Chinese box office prompted some to accuse him of snobbery toward popular audiences. Tian's response that his films were ahead of their time—they were intended for sophisticated twenty-first-century audiences—would later prove true, but not in the way he intended.

The Cultural Revolution occurred during the formative teen years of Chen, Zhang, and Tian, and its lingering effects informed the work of these directors in significant ways. Each would treat the events of the Cultural Revolution directly at some point. More than Chen's *Farewell, My Concubine*, and certainly more than Zhang's *To Live*, Tian's *The Blue Kite* (1993) unflinchingly depicts the horrors of Mao's reforms and the Cultural Revolution, and the way they gradually, painfully destroy a family. Coming in from the wilderness of his first two features, Tian here uses the crowded architecture of old Beijing as a way of conveying the claustrophobia of living in a society in which your every move is being watched, and in which even a minor misstep can result in very bad consequences. At heart, though, *The Blue Kite* is a moving portrait of the love between a mother and son. It is told from the point of view of the son, Tietou, who watches as three successive father figures are brought to ruin by Mao's reforms, but the bond that these misfortunes create between him and his mother provides at least a ray of hope.

Tian's original screenplay had been approved, but when authorities saw the raw footage, they accused him of deviating from the script and forbade

The Blue Kite

him to continue working on it. Somehow, this footage made it to Holland and into the hands of the distributor Fortissimo Films, who completed editing and postproduction according to Tian's instructions. Needless to say, this infuriated the authorities even more. Although they could never prove that it was Tian who smuggled the footage out of the country (which would have been a serious crime), they still barred him from making films. Meanwhile, *The Blue Kite*, though banned in China, debuted to great acclaim at Cannes, won awards at the Tokyo and Hawaii international film festivals, and went on to play to accolades around the world.

The ban on Tian was eventually lifted, but it would be ten years before he directed another film. When he returned to the world-cinema scene, it was with a luminous reimagining of Fei Mu's 1948 *Springtime in a Small Town*, one of China's most revered classics.

Tian's 2002 version retains the original's story and setting. It takes place in a crumbling estate, where a sickly landlord and his young wife receive a surprise visit from the landlord's old college friend, now a doctor, who was once in love with the landlord's wife. These three characters engage in an intricate balancing act in which subdued passions play out beneath the surface of the rigid rules of

decorum to which they must adhere. Fei's original version is justly lauded for its use of modernist—almost avant-garde—devices including a poetic stream-of-consciousness narration by the lead female character, and an unorthodox use of dissolves within scenes. Tian's remake is an entirely different animal. Enlisting the talents of cinematographer Mark Lee Ping-ping, he dispenses with Fei's modernist techniques and instead portrays the simmering emotions of his characters through languorous, gliding long takes of the kind Lee Ping-ping applies to similar effect in Tawianese director Hou Hsiao-hsien's *Flowers of Shanghai* and *Millennium Mambo*. Tian is nothing if not a master of depicting the ways in which emotion, behavior, and culture are linked to landscape and setting, and here the fading opulence of the interiors, the estate's crumbling stone walls, and the vastness of the surrounding area are as much a part of the plot as the three main characters. (So connected is Tian to the natural settings of his films that he literally hugged a large tree that features prominently in the film before commencing shooting.)

A gem of a film, *Springtime* certainly holds its own as a companion piece to the original. But rather than continuing in the same vein for his next project, Tian instead pursued his continuing interest in China's remote areas and the people who live there. *Delamu* (2004) is a fascinating and quite beautiful documentary about the ancient Tea Horse Road, a two-thousand-year-old trade route connecting China to Nepal, India, and western Europe via a perilous, winding route through Tibet's awe-inspiring mountains.

There is a spiritual dimension to Tian's deep appreciation of nature, and matters of the spirit play a big part in his 2006 feature *The Go Master*, a biopic about Wu Qingyuan, a famous Chinese player of the game of the title. Somewhat similar to chess, Go is a game of strategy and requires intense concentration. Games can last for days. Wu, who spent his career in Japan while it was at war with his home country, seeks a kind of transcendence through contemplation of the game and of life.

The fifth-generation directors broke new ground. They released Chinese cinema from its moribund reliance on propagandistic narratives and stilted storytelling, they addressed previously taboo subjects, and they brought international recognition to Chinese film. They also paved the way for a new, even more rebellious generation of filmmakers who would simultaneously repudiate and build upon their predecessors' achievements.

TIANANMEN SQUARE • In 1989, Chinese students commemorated the April 15 death of the reformist former general secretary of the Chinese Communist Party, Hu Yaobang, with pro-democracy demonstrations, which grew into a massive protest movement centered on Beijing's Tiananmen Square. Calls from the government to disband the demonstrations were ignored, and on June 3 and 4 the military moved in, killing hundreds of protesters, and injuring thousands more. The protests and the crackdown were seen around the world on television, earning the Chinese government widespread condemnation. The often subversive films of China's sixth-generation directors were deeply influenced by the protests' brief era of idealism and the brutality of the government's reaction.

THE SIXTH GENERATION AND INDIE-CHINA: UP FROM UNDERGROUND

If the fifth generation's films bring to mind beauty, exoticism, and meticulous attention to craft, the sixth generation's films counter with raw immediacy and gritty realism. Farewell concubines, emperors, and rural peasants; hello wasted rock musicians, death-obsessed performance artists, jaded bar hostesses, and petty crooks. Emboldened by the 1989 Tiananmen Square protests, many sixth-generation filmmakers share a deep distrust of their government and the Communist Party, as well as an impatience with China's strictly regulated film industry—in which an aspiring director can languish for years at menial jobs before being trusted to direct a film, and even then the script, raw footage, and final product are closely monitored by government censors. Often, the results are the kind of bland, mediocre cultural products that are acceptable to government bureaucrats the world over, but not so satisfying for audiences.

The sixth generation's solution was to create an underground film industry of its own. Never mind that making independent films was illegal in China, when the sixth generation got their start in the 1990s. The government controlled the supply of film stock, and it was provided only to officially sanctioned productions. But the members of this restless generation have been remarkably bold and resourceful in their quest to show the world the other side of China's official image. They cobble together financing from their own pockets or foreign investors, they shoot clandestinely using film stock scrounged from underground sources, they smuggle their materials overseas for postproduction when officials shut them down, and they often shoot on digital video, a technology that the government can't control.

All of which makes the life of an independent filmmaker in the United States seem perfectly cushy by comparison. But, as with many things in China, rules are more fluid than they appear, and part of being a filmmaker there is working with and around them. Just as the international marketing of the fifth generation's films tends to emphasize their exoticism (some would even say Orientalism), the "banned in China" label can give a marketing boost to a young director's work overseas, even if the ban may soon be lifted or it's an open secret that underground films circulate widely on bootlegged DVDs. It's also true that the Chinese authorities have become increasingly lenient. It is a common practice for them to invite underground filmmakers (such as Jia Zhangke) to "renounce" their outlaw ways and benefit from the resources available to them through the state-run film industry. None of this is meant to downplay the risks Chinese independent filmmakers have taken or to diminish their achievements; it merely sheds a bit of light on the complexities of China's constantly evolving cultural climate.

Especially in the early days, sixth-generation films certainly display an outlaw sensibility. The opening salvo came in 1993 with Zhang Yuan's *Beijing Bastards*. Cui Jian, China's first bona fide rock star, plays a musician who goes in search of his pregnant girlfriend through a nihilistic world of sex, drugs, and seedy nightclubs. To make it, Zhang circumvented official channels by financing it with money he'd earned directing music videos. *Beijing Bastards* was banned in China, but it made quite an impression overseas, where it gave audiences at international film festivals an unprecedented view of Beijing's underworld. It also served as an inspiration for other young Chinese filmmakers.

Zhang followed *Beijing Bastards* with *The Square* (1994), a documentary shot at Tiananmen Square in which the traces of what happened there in 1989 are glaringly conspicuous for their absence. His next film, *Sons* (1996), is a fiction/documentary hybrid in which a family headed by a violent, alcoholic father reenact the traumatic events that led to him being committed to an asylum. Zhang made his biggest splash in 1997, with *East Palace, West Palace*, which addresses one of China's most taboo subjects: homosexuality. In it, a gay man is arrested for cruising and interrogated all night by a police officer whose disgust slowly changes into attraction. A bold plea for tolerance, it also shows off Zhang's immense skill at creating painfully intimate, emotionally raw dramas. It had to be smuggled out of the country for its debut at the Cannes Film Festival.

Zhang and his colleagues consciously set themselves apart from the fifth

generation. As Zhang himself said, "They had a slogan: 'Not like the past.' It motivated us to create our own: 'Not like the Fifth Generation.' " But many of them have found themselves playing the same exhausting cat-and-mouse games with the authorities. Sometimes the only way to work is to come up from underground, which is exactly what Zhang did. Tired of making films that his fellow Chinese citizens were forbidden to see, he moved into the world of official production with *Seventeen Years* (1999), a sad, perfectly crafted drama about a woman who accidentally murders her sister as a teenager and, after seventeen years in prison, is granted a holiday furlough to visit her family, only to find that they may not want to see her. Even with its official seal of approval, it took eight months after it won two major prizes at the Venice Film Festival for the censors to allow it to be shown in China.

Its depictions of some of the messier aspects of contemporary life in China may have caused the delay in its release, but the film's power comes, not from whatever political subtext it may have, but instead from Zhang's always clear-eyed way of showing how every relationship, whether it be within a family or not, carries with it fathomless depths of buried emotion. He honed this theme to its rawest expression in 2002's *I Love You*, which follows a young married couple through the ups and downs of their relationship. Set for the most part in a cramped apartment, its crisp dialogue and acting, enhanced by Christopher Doyle's always creative cinematography, portray the tragedy of a couple who love one another deeply yet can't help falling into vicious fights again and again. Doyle also shot the slightly lighter, less claustrophobic *Green Tea* (2003), in which a lonely bachelor in search of love finds himself torn between a bookish young woman and the more mysterious seductress he meets in a nightclub, who may or may not be the same person. Both of these films were very popular in China, but they have drawn fire from critics who accuse Zhang of abandoning his rebellious ways for the lure of money and popularity.

It's a dilemma many sixth-generation filmmakers find themselves facing. Wang Xiaoshuai has spent his career in a running battle with the authorities over his films' content, repeatedly crossing the line between official and independent production. After graduating from the Beijing Film Academy in 1985, he saw firsthand the laborious machinations of the official film industry. He spent several years in menial film studio jobs until he was able to scrape together enough money to make his first film, *The Days* (1993), about an artist couple's crumbling

relationship, which he shot on weekends using his friends as actors. A talented painter as a teenager, Wang also delved into the art world for *Frozen* (1995), which he released under the pseudonym Wu Ming (literally "No Name"). Based on a true story, it follows a disturbed young artist through a series of performances that he intends to culminate in his own death by burial in ice. It's a fascinating depiction of Beijing's lively, subversive, post–Tiananmen Square avant-garde art milieu.

While making the underground *Frozen*, Wang was also at work on an official production, *So Close to Paradise*, which he filmed in 1994 but, because of censorship battles, wasn't released until 1998, and then only in a heavily edited version. Produced by Tian Zhuangzhuang during his long hiatus from directing, it extends Wang's interest in Chinese society's outsiders, but shifts the focus from

the artists of his earlier films to the migrants who are drawn to the underground economies of China's cities. Set in the city of Wuhan, *So Close* features two roommates from the country—one plying the honest trade of a "shoulder pole," carrying goods back and forth across the river, the other mixed up in the city's criminal underworld—who become involved with a Vietnamese nightclub singer. It was originally titled *The Girl from Vietnam* in English—a nod to Orson Welles's *The Lady from Shanghai*—and it is full of film-noir style and themes transposed to contemporary China.

Classic American cinema has been a touchstone for Wang's sixth-generation contemporary Lou Ye as well. His masterful 2000 film, *Suzhou River*, channels Hitchcock's *Vertigo* (1958), the first-person camera experiments of Robert Montgomery's *The Lady in the Lake* (1947), and the disenchanted narrative voice of any number of American film noirs into a perpetually gray and cloudy modern Shanghai, where a world-weary videographer gets mixed up with a motorcycle courier dangerously lacking in scruples and the mysterious young woman the courier takes advantage of. A prime example of form following function, *Suzhou River*'s aesthetic springs from the possibilities inherent in the digital video camera: its mobility, its intimacy, and its function as a tool for personal expression (the film's hero not only uses it on the job but obsessively records events from his own life). Lou's great achievement is the realization that the video camera has its own strengths. It's not simply a smaller, lighter film camera. Video has its own look, feel, and way of rendering the internal thoughts of not only those it records but the person behind the camera as well. Lou's sensitivity to video's particular qualities, and a story that is at once timeless and rooted in present-day Shanghai, make *Suzhou River* something of a landmark.

Lou landed superstar Zhang Ziyi to play the lead in his ambitious, sprawling *Purple Butterfly* (2003), which is set in the 1930s among the underground resistance to the Japanese occupation of Shanghai. Sliding back and forth in time and alternating between hazy romance and staggering violence, *Purple Butterfly* cranks the innovations of Lou's previous film into overdrive, combining the scope of a historical epic with the intimacy of the innovative camera-work he developed in *Suzhou River*.

In 2000, Lou was banned from making movies for over a year by the Chinese authorities after he submitted *Suzhou River* to the Rotterdam and Tokyo film festivals without their approval. The same thing happened again with his 2006

Suzhou River

film *Summer Palace*, which premiered at Cannes without authorization. Not only is *Summer Palace* a rebellious, sprawling journey through several years of recent Chinese history, it's a surprisingly explicit exploration of sex and desire among a group of intellectuals trying to find their place in the post–Tiananmen Square years, with lead actress Hao Lei delivering a ferocious performance as a woman whose emotional growth mirrors China's development. To say the film blends the personal and political is too simple. *Summer Palace* is a devastating look at how time slips away, changing lives in ways that are both inexorable and unfathomable.

It may be a while before we see another film from Lou. Because of his Cannes transgression, the Chinese Film Bureau announced that it is banning him from making movies for five years.

A shared affinity for classic American cinema isn't all that unites Wang Xiaoshuai and Lou Ye. Lou starred in Wang's debut feature, *The Days*, and Wang returned the favor by starring in Lou's 1995 love-triangle drama, *Weekend Lovers*. But while Lou didn't make another film after *Purple Butterfly* until 2006's *Summer Palace*, Wang has been working at a steady pace. His 2001 film, *Beijing Bicycle*, won the Silver Bear at the 2001 Berlin International Film Festival (as well as awards for both of the film's male lead actors), and went on to worldwide release and glowing reviews from critics who grasped its importance as an incisive look at a changing China. Again drawing inspiration from the past, Wang adopts the premise of Vittorio De Sica's Italian neorealist classic *The Bicycle Thief* (1948) to once again explore the world of rural migrants in the big city. *Bicycle* addresses bigger themes than *So Close to Paradise*. It is a portrait of a city lurching from a communist economy to a capitalist one, and in the process, creating a newly bifurcated world of haves and have-nots, traditional laborers and ambitious modern businesspeople. And it focuses on the bicycle, that most antiquated yet essential form of transportation in Beijing. The titular one becomes the object of an escalating conflict between its rightful owner, a country boy working as a courier, and a social-climbing student.

Wang is a mainstay on the international festival circuit, so it is perplexing that his 2003 film, *Drifters*, hasn't received more attention. Equally as meticulously crafted as his other films (his eye for landscape and composition rivals anybody's), it is set in a coastal city where countless illegal immigrants begin their trip to the United States smuggled aboard cargo ships. Its protagonist is a young man who once made the trip and has since returned, after fathering a child overseas. When the mother and her family return but won't let him see the child, he launches

Beijing Bicycle

himself once again into a future of uncertainty, an uncertainty echoed throughout the film by repeated radio broadcasts tracking China's entry into the World Trade Organization.

Wang's 2005 *Shanghai Dreams*, returned him to international prominence, winning the Jury Prize at the Cannes Film Festival. A tale of displacement marbled with a thriller-like narrative thread, it is set in the early 1980s in the remote, mountainous Guizhou Province, where many families were sent from the cities in the 1960s to act as a barrier against possible Soviet aggression. For the film's teenage protagonist, this rural village is all she knows, but for her embittered father, it represents a painful temporary exile from his beloved Shanghai. The tension within the family simmers until tragedy forces it to boil over.

Recently another sixth-generation director, Jia Zhangke, has vaulted to even greater international renown than Zhang Yuan and Wang Xiaoshuai, and all on the strength of just a handful of films. That Jia seems to strike more of a chord internationally has much to do with the way his films engage the world at large. The ripples of global economic change carrying scraps of American pop culture wash over his characters, even in the remote Shanxi Province, where he grew up and where most of his films are set. And his style, which evokes those of Yasujiro Ozu, Hou Hsiao-hsien, and Robert Altman, among other influences, is broadly international as well. For Jia, perhaps more than any other contemporary filmmaker, globalization is not an abstract concept but a concrete fact of life.

Jia's talent for drawing attention to the cross-cultural stew that constitutes contemporary life (even if we rarely notice it consciously) is evident in *Xiao Shan Going Home* (1995), an hour-long short he made while still at the Beijing Film Academy. A mélange of dialects (a rarity in Chinese films) jostle with American pop songs by the likes of the Carpenters and Soul Asylum in the film's aural field, illustrating how even the daily experience of an unemployed cook trying to make his way home for the New Year's holiday is crosshatched with widely varied cultural influences. *Xiao Shan* won the top award at the 1997 Hong Kong Independent Short Film and Video Awards, giving Jia the chance make his first feature, *Xiao Wu* (1997), a low-budget 16 mm profile of a pickpocket in Fenyang, Jia's hometown. *Xiao Wu* establishes Jia's aesthetic technique, his particular way of constructing a film, which he would use to such emotionally devastating effect in *The World* (2004). In *Xiao Wu* the idea of theft is used as a concept around which every aspect of the film revolves. Just as the main character is a thief, so Jia "steals" different cinematic styles to tell his story, borrowing most obviously from Robert Bresson's *Pickpocket* (1959) but also incorporating documentary techniques and bursting at one point into stylistic exuberance reminiscent of the early work of Jean-Luc Godard. And throughout the film, as the title character's cons and dodges are gradually stripped away, leaving him both emotionally and physically exposed, so Jia strips down his style until it reaches a kind of cinematic purity.

Xiao Wu caught the eye of Japanese director Takeshi Kitano, who threw his production company's financial support behind Jia's ambitious feature *Platform* (2000), a film that was being called a masterpiece almost as soon as it hit screens. Beginning in 1979, it covers a decade in the life of a group of "arts workers," as they transform themselves from the Peasant Culture Group of Fenyang to the

All-Star Rock 'n' Breakdance Electronic Band, thanks to privatization brought on by China's post–Cultural Revolution economic reforms. As in Taiwanese director Hou Hsiao-hsien's great 1980s films *A Time to Live and a Time to Die* and *A City of Sadness*, history happens elsewhere, but it inevitably arrives, in a strangely mutated form, even in dusty Fenyang, on the edge of the Inner Mongolian wilderness. A kind of mournful humor pervades the film's mood of dissolution and uncertainty, itself a reflection of China's own difficult transformation. The 1980s-style rock songs and dance moves that the group perfects are just as silly as the Maoist odes they start out with, and watching them perform before crowds of indifferent peasants invites both muted laughter and pathos.

At 155 minutes (in the "distributor's cut" currently available—it was originally over three hours), *Platform* is difficult to encapsulate. Jia films his characters largely in middle-distance long takes. Modern lovers' quarrels take place before vast ancient battlements. The troupe's battered truck drives along dusty roads through dry, hilly landscapes as they tour the provinces, at first singing patriotic songs in praise of Mao or, after their privatization, belting out rock tunes to diminishing success. Along the way lovers come together and drift apart, and each character adjusts uneasily to their changing world. Time is deliberately undefined. It moves in the film in an imitation of the way it does in life, marked by the barely noticed arrival of color televisions, of tight jeans and long hair replacing official fashions, of gas stoves replacing coal and wood fires. *Platform*'s pleasures are deep and long-lasting, nestled in a narrative pace that seems to dissipate along with the ambitions of its characters.

A general permeability pervades Jia's films. Fiction slips into documentary; the currents of world affairs affect life in Shanxi Province. In 2002's *Unknown Pleasures*, Jia himself becomes a presence in the film's ostensibly fictional yet quite real milieu, appearing near the beginning as an apparent madman, wailing an operatic aria in what sounds like a jumbled mixture of Italian and Mandarin, and near the end in name only, when a character asks a DVD peddler if he has copies of *Xiao Wu* and *Platform*, only to be offered *Pulp Fiction* instead (compounding the irony even further, the customer is Xiao Wu himself, making a cameo). These enigmatic appearances carry more weight than mere self-reflexivity. Like Jia himself, the singer he plays is trying to express the polyglot world through artistic expression, while the works of Jia the famous director are harder to find in his home province than those of Quentin Tarantino.

On the surface, *Unknown Pleasures* is a youth film, part of that over-populated genre of East Asian movies in which aimless kids hang out smoking cigarettes and getting into trouble out of sheer boredom. The two main characters, Xiao Ji and Bin Bin, are a couple of luckless losers halfheartedly trying to make lives for themselves in the industrial city of Datong. What makes this film different is, once again, Jia's broad sense of the world. The film is set in 2001. The radio reports the real diplomatic standoff between the United States and China over a downed spy plane and the awarding of the 2008 Olympics to Beijing (which is celebrated with a pathetic fireworks display). *Pulp Fiction* inspires Xiao Ji and Bin Bin to make a knuckleheaded stab at petty crime. The discovery of a dollar bill leads to naively inflated speculation about its worth. If the characters in *Platform* are doomed to eternally return to Fenyang, those in *Pleasures* are trapped in Datong, even as the rest of the world beckons. Shot on video, *Pleasures* has a gritty yet somehow graceful feeling (Jia uses the video camera every bit as innovatively as Lou Ye in *Suzhou River*). It is broader and deeper than the average youth film, its message about globalism couched in a distinctly humanist sensibility.

Jia's success at international film festivals and with critics and audiences around the world prompted China's Film Bureau, in 2003, to publicly invite him to renounce his independent ways and accept their invitation to work with official approval. One is tempted to speculate that this significant gesture, which was apparently phrased in unusually flowery language, represents a shift in attitude, an acceptance that talented filmmakers are going to work no matter what, and that it's better to bask in their reflected glory than to look bad in the eyes of the world for repressing them. Although Jia's decision to accept their offer met with not a little disbelief and suspicion, it turned out to be the right one. Its result, *The World* (2004), is an altogether remarkable achievement.

It takes its title from a tourist attraction outside of Beijing, World Park, a theme park consisting of scale-model replicas of landmarks throughout the world, including the Eiffel Tower, the canals of Venice, and the Taj Mahal. Jia's frequent muse, Zhao Tao, in an acting tour de force, plays an employee of the park, a dancer who spends her day rushing from attraction to attraction, donning costumes and impersonating belly dancers, geishas, and the like. In this hyperreal setting, a potent metaphor in itself, Jia creates a meditation on the concept of worlds: inner worlds, outer worlds, the world itself, and World Park, whose workers will most likely never see the real versions of the simulacra they inhabit. When one of them

ZHAO TAO IN *The World*

tells another that they don't even know anyone who has ever flown in an airplane, their isolation becomes profoundly clear.

Jia's sure-handedness, his confidence in his style and his ideas, consistently amaze. Just as, in the hands of a lesser director, *Platform* could have veered into sentimentality and *Unknown Pleasures* could have become a symbolism-ridden bit of agitprop about capitalism, *The World*—with its elegantly composed long takes, its moving depictions of its characters' relationships, hopes, and dreams—refuses to reduce itself to the ready-made metaphor of its title. Instead, it somehow manages to reach something essential and universal about contemporary life, not just in *The World*, but in the world.

The characters in Jia's *Still Life* (2006) are lost in a different kind of world, one that is soon to disappear under the rising waters of the monumental Three Gorges Dam project. The film is set in the town of Fengjie, which is slated to be flooded during the next phase of the dam's construction downstream. Jia presents it as a landscape of destruction, where thousands of workers with sledgehammers swarm over crumbling buildings, pounding them into rubble in preparation for the rising waters, and where two new arrivals from Shanxi (played by Jia regulars Zhao Tao and Han Sanming) search for their estranged spouses. There is a kind of awful beauty to the slow destruction of Fengjie. Demolished buildings, distant hills, and the vast sky dwarf the characters in patiently scrolling panning shots that, as in his other films, emphasize the complicated connections between inner lives, outer lives, and the world at large, in this case, one that is about to disappear. *Still Life* is stubbornly earthbound—concerned with the grubby details of everyday life, the physicality of men doing hard labor, and the pain of broken relationships—yet somehow ethereal. The combination invites the viewer to absorb and think deeply about every element of the film—the beauty of destruction, the characters' stories, the controversial Three Gorges Dam project itself—yet wisely provides no easy answers.

CHINA TODAY AND BEYOND

The video revolution that began in the 1990s continues unabated, producing widely varied works that give us the unofficial view of today's China. He Jianjun, previously known for Hitchcockian suspense films like 2001's *Butterfly Smile*, shot his *Pirated Copy* (2004) guerilla-style on the

streets of Beijing to delve into the world of bootleg videos and those who sell and are obsessed with them. *Tie Xi Qu: West of the Tracks* (2004), Wang Bing's mesmerizing nine-hour documentary on industrial decay in northeastern China, would have been impossible to achieve on film, for political as well as technical reasons. Andrew Cheng's *Welcome to Destination Shanghai* (2003) and Zhu Wen's haunting *Seafood* (2001) both wallow in the sex trade, an unwelcome subject in official circles. Diao Yinan's cleverly subversive *Uniform* (2003) takes a few jabs at authority too, through the tale of a small-town tailor who dons a police uniform and finds himself enjoying the power it brings a bit too much.

Even in the realm of official and quasi-official filmmaking, China's increasing openness has inspired new energy. Zhang Yang's *Shower* (1999), a bighearted comedy, sends a businessman home to the traditional spa run by his ailing father, where he must take stock of his duty to his family. Liu Fen Dou, that film's screenwriter, won the top award at the 2004 Tribeca Film Festival for his directorial debut, *Green Hat* (2003), a biting tragicomedy about crime and cuckoldry. Xiao Jiang's warmly nostalgic *Electric Shadows* (2005) evokes the power of cinema to inspire the imagination, even during the dark days of the Cultural Revolution. Set during the Japanese occupation, Jiang Wen's *Devils on the*

Doorstep (2002) is a scathing antiwar satire that becomes increasingly horrific as it dashes to its shocking conclusion. Jiang, who is best known in China as an actor of exceptional talent and has starred in many high-profile movies, proved with this film that he is equally gifted as a director.

The creaky state aparatus is ripe for criminal exploitation in Li Yang's *Blind Shaft* (2003), in which a pair of itinerant laborers work up a scam that depends on China's notoriously lax mining-safety standards. One of the most significant Chinese releases of the past few years, it is a sharp depiction of a society in danger of being overwhelmed by cynicism, told in a dark, compelling style.

Cinema in China has evolved alongside its cultural, political, and economic changes. Once the land of moldy Maoist propaganda, China now gets involved in multinational blockbuster coproductions such as *Hero* and *Crouching Tiger, Hidden Dragon*. Reunification with Hong Kong has juiced the industry with that island's well-documented creative energy. No longer outlawed, independent production flourishes more than ever, while official productions have begun to attune themselves more closely to the desires of the moviegoing public. The once-banned Chen Kaige and Zhang Yimou are now lavished with previously unheard of budgets—and the blessing of the state—to make grand productions such as *The Promise* and *Curse of the Golden Flower*, intended to compete with imported Hollywood productions, which has provoked no small amount of grumbling from their younger peers. Lunar New Year movies, the equivalent of the big summer blockbusters in the United States, rake in millions at the box office. Perhaps it is a sign of these changing times that a recent New Year hit, Feng Xiaogang's *Cell Phone* (2004), treated the contemporary issue of infidelity via mobile phone with a breezy, assured humor that would once have been unimaginable. On the other hand, two years later a directive was handed down to China's film studios warning them that their popular movies were straying too far from the "true Chinese spirit" and that tougher regulations might be on the way. *Cell Phone* was singled out as a primary offender.

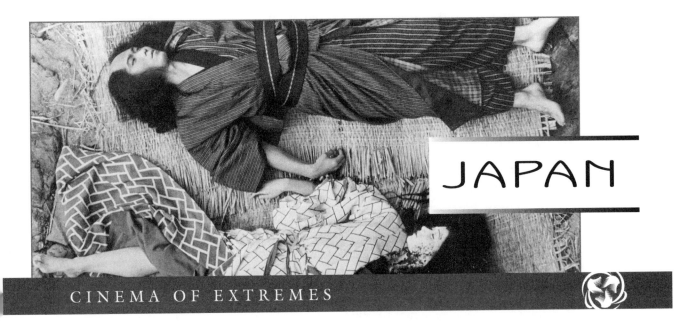

CINEMA OF EXTREMES

HISTORICAL BACKGROUND

While the Japanese archipelago is believed to have been inhabited since around 30,000 BC, the popular image of traditional Japan comes mainly from the fertile period that began in the late eighth century AD and lasted well into the nineteenth century. The samurai came into being quite early on, and the Edo era (1600–1868), named for the city that would become Tokyo, gave us the geishas, the gorgeous ukiyo-e woodblock prints of Hokusai and other masters, the development of Kabuki and Bunraku theater and other arts. All these elements came together to form the "floating world" that has been mined repeatedly by authors, artists, and, of course, filmmakers.

During this time a highly refined aesthetic tradition developed, which was codified into a series of concepts by the scholar Norinaga Motoori during the Edo era. Primary among these is *mono no aware*, which is often translated as the "pathos of things." It refers to a direct understanding of and sensitivity to the world of objects and nature, and a deep awareness of its transience. This concept is illustrated in the appreciation of cherry blossoms, which bloom for only about

a week before withering. The films of Yasujiro Ozu, called the most Japanese of Japanese directors, are often interpreted as embodying *mono no aware,* in both plot and construction. Ozu's compositional and editing style embeds narratives of families changing over time—characters growing up, growing old and dying—in a framework that encourages a heightened awareness of the sad inevitability of the passing of time, but also an appreciation of the transience of life.

Japan's isolated society changed with the arrival of the Western powers—primarily the United States—in the nineteenth century. By the end of the 1800s, the traditional ruling shogunate and its strict divisions of society had been abolished, power was consolidated under the emperor Meiji, and the samurai had been phased out, replaced by mandatory military conscription. In search of natural resources, Japan used its military might to invade the Asian continent, which led to wars with China, Russia, and the occupation of Korea. By 1942, Japan controlled a large part of China, Korea, Taiwan, and most of Southeast Asia. But World War II, during which Japan lost some 1.7 million soldiers and nearly 400,000 civilians, put an end to its imperial ambitions.

Filmmakers during the postwar years began to seriously question Japanese history and culture. Japan's cultural achievements began to be seen as symbols of a destructive, imperialist ethos that had ultimately brought on the atomic bombing of Hiroshima and Nagasaki, and occupation by American forces. Directors such as Kinji Fukasaku and Shohei Imamura—who famously said he was "interested in the relationship of the lower part of the human body and the lower part of the social structure"—depicted a more raw, earthy Japan, one that had always existed beside, or perhaps beneath, the cherry blossoms and tea ceremonies, and sought a cinematic style that rejected the refined poise of traditional aesthetics.

Culturally, Japan is a striking mix of tradition and innovation. Its ancient culture still lives, transformed by modern influences. Japan's hyperactive pop culture—and Tokyo itself—may look like something from the future or another planet, and one might wonder how the grotesqueries of Japan's more extreme cinema could have arisen from what is often seen as a tradition of delicate aestheticism and the appreciation of beauty. But look deeper and you'll see that these seemingly incongruous elements of Japanese culture have deep roots.

BEFORE THE WAR

The movies came to Japan just a year after their invention. Thomas Edison's Kinetoscope made its debut in the city of Kobe in 1896, followed quickly by the arrival of the Lumière brothers' *cinématographe*. Despite remaining stubbornly closed to the West for centuries, Japan has had a history of willingly absorbing disparate cultural influences, and cinema was no exception. Before they began making films of their own, the Japanese concentrated on finding ways to present these two- to three-minute-long Western curiosities to audiences. Screenings were accompanied by live music and narrated by performers who became known as *benshi*. As movies evolved, so did the *benshi*, becoming not mere narrators but theatrical performers who invented voices for the characters onscreen and, after Japan developed its own film industry, at times even demanded rewrites from the studios to suit their performance style. *Benshi* performances proved so popular that they were often more in demand than the films they accompanied. They had followings of fans who would go to see them no matter what movie was playing. Although sound eventually rendered the *benshi* obsolete, they fought for their jobs to the end. A 1932 strike over a policy encouraging theater owners to fire them as sound came into being led to the suicide of Akira Kurosawa's brother Heigo, who worked as a *benshi*, when it failed. The tradition is still occasionally carried on in special performances of silent films both in Japan and abroad.

Early Japanese silent films were simple recordings of Kabuki performances starring the famous actors of the day. But in the 1910s, European and American silent films began to arrive. These films had evolved beyond mere filmed theater, and they inspired younger Japanese directors to experiment with cinematic form, with American silent comedy and German expressionism providing major influences. Yasujiro Ozu, most famous for his later achievements, began by making delightful silent comedies like *I Was Born, But . . .* (1932). Teinosuke Kinugasa, under the influence of German expressionist masterpieces like Robert Wiene's *The Cabinet of Dr. Caligari* (1919), made *A Page of Madness* in 1926. A hallucinatory, avant-garde work that eschews all commercial convention, it evokes the world of the mentally ill—its plot concerns a man who takes a job as a janitor in an insane asylum in order to find his wife, who is confined there—through startling images and disjunctive cutting. It is one of great landmarks of Japanese silent cinema.

A Page of Madness

Partly because of the considerable power of the *benshi*, sound cinema arrived comparatively late in Japan. Foreign sound films like Josef von Sternberg's *Morocco* (1930) were popular, and the first Japanese sound film, Heinosuke Gosho's *My Neighbor's Wife and Mine*, appeared in 1931, but even Ozu resisted using sound until 1936.

JAPANESE GENRES • Quite early in its development, Japan's film industry divided itself into strict genre categories. The main division, which came about in the 1920s, was between *jidai-geki*, or period films, and *gendai-geki*, or films about contemporary life. These categories were further subdivided into even more specialized niches. Yasujiro Ozu, for instance, specialized in *shomin-geki*, a subset of *gendai-geki* focusing on lower-middle-class life; and *jidai-geki* movies known as *chambara*, or sword-fight films, have been popular since the 1920s. The categories have changed over the years, but genre films—be it yakuza gangster films, horror movies, or anime—remain a staple of Japanese popular cinema.

The Japanese film industry thrived throughout the 1930s. As in the United States, movies were big business in Japan, and film studios worked like factories. Compared with the Hollywood studios, however, Japanese studios such as Toho, Shochiku, and Nikkatsu gave their directors much more control over the writing, cinematography, and editing of their films, which allowed directors such as Ozu, Akira Kurosawa, and Kenji Mizoguchi to nurture and develop the personal styles now associated with them, as well as long working relationships with screenwriters and cinematographers. In addition, the hierarchy of Japan's film industry functioned as a kind of apprenticeship system. In the United States, assistant directors were (and still are) essentially drill sergeants, relaying the directors orders and keeping order on the set. In Japan, assistant directors were apprentices learning their craft by working alongside the masters. It was, for a long time, the standard way to become a director, and it is one reason for the consistently high level of artistry that Japanese cinema has maintained over the decades. Ozu, Kurosawa, and Mizoguchi might be household names among cinephiles, but it seems that every year a new classic-era director is rediscovered whose work has stood the test of time, as recent traveling retrospectives of the work of Kon Ichikawa, Mikio Naruse, and Tomu Uchida demonstrate.

While Japan's film industry was growing into a powerhouse, the nation was continuing on the imperialist path it had begun in the late nineteenth century. In 1940, three years after the onset of the Sino-Japanese War, a law was passed

putting the film industry under the control of the government and the military, which harnessed it as a propaganda tool. Those directors who weren't drafted into the army resorted to either patriotic movies or safe genres with nothing in them to raise political hackles. This continued until the Japanese defeat at the end of World War II.

THREE GIANTS: OZU, MIZOGUCHI, KUROSAWA

Until the rise of the fifth generation of Chinese filmmakers in the 1980s, Japan was just about the only Asian country whose films were shown with regularity in the West. Of all of Japan's great directors, the three who made the biggest mark on world cinema are Yasujiro Ozu, Kenji Mizoguchi, and Akira Kurosawa. Their differing styles and thematic concerns provide a hint of the vastness of Japanese cinema.

Ozu is considered at once the most traditional of Japanese directors and a daring formal innovator. His mature style—a self-invented film language of low, unmoving camera angles, elliptical construction, and meticulous compositions—ignores the accepted rules of narrative filmmaking. The stories of traditional family life that he tells might come across as banal in plot descriptions, but they contain an emotional depth that few other directors have ever achieved.

Ozu's early films were comedies. More conventionally structured than his later work, they belong to the *shomin-geki* genre of films about everyday people that Ozu's studio, Shochiku, favored. Even if he had never wavered from traditional narrative style, he would no doubt still be held in esteem for such wonderful early films as *I Was Born, But . . .* , in which two young brothers discover the hypocrisies of the adult world; *A Story of Floating Weeds* (1934), a moving drama about the travails of an itinerant acting troupe; and the heartbreaking *An Inn in Tokyo* (1935), which chronicles the effects of the 1930s depression on a man and his young son.

It was only after World War II that Ozu began to strip his style down to the tight formalism for which he is known, and to focus almost exclusively on a single theme: the disintegration of the traditional Japanese family. *Late Spring* (1949) provides the template. A widowed father lives with his devoted daughter. He wants her to find a husband, but she would rather continue to take care of him than venture into the world of marriage. Their conflict between devotion to one

another and the need to part is told in a grammar of still, low-angle shots. Rather than following the traditional rules for depicting conversations by shooting over the characters' shoulders, Ozu shoots them straight on, so they seem to address the viewer directly. The acting is calm, with emotion expressed minimally but powerfully. There are no fades or dissolves, the only transitions being landscape shots that move the narrative to the next scene.

This style, which feels both traditionally Japanese yet radically modern, has been subjected to endless analysis. David Bordwell's tome-sized *Ozu: The Poetics of Cinema* exhaustively explicates its many facets. In *A Hundred Years of Japanese Cinema*, Donald Richie argues convincingly that the modernist movement, avant-garde at the time, dovetails neatly with and was, indeed, influenced by traditional Japanese aesthetics. He points out that Kyoto's seventeenth-century Katsura Detached Palace was a primary influence on the modernist Bauhaus school of architecture, for instance. Just as the structure of traditional Japanese buildings is deliberately visible, so too are the structures of Ozu's films, which let the mechanics of his art show through, but never distract the viewer from the story.

Like John Ford, another brilliant film artist who was publicly modest about his gifts, Ozu claimed that he arrived at his style out of simple necessity For example, almost all the interior shots in his postwar films are filmed from a height of about three feet off the ground. Ozu scholars have interpreted these famous shots as being designed to place the viewer at the level of someone sitting on a tatami mat, or in the position for Buddhist meditation, but Ozu, who rarely admitted to symbolic or spiritual elements in his work, claimed it was simply the most effective angle for shooting inside a traditional Japanese dwelling.

One of the many pleasures of watching his films is seeing his personal cinematic grammar in action. In the disarming comedy *Good Morning* (1959), a remake of *I Was Born, But . . .* , a red teapot appears in numerous shots with no

CHISHU RYU, SETSUKO HARA, AND CHEIKO HIGASHIYAMA
IN *Tokyo Story*

regard for continuity, but simply for its compositional impact, the way its bright color draws the eye to aspects of his visual compositions. His gorgeous *Floating Weeds* (1959), a remake of *A Story of Floating Weeds*, opens with a series of shots constituting a visual pun, which juxtaposes the similar forms of a sake bottle and a lighthouse.

These perceptual games become apparent only on repeated viewings. What strikes one immediately in Ozu's films is their emotional effect, which builds imperceptibly in the subtle gestures and restrained line readings of the performers. Ozu was notoriously hard on his actors, rehearsing them repeatedly until they were so exhausted that their lines came automatically, with all traces of their own feelings eliminated. And yet, the emotions boil below the surface, accumulating into moments of astonishing power. *Tokyo Story* (1953), the film many consider to be his masterpiece, touches on the deepest currents of emotion running through all families, via the story of one. *Tokyo Story*'s plot—about an elderly couple and their grown-up children, who are too absorbed in their own lives to treat their parents with appropriate decency—is one that resonates across cultures. But Ozu's way of calmly portraying the emotional effects of the children's casual cruelty, and how a death in the family changes them, is his own way of showing how life, sometimes sadly, goes on no matter what. One of its key lines, "Isn't life disappointing?" brings the point home with Ozu's usual delicacy and succinctness.

Ozu's method pares down narrative into distinct shots, each of them carrying just the exact amount of information necessary. His contemporary, Kenji Mizoguchi, worked in a very different style. Mizoguchi's films are justly renowned for their flowing, languid tracking shots, which have been compared to Japanese scroll paintings. He is considered, along with Orson Welles, William Wyler, and others, a master of the deep-focus long take. These directors use few cuts within scenes, instead they fill the foreground and background with visual information, moving the camera for emphasis. In Mizoguchi's films, these layers of visual information move within the frame with graceful visual choreography. Like Ozu, Mizoguchi started his career during the silent era. He was a committed leftist and very early hit upon the theme that would run throughout his career: the suffering of women in traditional Japanese society. Mizoguchi's own sister when she was a teenager was sold to a "tea house" for eventual training to become a geisha, and his two 1936 films, *Osaka Elegy* and *Sisters of Gion*, transfer his outrage to the plight of the films' female characters. Mizoguchi's career had many peaks.

The Story of Last Chrysanthemums (1939), the deeply touching story of a Kabuki actor who falls in love with a servant girl, uses his graceful style to highlight how women suffer most in a strictly regimented society. Even when straying away from this usual territory to make *The Loyal 47 Ronin* (1942), a propaganda job taken to save the Shochiku studio, his contemplative camera work and staging lifts this patriotic legend into something approaching grand opera in its stately pacing and quiet grandeur.

After the war Mizoguchi, who died in 1956 at the age of fifty-eight, reached another peak with *Ugetsu* (1953). Perhaps the most sublime ghost story ever rendered on film, *Ugetsu* adapts a famous tale about a potter who wanders away from his wife during a time of war and falls under the spell of a ghost. Its chiaroscuro images evoke a world poised between the living and the dead, ending this master's sadly shortened career on the perfect note.

For decades, Akira Kurosawa has been a household name around the world, sitting alongside Ingmar Bergman, Federico Fellini, et al., in the mid-century auteur pantheon. His 1954 *Seven Samurai* appears with regularity on critics' all-time top ten lists (along with Ozu's *Tokyo Story*), and his films have been staples in art houses for half a century. Unlike Ozu or Mizoguchi, who developed identifiable personal styles that broke with or radically reworked Hollywood-inspired narrative cinema conventions, Kurosawa is quite simply a master of the classical narrative style who translated the tried-and-true Hollywood formula for movie storytelling into a Japanese vernacular. But within these boundaries he was a great innovator, injecting a previously unknown sense of individualism and social conscience into quintessentially Japanese stories, and using his mastery of cinematic technique to transcend the conventions with which he worked.

Hollywood acknowledged his mastery over the years by making American versions of his films. *Seven Samurai* became the John Sturges western *The Magnificent Seven* (1960). *Rashomon* (1950) became Martin Ritt's *Outrage* (1964). *Yojimbo* (1961) inspired Walter Hill's *Last Man Standing* (1996) and Sergio Leone's "spaghetti western" *A Fistful of Dollars* (1964). Even George Lucas's *Star Wars* (1977) took its plot directly from Kurosawa's *The Hidden Fortress* (1958). For his part, Kurosawa adopted several Western literary works for the screen, including two Shakespeare plays: *Macbeth*, which became *Throne of Blood* (1957), and *King Lear*, which became *Ran* (1985).

Kurosawa began directing during World War II (he was deemed unfit

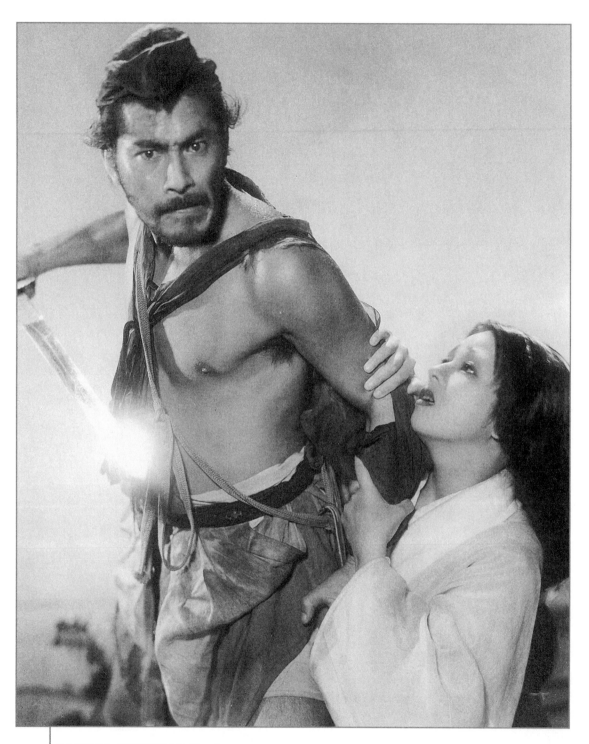

TOSHIRO MIFUNE IN *Rashomon*

for army service), but his career didn't really take off until he began his lifelong collaboration with the actor Toshiro Mifune in the 1948 gangster drama *Drunken Angel*, followed in 1949 by *Stray Dog*, starring Mifune as a cop who loses his gun, which is buoyed by moments of cinematic poetry mixed into its down-to-earth milieu. Mifune is an intense, explosive performer whose energy and rough charisma proved to be a perfect match for Kurosawa's directing style. Early on, Kurosawa was so impressed with Mifune's "overwhelming force" that he began tailoring his films to suit Mifune's raw, physical acting.

It was a Mifune collaboration, *Rashomon*, that sent Kurosawa's career into orbit. The plot of *Rashomon* is so well-known, yet so unique, that it has become the template for many other films and TV shows. The title itself serves as conversational shorthand for describing everyday situations from competing points of view. It is a perfectly constructed film, retelling the story of a murder from various characters' perspectives, each of whose story is altered to fit his or her own interests. It won the Golden Lion at the Venice Film Festival and received an Oscar nomination for Best Foreign Language Film.

The 1950s were a career peak for Kurosawa. During that decade he also made the acclaimed *Ikiru* (1952), the story of a bureaucrat searching for meaning in his life, and *Seven Samurai*, his first samurai movie and a landmark of the genre, single-handedly transforming it from cheap entertainment to sophisticated art-house fare. This pair of films represent some of the most appealing traits in his work. *Ikiru*'s titular civil servant, on being informed that he has terminal cancer, resolves to do a final good deed by using his particular skills to push—through an uncaring, clogged bureaucracy—a project to transform a mosquito-infested cesspool into a playground. Kurosawa's narrative ingenuity and humanism are apparent in the second part of the film, which switches point of view from the hero to his colleagues, who, though self-justifying, are also inspired by his example. The "bad guys" become as human and nearly as sympathetic as Ikiru himself. *Seven Samurai* is equally sympathetic to its characters and, along with its wonderfully choreographed battles, carries a message about equality: in its famous final battle in the mud, everyone is equalized by the forces of nature.

Kurosawa's success continued into the early 1960s with films like the kidnapping drama *High and Low* (1961), a tour de force of editing, staging, and narrative construction. The first half takes place almost entirely in one room, and the tension never slackens. By the end, every character, from the victim to the

Kwaidan

kidnapper, to the cops who crack the case, is accorded his measure of dignity. Sadly, several personal and professional setbacks throughout the decade (especially the failure at the box office of his underrated 1970 slum drama *Dodes Kaden*), drove Kurosawa to attempt suicide by slashing his throat and wrists.

After he recovered, he made a radical break with his past work, spending four years making *Dersu Uzala* (1974), a Japanese-Soviet coproduction filmed mostly in Siberia. Its simple story and ravishing images earned it a foreign film Academy Award—as the official entry from the Soviet Union.

Kurosawa's output slowed in his later years, partly because of difficulties in raising money, but the 1980s did see the release of two spectacular samurai epics, *Kagemusha* (1980) and *Ran*, which are feasts of color, ancient pageantry, and drama. Later he turned to more private subject matter in films such as *Akira Kurosawa's Dreams* (1990), an assemblage of stories featuring a cameo by Martin Scorsese as Van Gogh, and the family drama *Rhapsody in August* (1991). He died in 1998, leaving behind a legacy of films that wed great artistry to entertaining popular cinema.

THE GOLDEN 1950s AND 1960s

When Kurosawa's *Rashomon* won the Golden Lion at the 1951 Venice Film Festival, Japanese cinema was officially on the world-cinema map. Teinosuke Kinugasa, director of the aptly titled silent-era freakout *A Page of Madness*, won the Grand Prize at Cannes in 1953 for his samurai movie *Gate of Hell*, one of the most dazzling color films ever made, which also won an Oscar for its elaborate costumes. Mizoguchi also won major international festival awards for *The Life of Oharu* (1951), *Ugetsu*, and *Sansho the Bailiff* (1954).

Many other great directors worked during this flourishing period. Active since the silent era, Mikio Naruse, like Mizoguchi, made films about the plight of women, but his took place in the present, tracing women's changing roles in Japanese society during the twentieth century. Incisive, beautifully rendered dramas like *Repast* (1951), *Floating Clouds* (1955), and *When a Woman Ascends the Stairs* (1960) have earned him an international cult following among cinephiles. Kon Ichikawa, whose extensive filmography mixes classical technique with a perverse, dark sense of humor, viciously parodied postwar life in 1954's *A Billionaire*, which included jokes about atomic bombs and mass suicide just nine years after

Hiroshima and Nagasaki were destroyed. His antiwar film *Fires on the Plain* (1959) takes a distinctly unheroic view of the war in the Pacific; its tale of desperate troops resorting to cannabilism is spiked with acidic graveyard humor. His 1963 remake of Kinugasa's 1935 *An Actor's Revenge*, the tale of a Kabuki actor's quest to avenge the death of his parents, stands beside Kinugasa's own *Gate of Hell* as a vivid, painterly masterpiece of color cinema. A restless iconoclast, Ichikawa angered the Japanese government when his commissioned documentary *Tokyo Olympiad* (1964) emphasized the aesthetics of physical endurance, the honor in losing, and random faces in the crowd instead of glorifying Japan and its athletes. It is certainly one of the most unusual sports documentaries ever made and perhaps the greatest visual document of the beauty and pain of athleticism.

Masaki Kobayashi is another prominent director, whose powerful films include the antiwar *The Human Condition* (1959); *Harakiri* (1961), a damning examination of samurai honor; and *Kwaidan* (1964), a beautifully haunting set of ghost stories based on the writings of Lafcadio Hearn. Kaneto Shindo's *Onibaba* (1964), the story of a woman and her daughter-in-law who lure samurai into their hut so they can steal their armor, remains popular today. Though less well-known internationally, Keisuke Kinoshita, Tomu Uchida, and many others regularly created works of great beauty and depth.

But it was exactly the beauty and impeccable craftsmanship of classic-era Japanese movies that would come under attack from a new generation of filmmakers, who saw a clear disconnection between what was on movie screens and the reality of life in postwar Japan. For them, the real world was full of street protests, disaffected youths, gangsters, and bargirls—a place where cherry blossoms, kimonos, and tea ceremonies had no significance. Armed with considerable skills, thanks to the film industry's apprenticeship structure, they set out to challenge their elders with a new aesthetic that reflected the rapaciousness, violence, and hypocrisy of modern Japanese society.

THE NEW WAVE

The Japanese new wave is a loosely knit group, more of an umbrella term than a unified movement. Part of the generation that grew up during the war and its painful aftermath, they rejected Japan's tradition of "polite," well-crafted films, which they saw as dwelling in a dream of the mythical past. The

new wave's goal was to depict both the beauty and the ugliness of the present day. To do so, new cinematic forms had to be created. The film credited with starting this new trend is Ko Nakahira's *Crazed Fruit* (1956). Nominally a part of the "sun tribe" genre of films designed to shock audiences with the depraved behavior of juvenile delinquents, *Crazed* goes much deeper into the savagely competitive psychology of two brothers vying for the same girl at a beach resort. It wasn't designed to scare the grown-ups. Its aim was to get at the heart of a disaffected generation.

"SUN TRIBE" NOVELS AND FILMS • When Shintaro Ishihara's novel *Seasons in the Sun* was published in 1955, its depiction of nihilist, sex-hungry, violent youths (dubbed the "sun tribe") gave voice to a young generation disillusioned by the war and its aftermath, and increasingly under the influence of American pop culture. It also confirmed the deepest fears of their elders. His subsequent novels, and the movies adapted from them, became a pop culture sensation. While they did owe their popularity partly to shock value, films such as Ko Nakahira's 1956 *Crazed Fruit* anticipated the stylistic advancements and rebellious attitude of the new wave in the 1960s.

Yasuzo Masumura did the same with the gritty, nihilistic tale of doomed teenage love *Kisses* (1957). His fellow new waver Nagisa Oshima credited Masumura with freeing Japanese cinema from its "foggy beauty and stupid gardens," thus perfectly capturing the new-wave ethos in a phrase. Oshima's own Technicolor teenage wasteland *Cruel Story of Youth* (1960) is one of the new wave's key works. Oshima, the most politically outspoken of the new wavers, was just as disenchanted with the right wing for leading Japan down the road to imperialism and self-destruction as he was with the left for compromising their ideals. *Cruel Story*'s jarring wide-screen images angrily convey the lives of a young, jaded-beyond-their-years couple who, distrusting the older generation that created the cruel world they live in, declare that they "have no dreams, so we won't see them destroyed."

Oshima's next film, *Night and Fog in Japan* (1960), a scathing indictment of both the left and the right, so angered the film studio Shochiku that it refused to release the film. Oshima left the studio to make films independently and even demanded that Shochiku stop using the term "new wave" to promote its movies. His style and concerns changed over the years (he eventually became a well-known talk show host and was, at least once, a judge on the popular TV show *Iron Chef*), but the urge to provoke has never left him. *Death by Hanging* (1968), to cite just one example, uses a famous murder trial to attack Japanese racism toward

Cruel Story of Youth

ethnic Koreans, police brutality, and capital punishment. In 1976, he unleashed the scandalous *In the Realm of the Senses*, a graphic depiction of sexual desire taken to its extremes designed, in part, to challenge Japan's "public decency" laws, which led to a lawsuit in which Oshima challenged the authorities to define "obscene." He examined Japanese war atrocities in *Merry Christmas, Mr. Lawrence* (1983), an English-language film starring David Bowie as a POW in a World War II Japanese prison camp enduring sadistic treatment from the camp commandant, which shocked traditionalists with its suggestion of homosexual desire among the

prisoners. The gay subtext of *Merry Christmas* became the main theme of *Taboo* (2000), which turns the noble, macho image of the samurai on its head. In a rich, inky visual palette of deep blues and blacks, a band of samurai come undone over their desire for a beautiful young newcomer to their ranks.

Another new-wave director with a long and distinguished career is Shohei Imamura, who passed away after a long and fruitful career in 2006. Less stylistically wild than Oshima or Masumura, Imamura worked as an assistant director to Yasujiro Ozu (whom he compared to a "reclining god"). Although he is steeped in the classical tradition, Imamura makes films drenched in unconventional sexuality (literally in his final film, 2001's *Warm Water under a Red Bridge*, in which a woman's orgasms serve an important ecological purpose), made all the stranger by his realistic style. His films are full of very real, sexually assertive women, in stark opposition to the many traditional dignified suffering female characters in classic Japanese cinema. The heroine of his ribald 1963 tragicomedy *Insect Woman* is an ambitious prostitute unafraid to exploit her own charms and those of others. In *The Pornographers* (1965)—which revels in all sorts of debauchery, including orgies and allusions to incest—a dedicated smut producer becomes smitten with his girlfriend's teenage daughter, who is all too aware of her power over him. In *Profound Desire of the Gods* (1968), a remote island society still living according to primitive tribal traditions (including some odd sexual customs) is exploited by modern Japanese visitors.

Imamura uses his detached, impartial portrayals of his characters' disturbing behavior for other means as well, as in his horrifying 1978 portrait of a serial killer *Vengeance Is Mine*. The film is made doubly chilling thanks to Imamura's touches of dark humor and Kan Nagata's note-perfect performance as a charming sociopath. *Black Rain* (1989) is a stark, powerful modern-day fable about the aftermath of the bombing of Hiroshima, focusing on a group of villagers exposed to radiation. His *The Ballad of Narayama* (1983) is deliberately much more earthy than Keisuke Kinoshita's 1958 version, which was done in a Kabuki theater style, giving a much messier, more realistic spin to the story of a village ritual in which the elderly are put on top of a mountain at age seventy to die. It won him the Grand Prize at Cannes, as did 1997's *The Eel*, a charmingly oddball story about an ex-con and his pet, and a great example of Imamura's more gentle late style. *Dr. Akagi* (1998), about an eccentric small-town doctor set in the waning days of World War II, is equally affecting.

Many new-wave-associated directors fused traditional and modernist elements in their work. But these filmmakers deliberately explored the connection, in both style and subject matter. Yoshishige Yoshida's *Eros Plus Massacre* (1970) explores free love and anarchism by cutting between 1910 and the present day. The eye for precision and detail everywhere present in the films of Hiroshi Teshigahara shows his roots as the son of the founder of a famous school of traditional ikebana flower arranging (he later quit the cinema to take over his father's work). His most famous film, *Woman in the Dunes* (1964), is an existential parable about an amateur entomologist who wanders into a remote beachside village. He is trapped by the villagers in a huge pit with a woman, where he is condemned to continually remove the sand that threatens to bury them. It is admired for its sharp visual detail, nightmarish atmosphere, and dramatic intensity, as are his other collaborations with the novelist Kobo Abe, among them *The Face of Another* (1966) and *The Man Without a Map* (1968).

Masahiro Shinoda found in modern yakuza gangsters the remnants of samurai rituals, which he emphasized in *Pale Flower* (1964), a nihilist frolic through Tokyo's underworld with a gangster and a mysterious woman addicted to gambling and drugs. His 1968 *Double Suicide* is a fascinating experimental work based on a play by Edo-era playwright Monzaemon Chikamatsu. Chikamatsu wrote primarily for the kind of puppet theater known as Bunraku, in which stagehands, clad in black from head to toe so as to be "invisible," manipulate intricate puppets. Chikamatsu is a well-known writer in Japan, and his work had previously been adapted to the screen, most notably by Mizoguchi in *Chikamatsu Monogatari* (a.k.a *The Crucified Lovers*, 1954). For his film, Shinoda adapted and manipulated the conventions of Bunraku itself. Although the actors are not puppets, the stagehands are still present, observing and influencing the action but unable to change the tragedy of the play's ill-fated lovers. The sets and acting are deliberately artificial, making this a perfect example of the shared aesthetics of traditional Japan and avant-garde modernism. Shinoda's fascination with the past continued throughout his career. His 1979 *Demon Pond* is a hallucinatory fantasy starring Tomasaburo Bando, a famous *onnagata* performer (men who play female roles in Kabuki plays), and *Sharaku* (1995) speculates on the mysterious woodblock-print artist of the same name, who left behind a legacy of beautiful artworks during the Edo era and then vanished to history.

SAMURAI CINEMA

The samurai film has remained a staple genre of Japanese cinema throughout all the changes the industry has gone through over the years. Like the Hollywood western, samurai movies, while retaining basic features in common, mirror changes in culture and comment allegorically on contemporary issues. These films are a large subset of the *jidai-geki*, or period dramas, that have always been popular in Japan. The samurai themselves—with their warrior code,

SEVEN SAMURAI • Akira Kurosawa once said of *Seven Samurai* (1954) that he wanted to "make a film which was entertaining enough to eat." But Kurosawa's epic *chambara* does more than entertain. With its innovative camera-work and editing, and its well-rounded characters, *Seven Samurai* gave a new depth to action movies and provided a template for many films to come.

Not only has it been remade several times in various countries, its basic plot—a group of heroes assembles to achieve a goal—is the basis for movies as different as *A Bug's Life* and *Ocean's Eleven*. The reason it still seems modern today is that moviemakers have never stopped learning from it.

their elaborate weaponry and armor, and their heroic place in Japan's mythical and historical past—are, of course, analogous to American cowboys and, even further back, the knights of King Arthur's round table.

Before Kurosawa's *Seven Samurai*, *jidai-geki* films focused on romance and court intrigue, with violence kept to a minimum. Kurosawa's epic adventure brought action to the fore, along with a newly ambivalent portrayal of the samurai themselves, who are at once self-interested bandits and self-sacrificing heroes. The true heroes of *Seven Samurai* are the poor villagers they protect. Kurosawa's film brought on the maturity of the *chambara* genre, which is named for the sound of clashing swords.

But while Kurosawa would continue to question the honorable image of the samurai—in 1961's *Yojimbo*, Toshiro Mifune's title character is a cynical, if charming, double-dealer, and *Throne of Blood*, his adaptation of *Macbeth*, sets Shakespeare's examination of the corrupt, bloody pursuit of power in the samurai era—it was the exciting action sequences of *Seven Samurai* that would most influence popular *chambara* movies.

The rough-and-tumble, outrageously bloody *chambara* of the 1950s through the 1970s retain a rabid cult following today. The exploits of the ambling, comic/heroic blind swordsman Zatoichi, played by Shintaro Katsu in over twenty-five movies, are available in DVD box sets. Katsu's other famous character, Hanzo the Razor, a tough samurai constable as skilled with his sword as he is in the sack, battled corruption and bedded babes in a trilogy of films that are just as popular. Kenji Masumi's Lone Wolf and Cub movies, depicting the rollicking adventures of a disgraced assassin and his young son, are also cult favorites.

Other directors use the samurai genre to reconsider the ethics of the past and reflect the tenor of the times. The hero of Masaki Kobayashi's *Harakiri*, seeking revenge on those who forced his son-in-law to commit ritual suicide,

Seven Samurai

battles a corrupt, authoritarian system from which even he cannot escape. Kaneto Shindo's visually splendid *Onibaba* emphasizes the way that war degrades people. A woman and her daughter-in-law, trying to survive during wartime, dress as demons to scare lost, dying samurai and steal their possessions. Nagisa Oshima's 2000 *Taboo* foregrounds the well-known but rarely discussed homosexual element of samurai culture, much as Ang Lee would do for the western in 2005's *Brokeback Mountain*. In Yoji Yamada's Oscar-nominated *Twilight Samurai* (2002), the hero clings to a code of honor even as the feudal system of which he is a part collapses around him.

Over the years, the basic ingredients of the samurai film—heroism, swordplay, the code of honor—have proven endlessly manipulable, showing up in contexts both serious and comedic and constituting a durable, iconic Japanese genre that has spread throughout the world.

WILD JAPAN

While Kurosawa, Ozu, and Mizoguchi were bringing Japanese cinema to the West with artistically impeccable films that appealed to a generation of cineastes, other, more unruly trends were also developing. They constitute a kind of alternate history of Japanese cinema. The precursors to notorious contemporary practitioners of psychological and physical onscreen violence such as Takashi Miike (*Audition*, 1999) and Shinya Tsukamoto (*Tetsuo: The Iron Man*, 1989) were Kinugasa's *A Page of Madness* (1926), Ichikawa's *A Billionaire* (1954), and others. As Japanese cinema exploded with the new wave, even more opportunities for experimentation opened up.

Yasuzo Masumura, who studied at the prestigious Centro Sperimentale di Cinematografia in Rome, launched the new wave with *Kisses* and then went on to deploy his nasty sense of humor and dazzling feel for color in an all-out assault on good taste. *Giants and Toys* (1958), a brutal satire of the high-stakes world of corporate competition, has three rival candy companies creating increasingly absurd advertising schemes, culminating in a malicious plan to turn a homely switchboard operator into the glamorous public face of one of them. As film critic Jonathan Rosenbaum puts it, Masumura creates "a cinema of crazy people—films about fanatics—and never display[s] a trace of sentimentality about them or anyone else." Sex and madness are his dominant themes. In the lascivious *Manji* (1964), a bored

housewife embarks on a lesbian affair that eventually erupts into violence when her husband and the girlfriend's impotent boyfriend get involved. Even nuttier, *Blind Beast* (1969) features a blind, sex-crazed sculptor who kidnaps a woman and entraps her in his surreal evil lair/art studio. In this fantastic space, decked out with huge sculptures of female body parts, they enact a series of increasingly violent sadomasochistic games that at last reduces them to an animal-like state.

Other wild-style directors emerged not from the new wave, but from the sweatshops of the B-movie studios. As in Hollywood, B movies, with their tight budgets and relatively lax supervision, allowed directors to be more daring—provided they kept turning out products that kept audiences in their seats. In America many great directors, among them Jules Dassin, Jacques Tourneur, and William Wyler, developed their unique styles making cheap horror films, westerns, and gangster movies, many of which are now considered classics. So too in Japan.

Kinji Fukasaku is a perfect example. He is most notorious for his final completed film, *Battle Royale* (2000), a twisted movie set in a near future in which Japanese youth are so out of control that a program is implemented whereby groups of them are annually sent to an island to compete in a fight to the death. The sight of Japanese schoolgirls mowing one another down with machine guns in between gossiping about who likes which boy is so ludicrously grotesque that it makes you feel guilty for laughing.

There is, however, more to *Battle Royale* than sick thrills. In a way, it encapsulates Fukasaku's career. As a teenager he worked in a munitions factory, and survived American bombing raids only by taking shelter under the dead bodies of his coworkers. He has claimed that this vision of hell from his youth inspired certain elements of the film. Beyond that, *Battle Royale* is an allegory of official Japan's desire to stamp out the energy of its youth. Its dystopian near-future is a natural, if exaggerated, extension of the nation's competitive educational system.

Fukasaku got his start in the B-movie mills, specializing in cheap yakuza and samurai yarns, biding his time until he could make more personal films. His consciousness was profoundly formed by World War II and its aftermath. As Tom Mes and Jasper Sharp point out in *The Midnight Eye Guide to New Japanese Film*, Fukasaku wanted to believe that the destruction and chaos caused by the war would release a new energy in Japan, sweeping away the old values that had brought the nation down. The atomic bomb's mushroom cloud, which he used as the opening image of *Battles Without Honor and Humanity* (1973), is for him a symbol of

both destruction and rebirth. But he was outspoken in his disappointment with Japan's reconstruction plan, which he felt ignored those most disenfranchised by the war in favor of building the illusion of a successful new society. *If You Were Young: Rage* (1970) drives the point home with a story of five optimistic friends whose plan to build a business in Tokyo ends in violence. His disgust with postwar life is also conveyed powerfully in one of his greatest films, 1972's *Under the Flag of the Rising Sun*, in which a widow, nearly three decades after the end of the war, is still trying to find out how her husband died in the South Pacific. Employing jarring techniques such as freeze frames, switches from black-and-white to color, flashbacks, and actual documentary photographs of death and destruction, Fukasaku reveals not only the horrors of war, but how postwar Japan failed the soldiers who suffered the most—but rewarded the most brutal.

Although he learned his craft in the yakuza genre, Fukasaku came to despise the way gangsters were glamorized on film, especially since real-life gangsters were influencing government and big business in unsavory ways. Film such as *Battles Without Honor and Humanity, Street Mobster* (1972), and *Graveyard of Honor* (1975) depict the yakuza as amoral, ruthless thugs—hardly the inheritors of the samurai code that they believed themselves to be. But Fukasaku didn't always feel the need to vent his rage. *Black Lizard* (1968) and *Black Rose Mansion* (1969) both star female impersonator Akihiro Maruyama in narratives of bizarre obsession

that are stunning in their whacked-out plots and visual design. As rebellious as he was, the Japanese film establishment eventually embraced him. In 1982, he won a number of Japan's equivalent to the Oscars for *Fall Guy* (1982), the story of a vain actor who takes on a possibly deadly stunt to save his career. Fukasaku died in 2002, on the set of *Battle Royale* 2, which was completed by his son Kenta in 2003 and depicts the bloody vengeance exacted by the survivors of the first film on their tormentors. Its revenge plot contains some provocative commentary on the post-9/11 world and George W. Bush's foreign policy.

For sheer over-the-top onscreen weirdness, it's hard to beat Fukasaku's fellow B-movie toiler Seijun Suzuki. Suzuki has become a kind of patron saint of extreme cinema, an icon whose films are a delirious form of wacko pop art. Where Fukasaku bided his time in the Bs, letting his style bloom only when he could work independently, Suzuki experimented so wildly within B-movie genres that he was eventually fired by the Nikkatsu studio for his exuberance. For Suzuki, the screen is simply a two-dimensional canvas on which to splash bright colors and outrageous visuals contained within potboiler plots that threaten to explode from their own eccentricity. And he wasn't afraid of injecting a little political content if he felt like it. Charged with making a "roman porno" (a variety of upscale soft-core porn movie invented by Nikkatsu), Suzuki came up with *Gate of Flesh* (1964), a yarn about a group of tough prostitutes and an ex-soldier who hides out with them after killing an American GI. Suzuki dresses his streetwalkers in brightly colored outfits, contrasting them against the ruined cityscape of postwar Tokyo. Its ending, which cuts from a soiled Japanese flag floating in a filthy canal to an American one flying high over the slum, hammers home his generation's frustration with postwar life.

Suzuki's early hard-boiled gangster films, among them *Underworld Beauty* (1958), *Youth of the Beast* (1963), and *Kanto Wanderer* (1963), pop with lurid visual energy even as they hew close to the genre plot conventions with which they are saddled. Growing increasingly restless, he really pushed the boundaries with 1966's *Tokyo Drifter*, whose thin storyline about a yakuza trying to go straight has been fed into the mill of Suzuki's creative mind and comes out the other end as a flashy, nearly abstract thrill-ride of a movie held together by daring editing and spectacular visuals that are completely cut loose from all logic. The hero occasionally breaks into song. One scene is set in a room whose walls change color, and the ending takes place in an entirely white space—all the better to show off all the red blood.

AT RIGHT:
*Princess
Racoon*

The executives at Nikkatsu put him on notice for his excess, but rather than toeing the line, Suzuki went even further with his next film, *Branded to Kill* (1967). A fragmented narrative shot in black and white, its plot concerns a gang-world assassin, known simply as Number 3, who is part of an organization whose members start killing each other off in a contest to become Number 1. It's a wickedly perverse movie (the hero gets turned on by the smell of boiling rice), full of swinging sixties energy and Suzuki's spectacularly inventive imagery and editing—a maverick classic comparable to the work of Sam Fuller and Jean-Luc Godard. But it was the last straw for Nikkatsu. Suzuki was fired and essentially blacklisted from the film industry. Ironically, *Tokyo Drifter* and *Branded to Kill* are now regarded as two of his greatest films.

Throughout the 1970s he made a living directing commercials and television shows. In the 1980s he was able to secure independent funding to make a trilogy of films about the 1920s Taisho era, during which Japan was rapidly coming under the influence of Western culture. Made with his signature bravado, *Zigeurnerweisen* (1980), *Kagero-za* (1981), and *Yumeji* (1991) evoke a disturbing world of murder, ghosts, and tortured obsessions. Grounded in a pivotal period of Japanese history that was surreal in its own way, these films are unfettered by the rules of logic, and they show off Suzuki's eccentric brilliance without the constraints of genre filmmaking.

Over thirty years after *Branded to Kill* got him fired, Suzuki got the chance to make a sequel and came up with *Pistol Opera* (2002), a mind-boggling, dreamlike retelling of the original story, but this time starring a beautiful female assassin known as Stray Cat. Drenched in sumptuous colors and acted out in a series of ritualized tableaux, it showcases the septuagenarian Suzuki at the top of his game, as does *Princess Raccoon* (2005), a surreal musical fairy tale starring Zhang Ziyi that is every bit as weird and enthralling as the best of his output.

The very extravagance and experimentation that doomed Suzuki's career in the 1960s have proven to be very influential, not only in Japan, but in the West as well. Quentin Tarantino's *Kill Bill* movies owe much to Suzuki's violent flamboyance. In *Ghost Dog: The Way of the Samurai* (2000), Jim Jarmusch included a deliberate homage to Suzuki.

SHOCKING PINK

The upheavals of the 1960s led to another form of extreme cinema as well. *Pink eiga*, or "pink films," have been a profitable guilty pleasure for decades now, and like samurai movies, they have gained a worldwide cult following. They have also served as a training ground for young filmmakers, horror director Kiyoshi Kurosawa (no relation to Akira) being one of the most prominent examples. (Masayuki Suo, who later made the family-friendly hit *Shall We Dance*, began his career in 1983 with *Abnormal Family, Older Brother's Wife*, a pink parody of Ozu's films.) As long as they turn their movie in under budget with the required doses of sex and nudity, directors of pink films are relatively free to experiment. Born of the revolutionary mentality of the 1960s, many of them are also deliberately subversive. Like the violent, low-budget horror movies of the 1970s in America, early pink films represent an eruption of repressed and taboo subjects, which also account for their often disturbing narratives trading on rape and sadomasochism. One reason for the shocking extremity of their subject matter has been Japan's strict rules about sex on-screen, which require that genitals not be shown. As a result, pink directors have had to strive to find creative ways to display flesh and poke at sensibilities without being too explicit. Koji Wakamatsu is one of the favorites of pink film enthusiasts. Films such as *Ecstasy of the Angels* (1972) and *Go, Go, Second Time Virgin* (1969) employ radical politics and stylistic experimentation within their minimal budgets. Shunya Ito's *Female Convict Scorpion: Jailhouse 41* (1972) has become a cult classic for its mix of sex, violence, and visual daring—not to mention the Seven Sinful Women who stage a prison break.

Pink films themselves are divided into various subcategories, such as "violent pink" and "roman porno," a higher-budgeted, more romantic take on the genre dominated by the Nikkatsu studio. *A Woman with Red Hair*, Tatsumi

Kumashiro's 1979 film about a passionate affair between a beautiful hitchhiker and a construction worker, is considered a classic of the genre.

Even today, the occasional pink film still manages to pack a subversive punch. Mitsuru Meike's hilarious *The Glamorous Life of Sachiko Hanai* (2005) has as its protagonist a prostitute who, after being shot in the head, humps her way through the movie while quoting Noam Chomsky, delivering analyses of *Moby Dick*, and somehow coming under the control the malevolent George W. Bush due to a naughty finger, cloned from his hand and painted with American flag nail polish, that comes into her possession.

VIOLENT AND "COOL"

To the unsuspecting viewer, many contemporary Japanese films can seem shockingly violent. In Takashi Miike's *Audition*, a character is forced to eat vomit from a dog's bowl. Sion Sono's *Suicide Club* (2002) opens with fifty-four schoolgirls being pureed by a subway train. Takeshi Kitano, in his yakuza films, regularly indulges in bloody gunfights.

Renowned expert on Japanese cinema Donald Richie attempts to explain its appeal in *A Hundred Years of Japanese Cinema*. "Rape, torture, murder are there to be viewed in a manner not only nonjudgmental, but detached. It is cool to do so." This "cool" attitude, which is hardly limited to Japanese young people, is about the ability not to be shocked. Extreme violence presented as entertainment is to be viewed with knowing detachment, an acknowledgment that none of it is real. Richie also points out that this cool attitude even existed in Edo-era Japan, where it was called *iki*, and resulted in such trends as fashionable women adopting the "prostitute look." And it certainly exists in the United States today. Witness the ultraviolence of the popular *Saw* and *Hostel* franchises.

One could argue that the "cool" attitude, which has always existed in one form or another, was brought to its current apogee by the generally alienated condition of modern life, with its constant bombardment of media images, and the Internet, which reduces interpersonal communication—indeed, all of reality— to pixels on a screen. Younger Japanese filmmakers, raised on cool, distanced depictions of sex and violence in pink films and *manga* comic books, have perhaps embraced this attitude more fully than others.

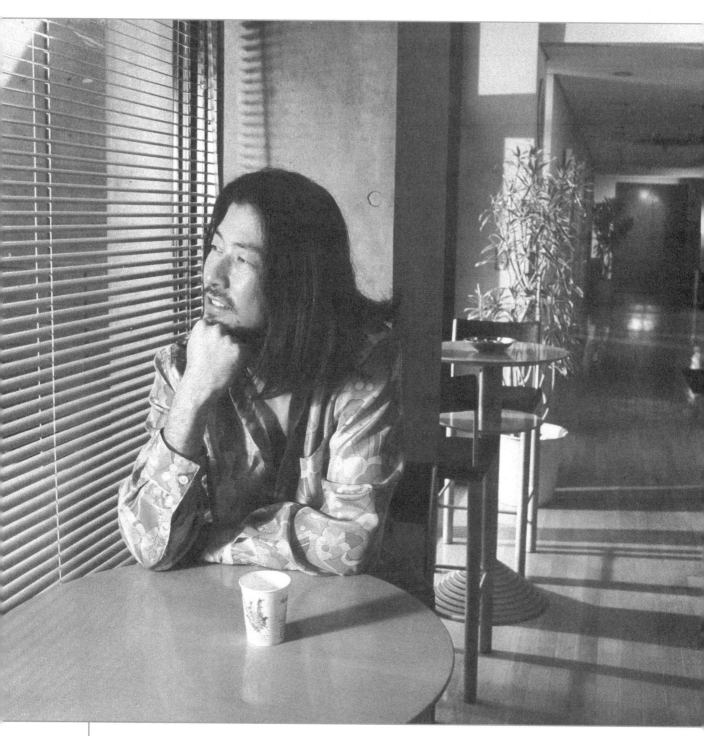

TADANOBU ASANO IN *The Taste of Tea*

Takashi Miike specializes in excess. He has made over fifty films since the early 1990s, from low-budget flicks for the home video market to high-concept theatrical features, many of them containing shocking levels of gore, torture, and mayhem. *Dead or Alive* (2002) commences with a blistering montage of cocaine abuse, sodomy, throat-slitting, and evisceration. *Visitor Q* (2001) satirizes reality television and the traditional Japanese family via necrophilia, torture, and incest. Yakuza movies like *Ichi the Killer* (2001) and *Graveyard of Honor* (2002)—a remake of the Kinji Fukasaku original—bring outrageous amounts of visceral violence to the genre. Interestingly, it was *Audition*, a somewhat restrained film (but perhaps all the more shocking for it), that got him widespread international notoriety. Turning the image of the submissive Japanese woman on its head, it features one of the most chillingly psychotic characters in recent memory—a quiet young woman who, with horrifyingly methodical precision, takes out her resentment toward the men who exploit her. Audience reactions to it have become almost legendary. There are tales of fainting and vomiting in the aisles of movie theaters all over the world, which, of course, only enhanced Miike's reputation.

TADANOBU ASANO • Tadanobu Asano, whose laid-back charisma and predilection for offbeat roles have earned him comparisons to Johnny Depp, is one of the most recognizable actors in contemporary Japanese cinema. He made his name playing menacing characters in films like Takashi Miike's *Ichi the Killer* (2001) and Nagisa Oshima's *Taboo* (1999), which prompted *Time* magazine to proclaim him Japan's "collective Mr. Hyde," but he has since branched out into more eclectic parts. He plays a gentle, eccentric uncle in Katsuhito Ishii's 2004 *The Taste of Tea* and a shy bookstore manager in Hou Hsiao-hsien's 2003 *Café Lumiere*, for instance. Once the "bad boy" of Japanese cinema, Asano has matured into one of its most consistently fascinating performers.

To be a Miike fan is, in a sense, to be in on the joke. The excessive violence in his films is laced with dark, even campy humor, a knowing wink to his audience letting them know that the point is not to be traumatized but to see just how far he'll go this time. Indeed, he's often at his best when the humor takes center stage, as in his demented musical *The Happiness of the Katakuris* (2002), a remake of the Korean film *The Quiet Family* (Kim Ji-woon, 1998), which is about a family whose brand-new country inn is in jeopardy because guests keep dying on them (then returning as singing, dancing zombies); or *Zebraman* (2004), a nonsensical comedy about a salaryman-turned-superhero who battles green globs of goo from outer space. He's even capable of switching gears completely. *Bird People of China*

(1998) is an almost family-friendly fable about two very different men on a spiritual journey through China's awe-inspiring natural landscape.

Like their predecessors Fukasaku and Suzuki—Miike's flamboyant visual style owes much to the latter—the younger batch of extreme directors react against changes in Japanese society while plugging into the zeitgeist. Shinya Tsukamoto, influenced by underground theater, do-it-yourself punk aesthetics, cyberpunk science fiction, and *Godzilla* movies, blasted onto the scene in 1989 with the perennial cult flick *Tetsuo: The Iron Man*. At the time, Japanese cinema was mired in an economic slump that had nearly wrecked the industry, and the films that did come out were mostly pretty bland. *Tetsuo* is the exact opposite. Shot on 16 mm on a low budget, it looks like a hyperactive David Lynch movie—a collision of human and machine, eroticism and violence—in which a man, after being involved in a hit-and-run accident, finds machinery taking over his body (the penis drill is a particularly nasty touch).

The film has some rough edges, but rough edges may have been exactly what Japanese cinema needed at the time. It became an international hit, and Tsukamoto followed it with a big-budget sequel, *Tetsuo II: Body Hammer*, in 1992. Taming the unfocused maelstrom of the first film, it fleshes out that film's themes of urban alienation and anxiety about the body, and harnesses the no-

less-disturbing visuals to a revenge plot about a businessman tracking down the young punks who kidnapped his son. These two films tagged Tsukamoto as a cyberpunk director, but his subsequent films are less concerned with the melding of technology and humanity than the fusing of emotion and flesh. In *Tokyo Fist* (1995), two boxers battle over a woman, and all three characters come to a kind of liberation through pain. In *A Snake of June* (2002), a woman is blackmailed into performing a series of sexual fantasies, for her tormentor's voyeuristic kicks, that teeter between pleasure and humiliation. With its blue-tinted, monochrome palette and its obsession with the erotics of technology, it harkens back to *Tetsuo*'s look and themes. Less stylistically outré but just as creepily compelling, *Vital* (2004) concerns a young man suffering from amnesia after a car crash that killed his girlfriend. When her corpse shows up in his medical school anatomy class, he finds himself drifting between reality and a half-dreamed, half-remembered life with her.

The energy, insouciance, and rebelliousness of punk can be found in other directors as well. Sogo Ishii's influential biker movies *Crazy Thunder Road* (1980) and *Burst City* (1982) prefigure the DIY energy of *Tetsuo: Iron Man*, giving cinematic expression to the anarchic rage of punk rock. Even Ishii's *Gojoe: Spirit War Chronicle* (2000), a big-budget period action film, channels punk energy into a classic Japanese warrior tale. Ryuhei Kitamura's brilliant *Versus* (2000) is a disrespectful mash-up of science fiction, yakuza yarns, and zombie movies. Made on a low budget, it takes place for the most part in the "forest of resurrection," a portal into another dimension where anyone who dies comes back to life as a zombie. In this mystical place, escaped convicts battle a legion of gangsters: zombies with guns.

Versus earned Kitamura a larger budget for the high-concept science fiction film *Alive* (2002), about a murderer who survives his execution only to be subjected to a most bizarre scientific experiment in violence; and *Azumi* (2003), which put the titular *manga* heroine (a kind of Japanese *Buffy the Vampire the Slayer*) on the big screen. Also in 2003, Kitamura and another director, Tsutsumi Yukihiko, challenged each other to, literally, a cinematic duel. The rules were simple: each would make a film using only a single set and two characters who must fight to the death. Kitamura's entry, *Aragami: The Raging God of Battle*, is a darkly beautiful medieval legend about a supernatural god who wants to die and enlists the aid of an unfortunate wanderer who happens upon his castle. Yukihiko responded to the

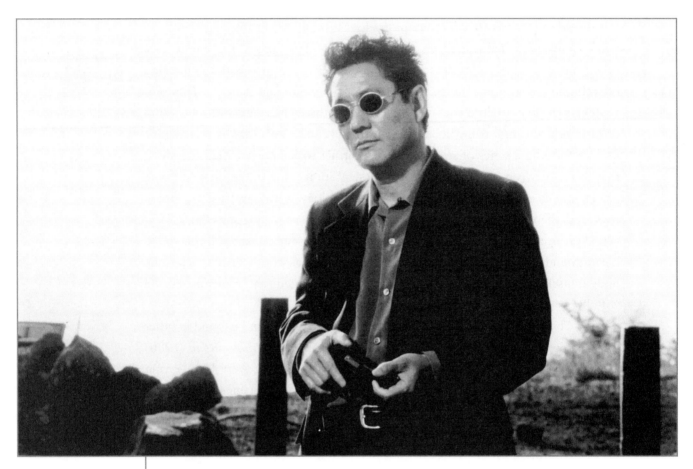

TAKESHI KITANO IN *Fireworks*

challenge with the over-the-top *2LDK* (from an abbreviation used in Japanese real estate ads referring to two-bedroom apartments), in which two female roommates take their petty grievances and jealousies to the ultimate extreme. Both duel films, indeed the idea of the project itself, reflect the independent spirit of this generation of "cool" filmmakers, whose works, despite their shocks (or, according to your taste, because of them), are great fun to watch. The pinnacle of this trend toward blending wackiness with Miike-like ultraviolence may be Gen Sikeguchi's madcap *Survive Style 5+* (2004), a candy-colored piece of pop psychedelia that mixes and matches several storylines, including one about a man who keeps murdering and burying his wife, only to return home to find her not only alive but increasingly handy with her fists (and any other nearby bludgeoning device), and another about

a salaryman who takes on the characteristics of a chicken, thanks to a hypnotism-gone-wrong.

Of course, the very embodiment of violent and cool is this generation's elder statesman, Takeshi Kitano. For most of the world, Kitano's image is that of the dapper, stone-faced, brooding policeman in his breakthrough film *Fireworks* (1997), which also displays his directorial talents at their best. The story of a cop, consumed with guilt over his disabled partner and grief over his wife, who is dying of leukemia, it alternates between gentle humor, sadness, and the jolting bursts of violence that are the hallmarks of Kitano's films.

But Kitano's image is quite different in Japan. Before he became a director, he was known as "Beat" Takeshi, the goofy half of a comedy team popular in the 1970s and 1980s, then later as the host of outrageous TV shows full of lowbrow pranks, obscene gestures, and prime-time vulgarities. One would have to imagine comedic prankster and *Borat* creator Sacha Baron Cohen transforming himself into a serious, internationally acclaimed auteur to get an idea of how unexpected it was for Kitano to go from TV comedian to winner of the Golden Lion at the Venice Film Festival for his film *Fireworks*. It's even been suggested that Kitano's directorial debut, 1989's *Violent Cop*, was, at least in part, a publicity stunt. Kitano, the star of the film, took over as director when Kinji Fukasaku had to leave because of ill health. It's a surprisingly assured debut, giving a standard plot, about a maverick detective delivering street justice against the wishes of his superiors, an almost classical polish, using contemplative long takes and a serene pace that lend the violent scenes serious punch. It's a style that has served Kitano well in films such as *Boiling Point* (1990), about an amateur baseball player who takes on the local mob, and *Sonatine* (1993), about an aging yakuza trying not to be forced out of his gang.

His gangster movies are the epitome of cool, with their sleek surfaces and Kitano's own inscrutable and often silent presence, his scarred face (which was partially paralyzed in a motorcycle accident) obscured by sunglasses. *Brother* (2000), is a strangely affecting fish-out-of-water story starring Kitano as a yakuza who goes to Los Angeles to search for his son and winds up fine-tuning a street gang into a powerful, organized mob. Its over-the-top finale, in which a histrionic Omar Epps, playing one of the American gangsters, delivers a tearful, lengthy, obscenity-laced tribute to his new boss, is the kind of morally ambiguous but emotionally satisfying moment that characterizes the appeal of Kitano's work.

Kitano has also branched out, with varying success, into other material. *Getting Any?* (1995) is a wacky slapstick comedy, which displays the old Kitano that Japanese audiences know so well from his TV shows. *Kikujiro* (1999) is a more gentle comedic road movie about an aging criminal escorting a young boy to a remote town to see his mother. He also made the ambitious *Dolls* (2002), three interconnected tales inspired by Chikamatsu's Bunraku puppet theater. Most recently, Kitano returned to his action roots with *The Blind Swordsman: Zatoichi* (2003), a tribute to the famous character played by Shintaro Katsu. Kitano's version is an infectious entertainment, concluding with a rousing tap-dancing scene that is simply irresistible. In 2005, he took a look in the mirror with *Takeshis'*, a fictional riff on his own famous image in which he finds himself confronted with his doppelgänger, a blond-haired striver trying to break into show business. Kitano calls *Takeshis'* and the film that followed, *Glory to the Filmaker!* (2007), part of the ongoing "creative destruction" of his career. Conceived as a cure to a creative block he was going through, it is a comedy that riffs on both Kitano's public persona and the history of Japanese cinema.

J-HORROR

One of the biggest world-cinema stories of the past several years has been the popularity of Japanese horror movies. The term *J-Horror*, a marketing moniker invented in the West, refers to a particular type of Japanese horror movie that eschews blood splatter for deep psychological creepiness, movies in which the glimpse of a figure out of the corner of the eye can give more nightmares than any ax murderer, where just about any piece of technology, from appliances to telephones to videotapes, can be haunted, and where it's not even safe under the covers: the ghosts are hiding there too. J-Horror films like Hideo Nakata's *Ringu* (1997) and Takashi Shimizu's *Ju-on: The Grudge* (2002) have proven so popular that they've spawned American remakes. The oft-repeated phrase among disgruntled moviegoers that "Hollywood is out of ideas" is nowhere more true than in horror movies: out of ideas of its own, Hollywood is buying them from Japan.

And why not? *Ringu* takes a great premise—a videotape that, once watched, will cause your death in seven days unless you pass it on to someone else—and runs with it. *Ju-on: The Grudge* puts a new twist on the classic haunted-house tale.

Nakata's *Dark Water* (2002) is a ghost story set in a leaky apartment where even the water dripping from the ceiling seems to have a supernatural sheen. *Ringu* is credited with starting the craze. Even though it was aimed at a teenage audience, its slow-burn creepiness made it a spectacular hit in Japan and around the world, spawning a sequel, *Ringu 2* (1998, also directed by Nakata), a TV series, and a third sequel, *Ring 0: Birthday* (2000), directed by Norio Tsuruta.

Japanese horror movies differ from American ones in various ways. In Japan, there is a general belief, inspired by ingrained folk traditions and Buddhism, that spirits can be present anywhere. Buddhist altars in the home are believed to house the spirits of deceased relatives. Ghost stories have a long history as well, and traditional Noh and Kabuki theater are replete with encounters with the uncanny and staging tricks that resemble movie special effects. Ghosts are everywhere in Japanese folktales. Writers like Akinari Ueda (1734–1809), whose *Tales of Moonlight and Rain* is one of the first collections of Japanese horror stories, drew on this folklore in their writings. Ueda's work inspired both Kenji Mizoguchi's *Ugetsu* and Masaki Kobayashi's *Kwaidan*, two elegant precursors to modern J-Horror.

Ghost stories are staples of worldwide folklore—the product of long, dark

KOJI YAKUSHO IN *Doppelganger*

nights and shadowy corners. But where generic American horror movies are more concerned with earthbound psychotics wreaking punishment on sexually active teenagers and its supernatural realm is ruled by cartoonish vampires and comic book demons, J-Horror films tend to tap into more primal fears.

Good J-Horror films lull you into an eerie world just slightly different from our own. What makes the hauntings and strange goings-on so creepy is that they take place in a recognizable milieu. The characters unlucky enough to play the wrong videotape or wander into the wrong house could be one of us. Kiyoshi Kurosawa is a master of the eerie atmospherics that make J-Horror so seductive, even when ghosts aren't the subject. Released the same year as *Ringu*, Kurosawa's *Cure* (1997) has as a central character an amnesiac who can hypnotize others into committing murder and who is pursued by a cop with demons of his own. Far from a standard thriller, it posits that horror, and the potential to perform horrific acts, reside within each one of us.

KOJI YAKUSHO • Although Koji Yakusho has starred in hits like *Shall We Dance?*, *Memoirs of a Geisha*, and *Babel*, he's certainly not the international celebrity that other actors with similar track records are. Perhaps this is because he specializes in playing the everyman, a quality exploited to great effect by Shohei Imamura, who cast him in *The Eel* and *Warm Water under a Red Bridge*, and especially by Kiyoshi Kurosawa, with whom he has worked in over half a dozen films. In these films, Yakusho is the regular guy confronted with extraordinary events. The normalness of his presence gives effective emphasis to the cosmic mysteries surrounding him.

The characters in Kurosawa's films are ruled by unexplainable forces that seem to emanate from the universe itself. Indeed, the way his camera seems to lurk and hover, like an unseen presence following the characters, reinforces this notion of a controlling, unexplainable force at work in his films. In *Charisma* (1999), various people battle over possession of a mysterious tree that holds an amorphous mystical power over them, and in the apocalyptic *Pulse* (2001), technology itself mutates into a supernatural force. Humans are gradually erased by ghosts who emerge from computers, leaving behind only shadowy smudges on the wall. Technology meshes with the uncanny, and what makes the film crawl so deeply under your skin is the way Kurosawa transforms technology into a mysterious presence, all around us but little understood, an electronic version of the supernatural. His recent films still take place in this same strange Kurosawan universe, but with less emphasis on giving the creeps. In *Bright Future* (2003),

a meditation on alienation and despair, two troubled young men bond over a poisonous pet jellyfish. It includes a memorable shot of hundreds of the glowing aquatic beasts floating on a canal toward Tokyo. But for all the nameless dread in his films, Kurosawa is not above parodying himself. *Doppelganger* (2003) turns the uncanny double of classic horror tales into the annoying look-alike of a frustrated inventor.

The *Ringu* craze inspired legions of imitators, as well as some fine movies that raise goose bumps in their own original ways. In *Uzumaki* (2000), by the mononymous Higuchinsky, terror takes the shape of a spiral form that shows up in everything from pottery to an elaborate hairstyle, in a tale told with wry humor. Joji Iida's *The Spiral* (1998) and *Another Heaven* (2000) mix touches of gore into the supernatural thriller genre.

BEYOND GENRE

Japanese cinema since the 1960s hasn't all been about extremes. Juzo Itami reinvigorated an ailing industry in 1985 with *Tampopo*, a sunny comedy, which became an international smash, about a woman's search for the perfect ramen noodle. He followed with other successful comedies, especially *A Taxing Woman* (1987) and its sequel, *A Taxing Woman Returns* (1988), which starred his wife, Nobuko Miyamoto, as a tax inspector who falls for a charming tax dodger. Masayuki Suo had an international hit in 1996 with the good-natured *Shall We Dance?*, the story of a dour businessman who discovers his true talent is ballroom dancing—which was recently given the Hollywood makeover treatment with Richard Gere in the starring role.

Even today, while horror, gore, and anime receive the most attention internationally, several Japanese directors are working in more personal modes, carrying on the high artistic tradition of their predecessors. Most prominent among them is Hirokazu Kore-eda. Kore-eda started out in documentaries, making, among other films, portraits of Taiwanese directors Hou Hsiao-hsien and Edward Yang, two artists whose styles influenced Kore-eda's own later fiction work. The first of these was *Maborosi* (1995), which portrays the lingering grief of a woman over her husband's unexplained suicide. It is an evocation of loss, but also a study of landscape and natural light, placing Kore-eda as an artistic descendant of Mizoguchi and Ozu. His 1998 film, *After Life*, also concerns death,

but in an oddly uplifting way. It takes place at a spiritual way-station between the land of the living and the dead, where the recently deceased must choose the one image from their lives that they want to take with them to the beyond. They are assisted by helpers who construct their memories in the manner of movie sets. It's a calm, absorbing film that asks the viewer to ponder deep questions about life and death.

As in *Maborosi*, the aftermath of tragedy is the subject of *Distance* (2001), which references the Aum Shinrikyo cult that released sarin gas in the Tokyo subway in 1995, an event that traumatized the nation. In *Distance*, relatives of dead members of an Aum-like cult, along with a former member of the cult who shows up unbidden, meet at a country house that once served as the group's headquarters to confront their sense of loss. Based on an actual event, *Nobody Knows* (2004) is about four children who've been hidden from the outside world by their young, wayward mother. When she disappears, they create a world of their own in order to survive. The children's touching resiliency becomes the

film's subject, and it is heartbreakingly depicted. Kore-eda made his first foray into period films with *Hana* (2006), an offbeat samurai film that emphasizes human relationships over swordplay in a grubby, working-class milieu that provides a kind of worm's-eye view of a world more commonly portrayed from the point of view of samurai heroes and their adversaries.

The Aum Shinrikyo aftermath also informs another of the most praised Japanese films of recent years, Shinji Aoyama's *Eureka* (2000). Usually the maker of stylish thrillers like *An Obsession* (1998), *Embalming* (1999), and *A Forest with No Name* (2002), Aoyama took a different course with *Eureka,* a nearly four-hour movie, filmed in sepia tones, that focuses on the survivors of a bus hijacking who find it hard to adapt to the world after what they've witnessed. Gripping yet serene, it taps into the general anxiety in Japan still lingering five years after the Aum Shinrikyo attacks, yet resonates more widely as well.

Aoyama and Kore-eda are sometimes lumped together with Nobuhiro Suwa, Naomi Kawase, and others under the banner of a new Japanese new wave, though their styles and themes differ considerably. Suwa's films are complex intertextual games. His unfortunately underdistributed *H Story* (2001) reimagines Alain Resnais's 1959 classic *Hiroshima Mon Amour,* with Suwa playing himself as a director trying to pull off a remake starring Beatrice Dalle, who also plays herself, as a difficult, tempestuous diva who disappears into an awkward friendship with a nerdy screenwriter. Kawase, like Kore-eda, started in documentaries, and the handheld immediacy of her 2003 *Shara* harkens back to those roots. She also shares with Kore-eda an interest in the aftermath of tragedy. The family in her film is crippled by the loss of a child, and finds joy only by joining their town's annual festival, the footage of which provides a cathartic finale.

An increasing number of talented directors have emerged on the international scene in the past decade. Shinji Iwai's *All About Lily Chou-Chou* (2001) depicts the difficulties of adolescence with remarkable sensitivity. The teenagers in the film, all confused and some dangerous, bond on a Web site devoted to the fictional singer of the title. Her music provides an anonymous emotional connection more real than the ones in their actual lives. Iwai, a veteran of music videos, manages to create lyricism with imagery normally associated with the pop ephemera that forms the visual landscape of the kids the movie addresses. Nobuhiro Yamashita, Japan's answer to Jim Jarmusch, makes dry, deadpan comedies in which hapless heroes grapple with the minor difficulties of life. *No One's Ark* (2002) sends a young

couple to the male half's hometown to live with his parents after the failure of an absurd business venture. His wonderful *Linda Linda Linda* (2004) follows the travails of a group of schoolgirls studiously forming a rock band, who finally come together to perform a raucous rendition of the title song, a Japanese pop classic.

The only drawback to the immense popularity of Japanese anime, horror, and other popular genres is that less flashy, less readily classifiable works are too rarely seen in the United States. For instance, Toshiaki Toyoda's *Nine Souls* (2003), about a pack of ex-cons in search of lost treasure, shifts between comedy and violence in a dreamlike atmosphere suggestive of spiritual powers at work. Jun Ichikawa's whisper of a film, *Tony Takitani* (2004), is based on a short story by Haruki Murakami; it beautifully translates the lonesome aura and deep mysteriousness of everyday life that characterizes Murakami's writing into a universal cinematic language, yet subtly experiments with the form. Ryuichi Hiroki has made two films, *Vibrator* (2003) and *It's Only Talk* (2005), with the talented actress Terajima Shinobu that explore, with passion and understated grace, the psyches of lost and troubled souls trying to find their place in the world. Katsuhito

Ishii, who previously made quirky, anime-influenced action films like *Shark Skin Man and Peach Hip Girl* (1998), delivered a portrait of an eccentric family in 2004 with *The Taste of Tea* (2004). In 2006, two women directors made subtle, compelling coming-of-age films about contemporary Japanese families: In Mipo O's *The Sakai's Happiness*, a sullen teen watches his family fall apart when his father declares that he is gay (but only to hide a more tragic truth), and Mayu Nakamura's *The Summer of the Stickleback* tells the story of a teenage girl coming to terms with her sexuality while dealing with her mother's alcoholism. While action, horror, and anime certainly have their pleasures, these and other smaller movies deliver rewards of a different, more contemplative sort.

ANIME

In a nighttime cityscape, a young girl flits out a window and onto a streetlight. She smiles, waves, and hops from streetlight to streetlight until she disappears into the night. The only person who can see her can't be sure that she's real (the figure looks like a younger version of herself), and neither can we. This supremely uncanny image from Satoshi Kon's 1998 film *Perfect Blue* exemplifies the magic that anime can invoke, as does the line "Excuse me, who are you?" that echoes throughout the film. The best anime films combine great visual beauty, fairy-tale narratives, and philosophical depth that make them something other than mere cartoons. Kon's films *Perfect Blue* and *Millennium Actress* (2001) deal with show business, the first about a teen singer trying to become a grown-up actress who keeps seeing the ghost of her former self, the second a mock documentary about an elderly, reclusive actress's colorful past and interactions with Japanese history. In these and the later *Tokyo Godfathers* (2003), the story of three homeless people who find a baby in the garbage and resolve to find the mother, Kon approaches something like animated realism, though unconstrained by the real-world obstacles of creating special effects with actual actors and locations. His 2006 feature *Paprika* travels beyond realism to the future, where a device that can record dreams falls into nefarious hands. Its many scenes in which dreams infiltrate the real world give Kon the opportunity to concoct some of his most hallucinatory imagery.

Anime's imaginary worlds, whether it be Kon's expressive rendering of contemporary Tokyo or the fantastic locales of Hayao Miyazaki's films, have proven

to be amazingly attractive to audiences of all ages. Anime series are broadcast on American television to an obsessed following of adolescents who somehow find their way into these films' highly sophisticated worlds through the blizzard of entertainment options marketed to them. There are anime clubs everywhere and annual conventions on nearly every weekend of the year, where the plots of movies and TV shows are studied and analyzed with scholarly zeal, and where everyone from toddlers to grandmothers shows up decked out in homemade costumes inspired by their favorite characters. There is no doubt that anime is an escape from the real world, even the unreal world of mainstream entertainment. It's an imaginary place where anyone can fit in, and some go deeper than others. The term *otaku*, which in the United States is an affectionate term for anime devotees, in Japan connotes someone who is obsessed with the form to the point of madness.

Anime films grew out of *manga* comics, which themselves evolved from ukiyo-e woodblock prints. The term *manga*, was used by one of the greatest ukiyo-e artists, Katsushika Hokusai (1760–1849), to describe his own more whimsical drawings. There were animated films in Japan from the early days of cinema, but they had a relatively minor role until the 1950s, when American-style animation studios emerged. Shortly after that, anime moved to television, where it proved

more popular than in the movie theaters. Anime (though it wasn't called that then) even made it to American television in the 1960s when shows like *Astro Boy* and *Speed Racer* hit the airwaves in dubbed versions.

Televised anime has grown exponentially more sophisticated since then. Even series aimed at kids, like *Inuyasha*, feature labyrinthine plots that confound their elders. But even grown-ups can enjoy creations like Shinichiro Watanabe's amazing 1998 *Cowboy Bebop*, a sophisticated (if short-lived) sci-fi adventure about interplanetary bounty hunters. Its episodes mix everything from jazz to cowboy-movie iconography to blaxploitation into a wild postmodern stew.

But it's on the big screen that anime enjoys its fullest expression. The shift from small to big screen began in 1984, when Hayao Miyazaki made *Nausicaä of the Valley of the Wind*, which became a surprise blockbuster in Japan. Miyazaki, one of the world's great film artists, is anime's elder statesman. His beautifully rendered films create worlds reminiscent of Japanese folklore and European fairy tales, and he populates them with imaginative characters, animals, and fantastical creatures. Yet they never pander. They respect the complexity of children's imaginative lives and tap into adults' childlike imaginings with equal effectiveness. *Nausicaä* takes place in the distant future, in a world polluted by unending warfare, and has at its center a young heroine struggling to reconcile humans with their environment. An ardent environmentalist himself, Miyazaki channels his concern about saving the natural world into his films without being heavy-handed. The dazzling *Princess Mononoke* (1997), which introduced Miyazaki to most American audiences, is an epic adventure set in the distant past, a battle between warlike humans and the animal gods trying to protect an ancient forest from their advance. The film's ideas about the natural world are surprisingly complicated for an animated movie. Nature is both comforting and dangerous, but above all worth saving.

Fantastic voyages, mystical forests, the exhilaration of flight, these are

some of the most enthralling elements of Miyazaki's work. Inspired by a tale from Jonathan Swift's *Gulliver's Travels*, *Castle in the Sky* (1986) takes place in an alternate eighteenth century, full of flying steamships and an island in the sky populated by gentle robots tending to the gardens of its extinct human inhabitants. In *My Neighbor Totoro* (1988), two sisters discover a magical forest near their home, where adorable creatures known as totoros help them cope with their mother's illness. In *Porco Rosso* (1992), pigs literally fly—the hero is a porcine former World War I flying ace.

In a career studded with great artistic achievements, *Spirited Away* (2001) is thus far Miyazaki's most magnificent. A modern-day *Alice in Wonderland*—and every bit as imaginative—it sends a young girl into an imaginary land of strange spirits and humans who transform into animals, where she is forced to work in a bath house serving forest gods while she tries to find her way back to the real world. *Spirited Away* is the kind of film one returns to again and again. Many regard it as Miyazaki's masterpiece. It broke box office records in Japan, and won the Oscar for Best Animated Feature. *Howl's Moving Castle* (2004) is another in Miyazaki's unbroken line of wonderful films, telling the story of a young girl who has been transformed by a witch into an old lady and can find the secret to changing herself back only by finding the mysterious wizard Howl in his ambulatory contraption that gives the movie its title.

Anime aims to please everyone. There are films for young children, teens, and grown-ups. Those who find human flesh too mundane can delve into pornographic *hentai* anime and watch pneumatically endowed cartoon girls cavort with tentacles and machinery. But for general audiences, the most successful anime subsection has been science fiction. The first anime film to achieve crossover success in the United States was Katsuhiro Otomo's *Akira* (1988), an apocalyptic odyssey set in a ravaged post–World War III Tokyo, where a young biker punk discovers that he has psychic powers that help him take on the city's corrupt rulers. Its vivid colors and striking images brought a new audience to anime, and paved the way for Mamoru Oshii's even more mind-blowing *Ghost in the Shell* (1995). Oshii's film is a sophisticated exploration of natural and artificial intelligence. The heroine is a police officer in a future where people have been so enhanced by technology that the border between human and machine has become blurred. (The film's title refers to her human consciousness—the "ghost"—inside her cyborg body, or "shell.") Like the best science fiction, the film uses its imaginary future to touch on complex philosophical concepts while supplying a satisfyingly propulsive plot. In Oshii's sequel, *Ghost in the Shell 2: Innocence* (2004), the heroine of the first film exists only as a floating consciousness discovered by her former companions while investigating a string of murders committed by pleasure droids. Even more visually dazzling than its predecessor, thanks to cutting-edge digital effects, it further investigates the intersection of body and technology.

Anime producers know their audience. The *otaku* are not just moviegoers, they are participants in an interactive world, not only buying toys and other merchandise, but creating their own costumes and artwork based on the films. The high-profile movies discussed in this section are just the tip of the ever-expanding anime phenomenon.

CONCLUSION: GOOD NIGHT, AND GODZILLA

No discussion of Japanese cinema would be complete without at least some mention of the great and powerful Godzilla, that rubbery beast who once strode across Tokyo embodying mid-century atomic anxiety. The titular hero of Ishiro Honda's 1954 film, and the dozens of sequels that followed, was once upon a time the very face of Japanese movies for most Americans. But the years since have proven that Japanese cinema is rich, diverse, and vast.

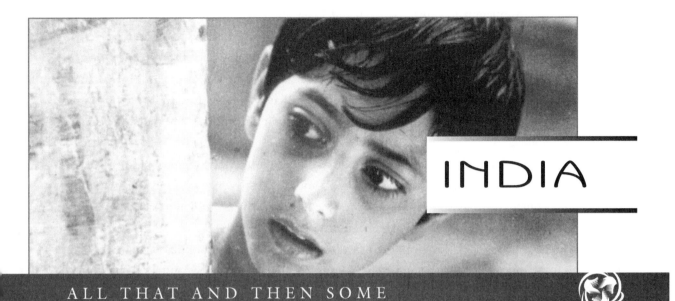

INDIA

HISTORICAL BACKGROUND

India is a polyglot place. Its official language, Hindi, is but one of at least eighteen languages recognized by the Indian constitution, which doesn't take into account the many dialects and subdialects that also exist. It is the birthplace of Hinduism and Buddhism, but also home to a sizable Muslim population, as well as Christians, Jews, Sikhs, Jains, Zoroastrians, and tribal peoples with their own distinct cultural traditions. Although India is often fetishized in the West as a land of mystery and spirituality, intertwined with its religious history is a complex intellectual tradition that is often overlooked. This can be seen in one of the Hindu religion's central sacred texts, the Bhagavad Gita, which consists of a philosophical conversation between the warrior hero Arjuna, and the Hindu god Krishna about whether one should follow one's duty even if it will result in human suffering.

The unique style of India's popular Bollywood cinema is a response to the diversity of the nation. While Bollywood films are almost always made in the Hindi language, their broad emotions and catchy songs are designed to appeal to non-

Hindi speakers as well, and there are smaller regional film industries producing films in languages such as Tamil and Malayalam, with their own popular stars and respected directors. India's long literary tradition still survives in its popular cinema. Ancient texts such as the Ramayana have been adapted for the screen. Director Mani Ratnam is reportedly working on a screen adaptation of the Mahabharata (the ancient Sanskrit epic that includes the Bhagavad Gita), and the moral dilemma that is at the heart of the Bhagavad Gita sometimes forms the plots of popular films.

India's classical music tradition, which stretches back thousands of years, finds its way into Bollywood scores, and the festive nature (and long running times) of Bollywood movies reflects a culture in which music is a part of daily life, where festivals of music and theater can last for days.

While traditional culture undergirds India's popular cinema, those traditions are questioned by art filmmakers like Satyajit Ray, Adoor Gopalakrishnan, and Girish Kasaravalli, whose works often emphasize the problems of clinging to cultural and religious traditions in a changing, modernizing India.

The British ruled India from 1858 to 1947, when they were dislodged by Gandhi's mass movement of nonviolent resistance. The subcontinent was partitioned into secular India and Islamic Pakistan. Some 12 million people migrated between the two states, and it is estimated that rioting as a result of Partition took some 200,000 lives. Tensions continue today, both between India and Pakistan, and within India itself. The sometimes peaceful, sometimes violent coexistence between Hindus and Muslims in India has been depicted repeatedly throughout the history of Indian cinema, to both comic and tragic effect.

Today, India's growing economy and changing society have captured the world's notice. At the same time, its cinema is gaining adherents outside the nation and its diaspora like never before.

A NOTE ON TITLES

Elsewhere in this book films are referred to by their English titles. However, most Indian films, particularly those made in the Hindi language, are best known by their Hindi titles, so Hindi titles will be used in this section unless the English version is more widely known.

BOLLYWOOD BASICS

Indian popular cinema is unique in all the world. Nearly everywhere else, movies, often following Hollywood's lead, evolved in similar ways. There are clear differences among dramas, comedies, musicals, melodramas, thrillers, and so on. A Bollywood movie is all that and more. Plot twists come out of nowhere, characters break into song to express their innermost thoughts, dance sequences with dozens of performers can erupt at any time, and emotional climaxes just as often hit right in the middle of a movie (just before the intermission) as they do at the end. It is a uniquely seductive and fulfilling formula for entertainment. Once you get hooked on these masala movies (named after the Hindi cooking term for any of a number of blends of many spices), the attraction can be irresistible.

The term *Bollywood*, a conflation of *Bombay* and *Hollywood* allegedly coined by an Indian gossip columnist in the 1970s, is sometimes seen as a derogatory term, a synonym for mindless kitsch mistakenly applied not only to movies made in Bombay (now called Mumbai) but to films made in other languages throughout India as well. To be sure, a bad Bollywood movie can be a tedious exercise in vacuity. The Indian film industry produces over one thousand movies annually, and as is the case with Hollywood's comparatively puny output, the majority of them are mediocre. The good ones, however, are transcendent entertainments— three hours of pure joy.

Movies were first shown in India in 1896, when the globe-trotting Lumière brothers brought their *cinématographe* to Bombay. But the origins of India's popular cinema aesthetic go much further back, all the way to the Ramayana and the Mahabharata, ancient epic poems that have a central place in the Hindu religion. The first Indian feature film, Dhundiraj Govind Phalke's 1913 *Raja Harischandra*, was about the life of Lord Krishna, and apparently included an array of dazzling special effects. It started a long-running genre of "mythologicals," about the adventures of Hindu gods and goddesses. When sound came along in 1931 with Ardeshir Irani's *Alam Ara*, it arrived full of music and fantasy, and its popularity ensured that there would be more to follow.

It is perhaps natural that Indian popular cinema would foreground music and spectacle. These were a major part of ancient Sanskrit drama, folk theater, and the Parsi theater, a popular form that came into being in the nineteenth century and blended traditional Indian theater with Edwardian drama. In their book

Indian Popular Cinema, K. Moti Gokulsing and Wimal Dissanayake relate that the Parsi theater "with its lilting songs, bawdy humor, bon mots, sensationalism, and dazzling stagecraft were designed to appeal to the broad mass of people." Gokulsing and Dissanayake also point out that the Ramayana and Mahabharata influenced not just the content of Indian films, but the narrative structure as well. The "endless digressions, detours, [and] plots within plots" that tend to leave the first-time Bollywood viewer slack-jawed with amazement follow the pattern of traditional Indian storytelling dating back to those two ancient texts.

But Indian cinema didn't develop in a vacuum. Indian filmmakers were aware of Hollywood. But rather than adopting its style, they simply took the elements they found effective (the star system, advances in cinematography, editing techniques, etc.) and discarded the rest. This should come as no surprise, since these filmmakers were the product of a culture some five thousand years old with a long history of interacting with and absorbing elements from diverse other cultures.

This remarkably sturdy and effective recipe for entertainment has been in place for over sixty years, and the ingredients are simple. Plots revolve around love and family devotion. Endings are happy. And there must be music. The difference between films is in how these elements are handled: in the performances of the actors, the integration and "picturization" of the songs, and the trials the characters must endure before they get to their happy ending.

Bollywood continually recycles storylines—*Devdas*, the tale of a prodigal son returning to his true love, has been made four times since 1928—so it is up to the actors and the music to transform these variations on a theme into something more. In return, India's movie stars are rewarded with a kind of devotion that their American counterparts rarely receive. When Amitabh Bachchan, one of Bollywood's biggest stars, was hospitalized after an injury on the set in 1982, Prime Minister Indira Gandhi rushed to his bedside, and the entire nation came to a standstill as prayers were offered from mosque, church, temple, and synagogue

AISHWARYA RAI IN THE 2002
VERSION OF *Devdas*

alike, and thousands gathered outside the hospital where he was staying to try to catch a glimpse of their idol.

Music is as central to Bollywood movies as it is to Indian life in general, where there are ragas for every hour of the day and, from cradle to grave, one participates in festivals full of music and dance. Film composers are stars in their own right, as are the "playback singers" who record the songs (Indian actors and actresses rarely sing their own songs). Composers like R. D. Burman and A. R. Rahman are household names. Playback singer Lata Mangeshkar's distinctively light, lilting voice has wrapped itself around some twenty thousand recorded songs in her long career. Her sister Asha Bhosle's earthier, sassier delivery can be heard in over eight hundred films, as well as with the Kronos Quartet on *You've Stolen My Heart* a Grammy-nominated CD of songs composed by her late husband, R. D. Burman.

The Kronos recording is but one example of how Bollywood is gradually moving beyond its native culture. Terry Zwigoff's 2001 film *Ghost World* features a clip from the 1965 Hindi film *Gumnaam*. Baz Luhrmann claimed Bollywood movies as an influence on his 2001 musical *Moulin Rouge*. Spike Lee used a song from Mani Ratnam's *Dil Se* (1998) to open and close his 2006 drama *Inside Man*. And Andrew Lloyd Webber recently collaborated with A. R. Rahman on *Bombay Dreams*, a London stage musical. There's even a Hollywood remake of a Bollywood movie in the works. *Munnabhai MBBS* (2003), Rajkumar Hirani's comedy starring Sanjay Dutt as a gangster who has to pretend to be a doctor to fool his parents, may soon appear on American movie screens retooled as *Gangsta MD*, reportedly with Mira Nair at the helm and comedian Chris Tucker in the starring role. Not that Bollywood doesn't repeatedly plunder foreign shores for material itself. The Cannes-award-winning revenge drama *Oldboy* (2003) by Korean director Park Chan-wook resurfaced almost shot for shot as Sanjay Gupta's *Zinda* (2005), as did Nicholas Winding Refn's gritty Danish street drama *Pusher* (1996), which came out under the same title as a Bollywood remake by Assad Raja in 2007. Even *Fight Club* (1999), David Fincher's ham-handed look at violence and alienation, received the remake treatment courtesy of Vikram Chopra.

Bollywood movies are inclusive. They are aimed at the masses and reflect current events and concerns, as well as changes of taste in music and style, while remaining true to their core elements. Their broad emotions and catchy songs were originally designed to draw in non-Hindi speakers both in India and abroad,

which resulted in sizable audiences across the Middle East, in Africa, and even the former Soviet Union. And audiences are adoring and critical in equal measure. Bollywood fan Web sites dissect performances and chemistry between stars with the kind of critical discernment usually displayed by serious film scholars. People speak of movie stars as if they were on a first-name basis. Mention "Amitabh" or "Shah Rukh" and anyone in India with a glancing familiarity with movies will know whom you're talking about. Their respective last names, Bachchan and Khan, are unnecessary. Over the past few years, Indian producers have begun actively courting the nonresident Indian (or NRI) market. Many American cities now have movie theaters showing only Bollywood movies, and subtitled DVDs of recent and classic Indian movies can easily be rented or purchased over the Internet, or even in grocery stores in Indian neighborhoods. For NRIs, they are a reminder of home. For the rest of us, they are a new world of cinematic pleasure to enjoy.

GOLDEN YEARS

The only problem is that the world of popular Indian cinema is so huge that it's hard to know where to start. All Bollywood buffs have their lists of essentials, but, as with any art form, it's good to have a grounding in the classics. The best place to begin is the unanimously agreed upon golden age of Indian cinema: the 1950s and 1960s. Bombay received a flood of performers, technicians, and artists in the aftermath of independence and Partition, as people fled from the strife that was convulsing the nation. The resulting pool of talent created a body of work comparable to the great classics of Hollywood cinema.

During the 1930s and 1940s India's film industry operated as a studio system. Directors and actors were contract employees doing the bidding of their studio bosses. But this system collapsed in the late 1940s. Producers now had to raise money independently (and not always legally), to attract talent with cold hard cash. This made it harder to make movies, but it also gave great talents like Guru Dutt, Raj Kapoor, and Mehboob Khan (known popularly as simply Mehboob) more room for individual creativity. Golden age directors also tapped into the nation's general anxiety. Economic uncertainty, social upheavals, religious strife, and conflict between tradition and modernity are all reflected in the films of the period, which were designed to entertain and comfort a populace struggling with these problems on a day-to-day basis.

Director-star Raj Kapoor plugged into the zeitgeist with his 1951 film *Awara*, one of the all-time classics of Indian cinema. Kapoor's persona in this film and others, inspired by Charlie Chaplin right down to the mustache, is a happy-go-lucky tramp, an outcast who represents India's have-nots. In *Awara* (which translates as "vagabond"), his character is a street urchin who, unaware that he is actually the son of a wealthy judge, falls into a life of crime under the influence of the judge's enemy. The movie mixes melodrama with a sense of social inequity and is made with consummate craftsmanship (Kapoor was notoriously detail-oriented, controlling everything from the lighting to the music to the marketing of his films). It also features a famous twelve-minute dream sequence of three linked songs that recasts the plot in surrealist terms. Kapoor's outcast character connected not only with downtrodden Indians. The film also made him a household name in West Africa and the Soviet Union.

In *Shree 420* (1955)—named for the section of the Indian Penal Code under which petty criminals are prosecuted—Kapoor plays a college-bound young man who discovers the inequities of Bombay when he disguises himself as a tramp to woo a young teacher. One of its songs contains the famous lyrics "My shoes are Japanese / My pants are English / The red cap on my head is Russian / But my heart is still Indian," words that connected deeply with a society emerging into the modern world.

Thanks to the demise of the studio system, popular actors could demand to be paid what they were worth, so the 1950s saw the rise of a star system that remains in place today. The biggest female star of the day was Nargis, who starred alongside Kapoor in *Awara*, *Shree 420*, and other films. She gave perhaps her most famous performance in Mehboob Khan's *Mother India* (1957), a Technicolor national epic that has been called India's *Gone with the Wind*. A perfect example of the masala movie, it blends Soviet-style social realism (the logo of Mehboob's production company displayed the hammer and sickle), melodrama, slapstick comedy, and a dozen production numbers to tell the story of a put-upon peasant woman who suffers injustice while trying to raise two sons on her impoverished farm. Nargis's character is an Indian everywoman, who, at a crucial juncture, is faced with a moral dilemma right out of the Hindu epics that are so ingrained in Bollywood plots. Like many in the Indian film industry, Mehboob was a Muslim, but movies have always been a place where the Hindu-Muslim strife that still affects Indian life can be put aside. Like Kapoor, Mehboob was a solid craftsman

even when not directly addressing social themes. His 1948 *Andaz*, starring Nargis and Dilip Kumar, established the love-triangle plot used so often in Indian popular films, in a supremely entertaining tale set within the Indian demimonde.

Another giant of the time was Guru Dutt, a brooding auteur and star with matinee-idol looks and a complete mastery of cinematic language. Dutt's films, with their delicate interplay of light and shadow, haunting music, and deftly integrated song sequences, address Indian history and culture, and often concern the role of the misunderstood artist in society, a subject very close to his heart. He addressed Indian divorce law in the comedy *Mr. and Mrs. 55* (1955), but followed it with the much more personal *Pyaasa* (1957), the film many consider his masterpiece. Dutt plays an impoverished, misunderstood poet who is disowned by his family but ultimately finds triumph in his art. An equal to *Pyaasa* in cinematic poetry, *Kaagaz ke Phool* (1957) also stars Dutt as an artist, in this case a film director, who suffers disgrace and a crumbling marriage when he enters into a relationship with a budding starlet.

Praised for its emotional intensity and gorgeous cinematography, *Kaagaz ke Phool* is now a classic, but its financial failure at the time so tormented Dutt that his later films no longer bear his signature as a director, even if they carry his artistic stamp throughout. *Chaudhvin ka Chaud* (1960), credited to M. Sadiq, addresses Hindu-Muslim tensions through a love-triangle story set in a sumptuous past. Credited to Albrar Alvi, Dutt's final feature, *Sahib, Bibi aur Ghulam* (1962), is a haunting romance that takes place during the decline of the Bengali aristocracy. Alcoholic and still depressed over the failure of *Kaagaz ke Phool*, his most personal film, Dutt died in 1964 at the age of thirty-nine, an apparent suicide.

Bollywood's golden age is dotted with masterpieces, vast, sumptuous entertainments full of wonderful music drawing on the winding melodies of the Indian musical tradition. It is the age of stars like Dev Anand, Shammi Kapoor, Meena Kumari, and Waheeda Rehman (Guru Dutt's muse). Dilip Kumar's

historical epic *Mughal-e-Azam* (1960) evoked the glories of the Mughal era in all its splendor. Worth seeing for its magnificent musical numbers alone, it carries with it the aura of ancient love stories and poetry, a time when lovers communicated in suggestive verse and the subtlest touch implied the most intense eroticism. V. Shantaram created many classic melodramas throughout his long career, among them *Subah ka Tarah* (1954) and *Jhanak Jhanak Payal Baje* (1955). Bimal Roy combined sharp social criticism with supreme popular-cinema technique in films such as *Do Bigha Zamin* (1953) and *Sujata* (1959). To see these films, and others from this period, is to experience the Indian popular film industry at its height: a conjunction of art, commerce, and entertainment instincts that address Indian culture and desire but also connect to the universal desire to be entertained.

SATYAJIT RAY AND INDIAN ART CINEMA

The 1950s also saw the arrival of Satyajit Ray, whose name is practically synonymous with Indian art cinema. In an attempt to counter the influence of the illegal "black money" that was circulating in the popular film industry, the Indian government took steps in the 1950s and 1960s to build a national film infrastructure, creating the Film Finance Corporation, the Film Institute of India, and the Film Archive of India. These organizations were designed to encourage, fund, and promote serious cinema culture. At the same time, film societies with similar goals sprouted up around the country, including one in Calcutta cofounded by Satyajit Ray. In addition, India's first International Film Festival, which took place in 1951, gave mass audiences their first look at the best cinema from around the world. The Italian neorealist films shown in the festival inspired both Raj Kapoor and Bimal Roy to attempt to incorporate their aesthetics into a popular context. But they had a different effect on Ray.

The product of a family that had already made significant contributions to Bengali literature and art, Ray made his first film, *Pather Panchali* (1955), with non-actors, on a tiny budget, creatively using natural light and a realistic village setting. No one sang or danced, and the film's story—about a family struggling to make ends meet, as seen through the eyes of a young boy—was hardly pop fodder. In fact, it was the very antithesis of Bollywood, but it put Indian cinema on the world map by winning two awards at the Cannes Film Festival and established an alternative, artistic cinema in India. It is a warm, deeply human film whose graceful

Pather Panchali

images capture the rhythms of rural Bengali life, accompanied an equally graceful score by the famous sitar player Ravi Shankar. Two subsequent films following *Pather Panchali*'s central character, *Aparajito* (1957) and *Apu Sansar* (1959), became known, along with *Pather Panchali*, as the Apu Trilogy. Together they form the core of Ray's artistic project: the humanist, respectful portrayal of the lives of ordinary people, far from the escapism of Bollywood.

Ray's impact on world and Indian cinema is enormous. At one time *Pather Panchali* was screening somewhere in the world every day of the year. Bengalis take great cultural pride in Ray as the carrier of a distinguished intellectual and artistic tradition in the manner of Rabindranath Tagore, the great educator, writer, and poet. In his long and varied career, Ray made everything from children's films (including *Goopy Gyne Bagha Byne*, 1968) to documentaries, but his features, which often directly address the conflict between tradition and modernity that popular films at the time only alluded to, are his greatest achievements. *Devi* (1960) potently distills these issues into the figure of one person, a village girl (played by the Sharmila Tagore), believed by her father-in-law to be an incarnation of the goddess Kali and worshipped by the local villagers, who is dying inside from the desire to live a normal life. Another masterpiece, *The Music Room* (1958), depicts the erosion of an aristocratic family thanks to its music-obsessed patriarch, who continues to throw decadent concerts (which provide the film's most mesmerizing moments) while his mansion crumbles around him. Aristocratic apathy leads to the British takeover of Lucknow in one of his later films, *The Chess Players* (1977). Set in 1856, its two main characters play endless games of chess while ignoring the mounting troubles around them. The moves and countermoves of the film's plot echo the structure of chess itself. *Charulata* (1964), one of his greatest films, examines the role of women in a changing society, taking as its source material a Rabindranath Tagore novel set in the late nineteenth century about a neglected wife.

Ray's work can be uneven, especially in his later films. (He made his last, *Agantuk* in 1991). But overall, his body of work is one of incisive characterization, exquisite visual composition, and deep sensitivity to human nature and the profound changes sweeping over India as it moved from the consolations of traditional life to the uncertainties of modernity. He casts a long shadow over Indian art cinema. Any young director who makes a promising debut film is invariably saddled with the burden of being called "the next Satyajit Ray."

There can be no doubt that Ray paved the way for the emergence of an art-cinema movement in India that has produced some remarkable talents, many of whom are quite dissimilar in style to Ray. Ray's fellow Bengali, the iconoclastic Ritwik Ghatak, was inspired by *Pather Panchali* to explore the possibilities of cinema (he was equally accomplished as a writer and theater director). His films are more formally daring than Ray's, incorporating theatrical devices and experimental imagery. The lingering scars of Partition, the pain of displacement, and the rapid intrusion of modernity into rural life are the major themes that crop up in films such as *Ajantrik* (1957), *Maghey Dhaka Tara* (better known as *The Cloud-Capped Star*, 1960), and *Titas Ekti Nadir Naam* (a.k.a *A River Named Titas*, 1973). Mrinal Sen shares with Ghatak a leftist political sensibility that is even more pronounced. A committed Marxist influenced by the formal innovations of the French new wave, Sen over his long career made a number of inventive films, ranging from realistic stories about the middle classes like *Bhuvan Shome* (1969) to the quasi-religious fable *Genesis* (1986).

Other directors emerged in the early 1970s from all over India with distinctive visions of the possibilities of cinema. Adoor Gopalakrishnan, from the southern state of Kerala, examines issues similar to those explored by Satyajit Ray, but with his own sensitivity to his local culture and its unique landscape. The antihero of *The Rat Trap* (1981), for instance, unable to adapt to social change, represents a dying feudal class desperately clinging to its outmoded ways. Gopalakrishnan's films are all strong, but *Shadow Kill* (2002) is possibly his masterpiece. Religion, politics, and human frailty are all embodied in its central character, an executioner who spends his time dreading when he will be called upon to ply his trade. Because of his proximity to death, his fellow villagers believe he has healing powers. Told powerfully in radiant color images, it unfolds like an ancient legend, but has very modern things to say about politics, spirituality, and the burdens they place on those caught at their juncture. Girish Kasaravalli, from the Karnataka Province in

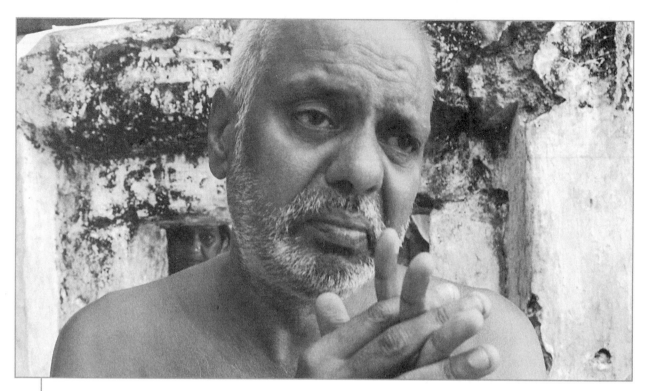

Shadow Kill

southwestern India, makes visually varied films, each with its own animating force. His debut, *The Ritual* (1977), uses searing black-and-white images to create a powerful indictment of the caste system's treatment of women. By contrast, his 2002 *Dweepa*, an environmentalist fable about a woman refusing to leave an island that is about to be flooded by the construction of a dam, is drenched in deep natural colors and the effects of light on water.

Shyam Benegal also often makes films about the role of women in Indian society. Stylistically, he straddles art and popular cinema, sometimes using popular actors like Naseeruddin Shah and Om Puri, and sometimes working on a shoestring: *Manthan* (1976) was funded by the dairy farmers whose story it tells. Along with *Ankur* (1973), *Nishant* (1975), and *Bhumika* (1977), it composes a quartet of films that put Benegal at the forefront of a loosely defined new wave that also included Gopalakrishnan, Kasaravalli, G. Aravindan (*Kanchana Sita*, 1977), Mani Kaul (*A Day's Bread*, 1970), and others. The movement died out in the 1980s and Benegal had trouble getting films produced, but he returned to form in the 1990s. *The Making of the Mahatma* (1996) looks at Mahatma Gandhi's years in South Africa, where he studied what he called the twenty-one forms of truth, which he would later use to lead India out from under British rule. *Suraj ka Satwan Ghoda*

ASIAN CINEMA: A FIELD GUIDE

100

(1993) is a thoughtful study of love, with short vignettes told from varying points of view. In an interesting departure, his recent film *Zubeidaa* (2001) is an old-fashioned Bollywood drama harkening back to the glory days of the golden age in style and sophistication. Its melodious A. R. Rahman score and Benegal's gliding camera and ability to keep the plot from veering into melodrama give it more weight than the average Bollywood outing.

The tradition of quality art cinema begun by Ray in Bengal is being carried on by a number of contemporary directors. Aparna Sen, who appeared as an actress in some of Ray's films, makes well-wrought dramas about interpersonal relationships, among them *36 Chowringhee Lane* (1981), about the friendship between a lonely English teacher, a former student, and her fiancé; and *Mr. and Mrs. Iyer* (2002), in which a Hindu woman and a Muslim man form a bond on a bus that is attacked by terrorists. Rituparno Ghosh also examines relationships—particularly family ones—in skillfully crafted dramas like *The Festival* (2000) and *Raincoat* (2005). Goutam Ghose and Buddhadeb Dasgupta, though neither has had any luck finding distribution in the United States, are mainstays in the international festival circuit. Ghose works in a realistic mode, while Dasgupta makes films distinguished by their visual poetry and experimentation with narrative structure.

CHANGING TIMES

Indian popular cinema began to change with the culture at large in the 1960s. Classic spectacles continued to be made. A prime example is *Waqt* (Yash Chopra, 1965) a story about a Muslim family sundered by an earthquake, featuring an all-star cast including Raj Kumar, Sunil Dutt, and Sharmila Tagore. But contemporary crime thrillers (though still with plenty of song and dance) like Vijay Anand's *Kala Bazar* (1960) and *Guide* (1965), both starring his brother Dev, began to replace the epic romances of the previous decade. Touted as India's first supernatural thriller, Raja Nawathe's goofy haunted-house mystery *Gumnaam* (1965) is all groovy, swinging sixties style, right down to the fantastic opening musical number featuring a cast of dancers wearing Austin Powers–type suits. Even the music by and large employs rock influences and electric instrumentation rather than traditional instruments.

The golden age's final flowering was Kamal Amrohi's magnificent *Pakeezah*, released in 1972 after some fourteen years in the making. Amrohi's tale of a high-

class courtesan's desire for a mysterious man who leaves her a love note on a train carries an aura of tragedy that reaches beyond the confines of the narrative. One of the reasons it took so long to make was that the star, Amrohi's wife, Meena Kumari, was slowly dying of alcoholism, and passed away just a few days after the film was released. *Pakeezah*'s misty wide-screen color images and breathtaking songs (sung gorgeously by Lata Mangeshkar) give it a timeless feeling, placing it among the great classics of popular cinema anywhere.

Part of the timeless quality one feels when watching *Pakeezah* is that it seems to come from another era. By the time it was released, a new kind of movie, with a new kind of hero, was taking over. Despite the cultural changes wrought by independence and Partition, the 1950s and 1960s were a fairly stable time, presided over by Jawaharlal Nehru's principled leadership. That began to change in the early 1970s. The regime of Indira Gandhi, who took over as prime minister in 1966, was seen by many as becoming increasingly dictatorial and corrupt. Government officials routinely engaged in embezzlement and nepotism, filling their bank accounts with kickbacks from gangsters, while the honest, hardworking people became increasingly disenfranchised.

Enter Amitabh Bachchan. Throughout the 1970s and 1980s, Bachchan was the "angry young man" of Indian cinema, embodying the imagined vengeance of a cynical populace. Tall and gangly, he was an unconventional star, but in films like *Zanjeer* (Prakash Mehra, 1973), *Sholay* (Ramesh Sippy, 1975), and *Don* (Chandra Barot, 1978), he created a new genre of popular film, relying less on music and dance and more on action and violence. When Bachchan's character exacted the revenge the plots inevitably called for, it was bloody. *Zanjeer*, in which he plays a tough cop, was his breakthrough, but *Sholay* is the essential Bachchan landmark. A well-made action film, it has been dubbed a "curry western" because of its rugged outdoor scenery, revenge plot, and action scenes that include a thrilling train robbery. Bachchan plays a jailbird hired by a retired police officer to hunt down the bandits who killed the officer's family. He has great comedic instincts and a wealth of charisma. The sight of him bouncing through the countryside with his buddy, singing and clowning around on a motorcycle and sidecar, tempers his more violent outbursts.

In *Don*, Bachchan plays both a crime boss and the dimwitted look alike hired to impersonate him, in a campy 1970s milieu of kung fu and disco dancing. He also starred alongside Vinod Khanna and Rishi Kapoor in Manmohan Desai's

MEENA KUMARI IN *Pakeezah*

1977 carnival of Bollywood excess *Amar Akbar Anthony*. The trio play brothers separated at birth and raised Hindu, Muslim, and Christian who are eventually reunited via an over-the-top action-comedy plot.

Bachchan left acting for a while in the mid-1980s to enter politics, but after a few false starts trying to regain his (now aging) angry-young-man mantle, he has in the last decade settled into roles more suited to his age and, with his distinctive salt-and-pepper hair, mustache, and beard, remains as popular as ever.

RETURN TO SPLENDOR

The 1970s and 1980s weren't all about action. In 1981, for instance, Muzaffar Ali made *Umrao Jaan*. Based on a classic tale of star-crossed lovers in nineteenth-century Lucknow—which is evoked through traditional dance and melodious *ghazals* (poems, usually about love, set to music) sung by Lata Mangeshkar—it stars Rekha as the titular heroine, who is sold into prostitution, becomes a famous courtesan and poet, but can never marry the man she truly loves.

The 1990s saw the return of music and romance on a grand scale. Big production numbers made a comeback, but tailored to fit contemporary tastes, with soaring camerawork and an MTV influence apparent in the music and editing. Bollywood movies became the playground of a new batch of young stars, hunks like Shah Rukh Khan and Hrithik Roshan, starlets like Karisma Kapoor and Madhuri Dixit, all of them cast for their youth and good looks. The rules of engagement are strict when it comes to sex in Bollywood movies. Nudity is forbidden, and kissing scenes are considered so taboo that they rarely occur. An Indian lawyer named Shruti Singheven filed suit in 2007 against actress Aishwarya Rai and actor Hrithik Roshan over a kissing scene in the 2006 blockbuster *Dhoom 2* for "lowering the dignity of Indian women and encouraging obscenity among Indian youth." But

sensuality is far from absent. Eroticism is displayed in suggestive dances, wet saris (all of today's starlets end up in a lake, a downpour, or under a waterfall at some point), and skin gently grazing skin. Subhash Gai's many-splendored romance *Taal* (1999) is a perfect example of Bollywood's subtle yet intense eroticism. It makes two characters drinking from the same Coke bottle seem like the height of sexual bliss.

Old plots have been outfitted in new garb. Dance sequences, once filmed in the studio, are now shot against the natural wonders of Switzerland, Vancouver, or New Zealand. The 1995 megahit *Dilwale Dulhania Le Jayenge* (*DDLJ* for short), which has played for over ten straight years in Bombay, is among the best of the new breed. It takes an old story—boy (Shah Rukh Khan) meets girl (Kajol), but must win over her stern father before marrying her—and adds a contemporary twist. The boy is a nonresident Indian and, in effect, has to relearn how to be an Indian to impress his sweetheart's dad. It was one of the first films to use Switzerland as a location and features top-notch music and splendid visuals (a field of yellow flowers extending to the horizon is particularly striking). Shah Rukh and Kajol have starred together in a number of hits. Two of the most highly regarded were directed by Karan Johar. In *Kuch Kuch Hota Hai* (1998), they play college friends who later realize their love for one another. It won numerous Filmfare Awards in India and led to Johar's second blockbuster, the epic family drama

Kabhi Khushi Khabie Gham (2001), a tremendous hit both in India and overseas, whose all-star cast also included Amitabh Bachchan and Hrithik Roshan.

Love stories continue to be a staple of the Bollywood diet. *Devdas*, based on a famous Bengali novel by Sarat Chandra Chattopadyay, is now a four-times-told tale about a pair of star-crossed lovers. It first appeared as a silent movie in 1928, was remade with sound in 1935 by P. C. Barua, made again in 1955 by Bimal Roy, and finally became a blockbuster again in 2002 under the direction of Sanjay Leela Bhansali, whose version shimmers with color and light. At the time, it was the most expensive Bollywood production ever, and it shows. *Dil Chahta Hai* (Farhan Aktar, 2001) and *Mohabbatein* (Aditya Chopra, 2000), look at love among the young, hip, and urban. Rajiv Menon looked to Jane Austen's *Sense and Sensibility* for the plot of his buoyant *Kandukondain Kandukondain* (2000), a Tamil-language film with catchy music by A. R. Rahman, who specializes in memorable melodies.

This is all but the tip of the iceberg, a sampling of Bollywood's contemporary pleasures. The stories, the acting, and the lack of sex and violence may make these movies seem innocent, but innocent pleasures are sometimes the most fulfilling. And the return to splendor has also spread Bollywood's popularity beyond the diaspora. *Kabhi Khushi Khabie Gham* was a big hit in England, where significant parts of it were filmed. American critics are starting to be seduced by Bollywood movies as well. They write enthusiastically about them on the increasingly less rare occasions when they show up in theaters or on television. There's now a Bollywood On Demand cable channel in the United States. The biggest crossover hit thus far has been Ashutosh Gowariker's *Lagaan* (2001), a four-hour long crowd-pleaser set in the 1880s about villagers rebelling against the British-imposed land tax. One sign of its remarkable effectiveness is that it culminates in an hour-long cricket match and still held American audiences' attentions. It was nominated for the Oscar for Best Foreign Language Film.

THE OTHER SIDE OF BOLLYWOOD

Lately a number of directors have begun to tackle more serious subjects within the context of popular cinema. Until quite recently, movies were not considered a "manufacturing industry" by the Indian government, which made productions ineligible for bank loans, and it's always been an open

secret that much of the money flowing into Bollywood comes from organized crime. Movies provide an easy channel for laundering money, and exerting influence over productions gives gangsters a certain measure of prestige. In addition, the unfortunate rise of Hindu fundamentalism exploded in the 1993 terrorist bombings and Hindu-Muslim riots in Bombay. This led to violent rifts within the Bombay underworld between Hindu and Muslim crime lords who had once kept an uneasy peace. Film producers were targeted for assassination or kidnapping. Actor Sanjay Dutt, star of over a hundred Bollywood movies, has been entangled in legal trouble for allegedly being involved in the Bombay bombing plot.

Ram Gopal Varma's crime films bring the underworld to the big screen, often making explicit the link between gangsters and the movie industry. Far from the Swiss Alps or the beaches of New Zealand, his films revel in the teeming streets of Bombay, the jumbles of buildings and ramshackle shanties, but also the skyscrapers and seaside vistas that give his characters hope. The documentary-like street photography he uses in *Shiva* (1990), *Rangeela* (1995), and *Satya* (1998) reveals his love for the city, warts and all. *Satya* touches, through fiction, on all the harsh realities of the battle between the police and organized crime—the assassinations, the brutal interrogations—described by Suketu Mehta in his book *Maximum City: Bombay Lost and Found*. *Satya* and *Shiva* both show how poor, desperate young men are drawn into organized crime, and how crime lords exploit the endless supply of these men that come their way.

Bombay

Lalitha Gopalan, in her study of Indian action films, *Cinema of Interruptions*, relates that Varma claims to know every shot of *Sholay* and *The Godfather* by heart, and it shows in his skill at plotting and pacing his thrillers, which, in line with Bollywood convention, last nearly twice as long as American ones. His crowning achievement, *Company* (2002), is slick, perfectly paced, and engrossing. Ranging from Bombay to Hong Kong to Nairobi, it relates, in true-crime-epic form, the sundering of a powerful gang into two opposing organizations. And it reveals how Bombay's crime bosses operate.

Varma is something of a movie mogul, running a production company with a stable of young directors imitating his successful style. And between making thrillers, he also makes more lighthearted fare. *Rangeela*, *Mast* (1999), and *Naach* (2004) are all peeks into the Bollywood dream factory from the vantage point of aspiring stars and obsessed fans.

One of the most interesting directors working today in India is Tamil-language filmmaker Mani Ratnam. Ratnam also tackles important, controversial subjects with great emotional depth and visual flair. His *Bombay* (1995) addresses Hindu-Muslim tensions through the story of a Hindu man and a Muslim woman who marry and move to Bombay to escape the wrath of their respective families, only to find themselves caught up in the 1993 riots. The plot of 1998's *Dil Se*

concerns a radio journalist who becomes intrigued by and attracted to an interview subject who turns out to be a potential suicide bomber. Along with its serious themes, it includes an audacious musical number with dozens of dancers on top of a moving train. These films are two of the masterpieces of recent Indian popular cinema and, along with Varma's work, signal an encouraging trend in Bollywood toward engaging with the world through the language of popular cinema.

The 1993 bombings put terrorism in the minds of people all over India. Ratnam is not the only one to have addressed it on film. Vidhu Vinod Chopra's *1942: A Love Story* (1993) takes place during an earlier wave of religious and cultural strife, and his 2000 *Mission Kashmir* tells the story of the intertwined lives of a police officer trying to quell Muslim violence in Kashmir and an aspiring suicide bomber. In *Maximum City*, Mehta, who worked as a screenwriter on the film, relates, with some bemusement, the complicated balance Chopra had to strike between realizing his aim to make a serious movie (he is a great fan of

Water

LA Confidential) and the demands of the marketplace. If Chopra's seriousness is dampened by necessity (critics have joked about Hrithik Roshan as a "singing, dancing terrorist"), the result is nonetheless a well-made thriller that really does make an attempt at social commentary.

THE DIASPORA

There are many compromises forced on a director working in the Indian film industry. Censorship rules are strict, and audiences can turn violent if certain boundaries are overstepped. Riots broke out in reaction to Karan Razdan's 2004 film *Girlfriend*, about a lesbian relationship, but it also opened up a discussion about gays and lesbians in Indian society. And the calculated sensation it caused resulted in there being more lesbian-themed movies in the production pipeline.

Indian filmmakers working outside of India do not have to deal with censorship issues and are hence able to make films addressing aspects of Indian culture that their industry-bound compatriots may not. Toronto-based Deepa Mehta's 1996 film *Fire* also dealt with a lesbian relationship, but more pointedly talked about the general oppression of women at the hands of religious orthodoxy. It is the first in a trilogy of films that examine religious strife and the treatment of women in India. *Earth* (1998) follows the fates of several families of differing religions during the rise of violent religious intolerance after Partition. *Water* (2005) concerns the plight of widows under Hindu religious doctrine.

British funding allowed Shekhar Kapur to make the powerful *Bandit Queen* (1994), based on the true story of the folk heroine Phoolan Devi, a low-caste woman who was married at age eleven, raped by the police when she tried to escape her husband, and ran off to become the most notorious bandit in Northen India. Kapur does not spare the audience the brutality of Devi's life, and he had to battle Indian censors to have the film shown in India, but it was well-regarded around the world. Veteran filmmaker Shyam Benegal declared it possibly the best Indian film ever made.

Other filmmakers illuminate the diaspora experience itself. After making the international hit *Salaam Bombay!* (1988), a portrait of Bombay through the eyes of its street kids that mixed professional and nonprofessional actors, Mira Nair made the touching *Mississippi Masala* (1991), about an Indian family living

in Nigeria who are forced to relocate to the American south because of political unrest. The daughter strikes up a relationship with a local African-American man (played by Denzel Washington), bringing up her own family's prejudices and those of the locals as well. *Monsoon Wedding* (2001), by turns joyous and moving, is about the stresses within an upper-class New Delhi family before and during an arranged marriage ceremony linking their daughter to an NRI from Texas. Nair further explored the diaspora in *The Namesake* (2006). Based on a novel by Jhumpa Lahiri, it tells the story of an Indian family living in New York, and the family's adult son's struggle to balance his desire to adapt with his parents' traditional ways. If Deepa Mehta's films point out the failings of following orthodoxy to the point of sacrificing one's own humanity, Nair's celebrate the possibilities of countering intolerance with familial and romantic love.

Gurinder Chadha achieves similar aims with her films *Bhaji on the Beach* (1993), about a multigenerational group of Indian women living in England who go on holiday to a resort town, and the crowd-pleasing *Bend It Like Beckham* (2002), about an aspiring female teen soccer star growing up in a conservative Indian family in England.

INDIAN CINEMA: A TRUE MASALA

Bollywood extravaganzas, serious art films, and films by directors from the diaspora all give us views of India as varied as the country itself. Indeed, any one of these categories includes widely differing styles and visions. Tradition and modernity, fundamentalism and tolerance, perhaps struggle more intensely in India than in other places, and its cinema is as multifaceted as its continually evolving culture.

HONG KONG

THE FINE ART OF POPULAR CINEMA

HISTORICAL BACKGROUND

Separated from mainland China by the Shenzhen River, Hong Kong comprises Hong Kong Island, Kowloon Peninsula, Lantau Island, the New Territories, and some 260 more islands in the South China Sea. Its name, which means "fragrant harbor," comes from the many sweet-smelling trees that once grew in huge numbers on Hong Kong Island. The rocky, mountainous islands remained sparsely populated for centuries until the third century BC, when mainlanders under China's Qin and Han dynasties began to settle there in large numbers.

Western influence arrived with the Portuguese in 1555, but it was the British who came to dominate the area, declaring it a Crown Colony in 1843. In 1898, China officially leased Hong Kong to Britain for a period of ninety-nine years. Because of its prime location, its deep natural harbor, and demand in the West for various Chinese goods, Hong Kong became a thriving trading port. The city bloomed into an international crossroads, a center of finance and manufacturing, and a cultural melting pot with influences from China, Europe, and Southeast Asia. The 1949 Communist takeover of China sent many thousands of refugees to

Hong Kong, leading to a large jump in population. Over the ensuing years, Hong Kong Island became one of the densest urban centers in the world, a cosmopolitan city of soaring skyscrapers and big business, with a thriving film industry reflecting the city's fast-paced, competitive way of life.

Occupying a crossroads of international influences, Hong Kong's cinema became more cosmopolitan as it developed. The sleek, urban action films of the 1980s and 1990s by directors like John Woo resonate with audiences worldwide because they absorbed recognizable Hollywood tropes, mixed them with local elements such as martial arts fight choreography, and came up with something new.

In accordance with the 1898 lease, Hong Kong was handed over to China on July 1, 1997, and declared a Special Administrative Region of China. China announced a "One Country, Two Systems" policy, which would allow Hong Kong to maintain its autonomy, its cultural and economic freedom, for the following fifty years. (Of the many things that the number 2046 means in Wong Kar-wai's film of the same name, one is it symbolizes anxious speculation on what the end of that term may bring.)

THE KUNG FU-HIP-HOP CONNECTION
Hip-hop was born in the Bronx in the late 1970s, at a time when martial arts movies, broadcast on local television and shown in cheap movie theaters, were very popular among the urban youth who started the art form. The connection has continued ever since. Break-dancing routines incorporate poses inspired by kung fu moves, references to kung fu films pepper rap lyrics, and the rap group Wu-Tang Clan's entire persona is the result of its members' deep immersion in kung fu movie arcana. Hip-hop's democratic scavenger aesthetic samples material from many sources, but kung fu is one that's been there from the beginning.

Anxiety leading up to the 1997 handover was very real indeed. Businesspeople began to flee, causing a distressing drop in the economy. The film industry also declined from its 1980s glory days, as talented actors and directors looked to Hollywood or elsewhere for work in case 1997 brought an end to the artistic freedom they enjoyed.

China is keeping its promise for now, but the handover, along with the Asian financial crisis of the late 1990s and the 2003 SARS outbreak, wounded Hong Kong's economy, and the film industry along with it. Hong Kong filmmakers have had to broaden their approach, seeking out audiences on the mainland and

throughout East Asia via coproductions with other countries, with the result that the Hong Kong cinema has, of necessity, developed into a more pan-Asian aesthetic, perhaps losing some of its local flavor as it adapts to a changing world.

HOW HONG KONG MOVIES
BECAME HONG KONG MOVIES

Few regions' movies have infiltrated American popular culture as thoroughly as Hong Kong's have. They've been staples in theaters, on television, and on video since the 1970s, influencing everybody from Quentin Tarantino to the Wu Tang Clan. Action stars like Jackie Chan and Bruce Lee are household names, and many other Hong Kong talents have enjoyed Hollywood careers. Hong Kong–style choreographed fight scenes are now de rigueur in American TV shows and movies (the best of them designed by Hong Kong's most famous fight choreographer, Yuen Wo-ping, who is now as in demand in Hollywood as he ever was in Hong Kong). Our pop culture landscape is almost unimaginable without them. At their best, Hong Kong movies are reminiscent of the glory days of old Hollywood. They aim to please without pandering, and they are made with consummate skill. Until recently, Hong Kong directors were required to attend preview screenings of their movies before raucous crowds. If their film clicked, they were rewarded with applause. If not, the audience would shower them with boos and ridicule, sending them back to the cutting room to make improvements. Passing through this crucible trained Hong Kong directors to please their very film-literate and outspoken audiences.

So how did this massive entertainment machine—at one time the third-largest in the world, trailing only those of the United States and India—get started, and why do its products appeal to everyone from rap stars to film scholars?

In the early days, movies developed side by side in Shanghai and Hong Kong. American entrepreneur Benjamin Brodsky, one of several westerners hustling the new motion picture technology in China in the early twentieth century, had a hand in the first films made there, including a two-reel short feature, *Zhuangzi Tests His Wife* (1913), which was directed by Lai Man-wai, the man now known as "The Father of Hong Kong Cinema." Like many Shanghai and Hong Kong films of the day, *Zhuangzi* was based on a Chinese opera.

Chinese opera has a history dating back thousands of years. Of its many

forms, Peking (or Beijing) Opera and Cantonese Opera have most inspired filmmakers. Unlike Western opera, the Chinese version is a popular art, designed to appeal to a broad audience. Performances are vast spectacles, featuring singers, acrobats, and mimes in colorful masks, makeup, and costumes. Adaptations of operas and movies about opera performers have been popular throughout Hong Kong's cinema history. But the connection goes even deeper. The very aesthetic of Hong Kong cinema as we've come to know it, its blend of superb craftsmanship, tight plotting, and pure entertainment value, has its roots in the opera. In fact, many performers, including Jackie Chan, started out as opera performers, following a rigorous training regimen from early childhood in order to master the acrobatic feats for which the performances are famous.

Another popular genre since the early days has been the *wuxia pian*, and this too is a form of entertainment that goes way back. *Wuxia*, which can be translated as "martial arts chivalry," refers to the wandering warriors of Chinese history and legend; *pian* simply means "film." Analogous to the knights of medieval Europe, the *wuxia* heroes are expert swordsmen (and women) who live according to a strict code of honor and regularly perform daring deeds of heroism. Recorded tales of warriors and assassins exist from as far back as the second and third centuries BC, but the modern *wuxia* novel most likely came into being around the time of the Ming dynasty (1368–1644). These novels have always been popular and are still written, read, and adapted for the screen today. *Crouching Tiger, Hidden Dragon*, for instance, was based on an early twentieth-century *wuxia* novel by Wang Dulu.

Unfettered by the state controls that would stifle the artistic development of cinema on the mainland after the Communist takeover, Hong Kong cinema is essentially the modern descendant of these two ancient, highly evolved, and sophisticated entertainment traditions. The *wuxia* code of ethics can be found in the deeds of the hero, which are studded with fight sequences performed by stuntpeople whose show-business ancestors would have thrilled audiences with their acrobatic feats in the streets and teahouses of old Beijing centuries ago.

The early history of Hong Kong cinema is hard to trace, because few films survive from the prewar years. Ten years after *Zhuangzi Tests His Wife*, Lai Man-wai and his two brothers established the China Sun Motion Picture Company in Hong Kong, and in 1925 he made the first full-length Hong Kong feature, *Rouge*.

It was a big hit, but a general labor strike in Hong Kong and Guangzhou Province in the latter half of the 1920s forced Lai to move his operation to Shanghai.

The end of the general strike in 1930 and the advent of sound radically changed Hong Kong cinema. Spoken Chinese has many dialects. Mandarin is the official spoken language of China, but in the southern Guangdong Province and in Hong Kong, Cantonese is the common tongue. Mandarin and Cantonese speakers use the same written characters, but the spoken languages are completely different. When sound came along, Chinese producers realized the potential of the Cantonese market, and set up studios in Hong Kong to exploit it. The war with Japan, which broke out in 1937, also led to an influx of talent, as Shanghai film industry veterans fled to Hong Kong to escape the conflict. But when the Japanese took Hong Kong in 1941, they destroyed the film studios, and not a single film was produced in Hong Kong until the end of the war. After the war, as the nationalist Kuomintang Party battled the Communist Party for control of China, even more film industry veterans fled Shanghai for Hong Kong, turning it into the largest producer of both Mandarin- and Cantonese-language films.

In fact these became two parallel film industries. Mandarin films tended to be lavish productions targeted at the Chinese diaspora, from Hong Kong itself to Southeast Asia and Chinatowns all over Europe and the United States. The lower-budget Cantonese films, made mostly for the local market, catered to the tastes of ordinary working- and middle-class Hong Kong natives. These included domestic melodramas, and kung fu *wuxia pian* serials, such as the amazingly long-lived series of approximately one hundred films—stretching from 1949 to 1970—starring Kwan Tak-hing as the Chinese physician, martial arts master, and folk hero Wong Fei-hung. The ever-popular Wong was also played by Jackie Chan in *Drunken Master* (1978) and *The Legend of Drunken Master* (1994), and by Jet Li in *Once Upon a Time in China* (1991), as well as by other performers in movies and television shows.

By 1970, the Cantonese film industry had collapsed, following a long decline that began around 1960. One reason for this was a law passed by the British in 1963 that required all films be subtitled in English (some suspect this was so the British could keep an eye out for seditious content). Producers began including Chinese subtitles as well, so now both Cantonese and Mandarin speakers could enjoy the same movie. The low-budget Cantonese industry was ill-equipped

Legend of Drunken Master

for this change, but the much wealthier Mandarin industry was poised to take full advantage. And one company in particular took more advantage than anyone else.

NO BUSINESS LIKE SHAW BUSINESS

To any fan of Hong Kong cinema, the Shaw Brothers name has a special ring. Larger than life moguls in the old Hollywood mold, Run Run, Runme, and Runjie Shaw were colorful characters and ruthless businessmen. They started out in the movie business in Shanghai in the 1920s, then moved on to Hong Kong before the outbreak of the Sino-Japanese War, and eventually branched out to Singapore and Malaysia, setting up a distribution network throughout Southeast Asia. Seeing the rise of Mandarin cinema in Hong Kong in the late 1950s, the Shaws decided to take on the then-dominant studio, the Overseas Chinese Motion Picture and Investment Company (MP&GI). Run Run, the youngest brother, was dispatched to Hong Kong from company headquarters in Singapore, and set about building Shaw Movietown, a gigantic studio complex that housed thirty outdoor stages, a dozen indoor soundstages, state-of-the-art postproduction facilities, and even a dormitory for employees. At its height, Shaw Movietown employed some 1,200 people churning out movies twenty-four hours a day.

As Jeff Yang puts it in his book Once *Upon a Time in China,* "The stage was set for an era marked by remarkable acts of skullduggery, vengeance, and double- and triple-dealing." Dato Loke Wan Tho, head of MP&GI, wasn't about to go down without a fight. For the next several years, these rival studios poached stars, stole ideas, and basically did everything they could to sabotage each other's businesses. Run Run was not only a shrewd businessman but a great movie buff as well. Shaw Brothers movies boasted the greatest actors and actresses, the most gorgeous sets, and luscious Technicolor cinematography. When widescreen CinemaScope came along, the Shaw Brothers introduced their own version, ShawScope.

The Shaw Brothers Studios occupies that curious intersection of commerce, entertainment, and art that constitutes Hong Kong's popular film industry. Perhaps that intersection should be named after Run Run. Commerce was his highest goal. He regarded his directors, performers, and technicians as workers first and artists, if at all, second. But he knew that what brought in the money was quality. It's not

surprising that one of the Shaws' most marvelous films came about as the result of exactly the kind of skullduggery Yang alludes to.

In 1962, Run Run got wind that MP&GI was planning a big-budget, all-star screen adaptation of the famous Chinese legend known as "The Butterfly Lovers," a romantic tragedy in which a young woman disguises herself as a man in order to become a scholar, only to fall in love with a fellow scholar who is unaware of her true identity. When she finally does reveal herself, their marriage is forbidden, leading to Romeo and Juliet–like consequences.

Run Run rushed a version of his own into production, helmed by Li Hanxiang, one of the many talented directors in the Shaw Brothers stable. The result, a Chinese opera variation on the tale, called *The Love Eterne* (1963), became an instant classic, drawing record crowds who returned again and again. It conjures up a colorful artificial world where the performers perform using the stylized gestures of Chinese opera, and sing beautifully, accompanied by traditional Chinese instrumentation. It remains beloved today. When asked by *The New York Times* to participate in the paper's "Watching Movies" series of profiles, Ang Lee chose *The Love Eterne* and revealed that he still cries every time he sees it.

The Master of the Flying Guillotine

The fierce competition continued apace until, in a turn of events that would seem contrived even in a Shaw Brothers movie, MP&GI's head Dato Loke Wan Tho died in a plane crash in 1964. His studio regrouped as the Cathay Organization Hong Kong, but foundered without its leader. The Shaw Brothers Studio now reigned alone.

Anyone who grew up anywhere near a television set in the 1970s and 1980s has at least a glancing familiarity with the outlandish kung fu and *wuxia* films the Shaw Brothers specialized in. In the wake of Bruce Lee mania (see "From Bruce to Jackie," which follows), TV stations across the United States regularly filled weekend mornings and afternoons with the likes of *The 36th Chamber of Shaolin* (1978), *The Master of the Flying Guillotine* (1975), and *Five Fingers of Death* (1972). For people like Quentin Tarantino and the rap group Wu Tang Clan, these films have proven to be lifelong influences. Tarantino and Wu Tang mastermind The RZA both have encyclopedic knowledge of Shaw Brothers films and Hong Kong cinema in general, which they employed when RZA created the Shaw-influenced soundtracks for Tarantino's *Kill Bill* movies.

While there is a certain kitsch value to these movies, the fact is that the Shaw Brothers had a slew of talented directors on their payroll. Foremost among them is undoubtedly King Hu, whose films, made at a time when kung fu and *wuxia* pictures were being churned out by the dozen, have emerged as a cut above the rest. Long before Ang Lee's *Crouching Tiger* or Zhang Yimou's *Hero*, Hu added depth and grace to the *wuxia* genre.

In truth, Hu was in the Shaw stable for only a short time, but even though he was born in Beijing and spent most of his career in Taiwan, his work is indelibly associated with the Hong Kong aesthetic. Hu arrived in Hong Kong in 1949, fleeing the turmoil on the mainland, apparently with no inclination to go into filmmaking. He fell into a job as a set designer, then an actor, and finally, in 1958, he joined the Shaw Brothers studio as a budding director. He assisted Li Hanxiang on *The Love Eterne* and *The Story of Sue San* (1964), before writing and directing his first film, *Sons of the Good Earth* (1965), a war film set during the Japanese occupation.

His second film, *Come Drink with Me* (1966), established his credentials as a master of the *wuxia pian*. Based on a Peking Opera tale (Hu had loved the opera since childhood), it tells the story of a female warrior named Golden Swallow, played by the tremendously athletic, yet stone-faced Cheng Pei-pei, who, with the assistance of a mysterious drunken beggar, goes on a quest to rescue the governor's son from a band of kidnappers. Fast-paced and full of bloody swordplay, it made plenty of money for Hu and the Shaw Brothers.

Hu elected to leave the Shaws and set up shop in Taiwan. Working independently, he had greater artistic freedom, as well as Taiwan's ruggedly beautiful landscape as a backdrop. His next film, *Dragon Inn* (1967), echoed many of *Come Drink with Me*'s themes. In it, a heroic Ming dynasty–era swordsman comes to a rural tavern to rescue a group of children from the members of a secret government military faction. It has been read as an allegory about Chinese politics, but what makes it fascinating today is the advances Hu made in the *wuxia* genre. His fight scenes are deliberately jarring, with quick cutting supplementing the acrobatic action in a kind of visual sleight of hand. Film scholar David Bordwell, in his book *Planet Hong Kong*, notes that Hu "calls on constructive editing, which is supposed to lay out the action clearly, and then does all he can to sabotage it." By subverting the traditional rules of *wuxia* filmmaking, he grabs the audience's attention by keeping them off kilter.

He further deepened the *wuxia* genre with *A Touch of Zen* (1970). In addition to even more graceful fight scenes, among them the famous gravity-defying battle in a bamboo grove that concludes it, Hu mixes heroism with Buddhism, giving this film a greater cosmic depth than other *wuxia* pictures. Its craftsmanship, if not its spiritual dimension, was recognized by the Cannes Film Festival in 1975, where it won a special award for technical achievement. The films that followed, *The Fate of Lee Khan* (1973), *The Valiant Ones* (1975), and *Legend of the Mountain* (1979), to name just three, continued Hu's project of reinventing the *wuxia pian* by experimenting with fight scenes and bringing to their plots larger political and spiritual issues than had hitherto been addressed.

As Bordwell notes, "From 1966 to 1979, Hu was one of the finest directors working anywhere." His career petered out later, in part because of difficulties with financing, and in part because of the rise of a new wave of Hong Kong action auteurs who supplanted the *wuxia* genre with modern gangster films. He died in 1997, in the midst of trying to secure funding for a film about Chinese immigrants during the California Gold Rush.

FROM BRUCE TO JACKIE

No two names are as readily associated with Hong Kong cinema as Bruce Lee and Jackie Chan. Lee single-handedly kicked off the craze for kung fu movies in the United States, and Chan repopularized them in a whole new way. Because of them, whenever a fight breaks out in an American TV show or movie, the actors battle it out with kicks and leaps instead of mere fists. Each in their own way, these two pop culture icons embody what makes Hong Kong movies so appealing.

Bruce Lee was actually born in San Francisco, while his parents were on tour with a Chinese opera troupe. After they returned to Hong Kong, Lee became a child actor, starring in dozens of Cantonese films. He returned to California for college and, while there, made a living as a martial arts instructor and enjoyed some success as an actor, playing a recurring role in the TV series *The Green Hornet* and showing up here and there in minor movie roles. When the Hong Kong–based Golden Harvest movie studio offered him a two-picture deal, he returned to the East and starred in two blockbusters, *Fists of Fury* (a.k.a *The Big Boss*, 1971) and *The Chinese Connection* (a.k.a *Fist of Fury*, 1972). Their success enabled him to

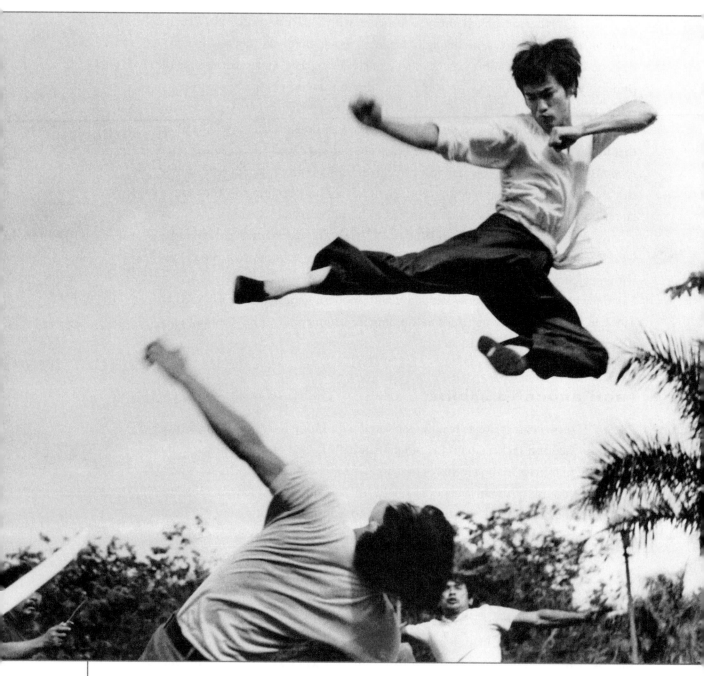

BRUCE LEE IN *The Chinese Connection*
(A.K.A *Fist of Fury*)

move into directing. First came *Return of the Dragon* (a.k.a *The Way of the Dragon*, 1973), in which he battles Mafiosi (and, finally, Chuck Norris) in Rome, followed by *Enter the Dragon* (1973), the film that made him a star in the United States, which finds him entering a kung fu contest sponsored by the nefarious drug dealer who has kidnapped his sister. Lee died suddenly and mysteriously on July 20, 1973, while working on *Game of Death*, at the young age of thirty-two.

And thus the legend was born. Lee died after falling into a coma in the apartment of a female friend. The consensus is that he died of a cerebral edema (swelling of the brain) brought on by a reaction to marijuana and a painkiller. Still, rumors of curses and conspiracies (no doubt helped along by the many people cashing in on his posthumous fame) have always surrounded Lee's untimely demise. They were given new juice when his actor son, Brandon Lee, also died young, while filming *The Crow* in 1994, as a result of an accident with a prop gun. But Bruce Lee's iconic status isn't due merely to the cynical exploitation of his name. His persona tapped into something in both Hong Kong and the United States. His self-invented fighting style, which he dubbed jeet kune do, or "art of the intercepting fist," was a synthesis of martial arts styles based on the philosophy that battles were fought, not according to choreographed rules, but to be won at any cost. He jettisoned the ritualized combat of earlier kung fu movies for aggressive, bare-knuckled brawling. This rebellious attitude meshed perfectly with the prevailing cultural mood of the early 1970s.

In his book *Hong Kong Cinema: The Extra Dimensions*, Stephen Teo suggests that Lee's appeal was different in the East and the West. In the Chinese diaspora, this fit, handsome fighter who battled racist enemies symbolized nationalist pride. Lee didn't need magic, like the *wuxia* heroes, to dispatch his foes. All he needed were his bare fists. In the United States, on the other hand, it was the charismatic narcissism of his screen presence that sold tickets. (Bordwell, in *Planet Hong Kong*, remarks that "the camera loved Lee only slightly more than he loved himself.") The reality is, as Teo notes, more complex. It wasn't just Lee's swaggering persona that struck a chord with Western audiences. Black and Latino youth identified just as strongly as Chinese audiences whenever he defeated the forces of bigotry in his films.

In the end, the plots of Lee's films hardly matter. He had barely developed as an artist before he died. To be sure, his name still retains an aura of 1970s kitsch. It readily brings to mind poorly dubbed "chop socky" flicks and the still

ubiquitous "Kung Fu Fighting" song. But his true legacy—aside from the many imitators and a posthumous body of features cobbled together from previously shot footage, biopics, and documentaries—is the enduring popularity of kung fu movies of all sorts.

And his legend lives on. Hong Kong erected a monument in his honor in 2005. In 2006, the Bosnian town of Mostar also built a monument to him (he's one figure the Serbs, Croats, and Muslims in that divided country all admire). In a very different form of tribute, China is building an amusement park in his honor, complete with a roller coaster that blasts his signature shrieks and screams at its turns and drops.

With Lee's sudden death, Hong Kong lost its biggest star, and the search was on for someone to fill his considerable shoes. The man who emerged to take his place was Jackie Chan. Chan is now, of course, a worldwide star, the public face of Hong Kong, who has gone on to conquer Hollywood with roles in films such as *Rush Hour* (1998) and *Shanghai Noon* (2000). In contrast to Lee's, Chan's beginnings were notably humble. Not only did he not go to college, he apparently never even learned to properly read and write. At age six he was sent by his family to live at the Chinese Opera Research Institute in Hong Kong, where he endured years of separation from his family and a grueling training regimen under instructors who were permitted to beat students severely for mistakes and infractions. Emerging from his training, Chan, like many other performers, found little work in the opera, but his tremendous skills in acrobatics and martial arts got him work in the film industry (he even worked as Bruce Lee's stunt double). He starred in a few run-of-the-mill kung fu flicks in the mid-1970s before hitting box office gold in two movies directed by Yuen Wo-ping: *Snake in Eagle's Shadow* and *Drunken Master* (both 1978), in which his trademark impish, happy-go-lucky persona first came to the fore. Bruce Lee included humor in his films, but for the

JACKIE CHAN IN *Police Story*

most part he remained steely eyed and dead serious, a superior fighter taking on legions of soon-to-be dispatched opponents. Humor is at the heart of Chan's films. Screwball comedy and physical prowess go hand in hand. He often plays a lovable underdog who just happens to have astonishing martial arts skills and the ability to perform jaw-dropping acrobatic feats.

Chan can turn any object, surface, or space into a jumping-off point for intricate, rapid-fire stunt sequences. In the documentary *Jackie Chan: My Stunts* (1999), he gives a tour of his studio, a warehouse filled with everyday objects from lamps to furniture to appliances to cars, where he and his team meticulously work out ways to turn them into props for Chan's athletic action scenes, paying particular attention to their comedic potential. He regularly breaks bones and suffers other injuries while performing his own stunts, which the blooper reels traditionally attached to the end of his movies display in painful detail. He gives his all for his art, in sometimes literally death-defying ways. In *Project A* (1982), he dangles, in an homage to silent film star Harold Lloyd's famous stunt, from the minute hand of a giant clock tower before plunging to the ground, buffered only by a couple of awnings. In *Police Story* (1985), he catches a ride on a hijacked bus by hooking onto the back of it with an umbrella. He nearly died on the set of *Armour of God* (1987) when he leapt from a wall, missed the tree that was supposed to break his fall, and landed on his head, sending a shard of bone into his brain. After removing it, doctors filled the hole in his skull with a plastic plug.

In the West, he's been compared to Hollywood's greatest physical screen performers, from Buster Keaton to Douglas Fairbanks, Jr., to Fred Astaire, and in many ways these comparisons are apt. Like them, he combines charisma with graceful athleticism. The joy of watching him comes from his effortless fusion of comedy and physical virtuosity. He's thrilling even when he's not indulging in life-threatening activities like sliding, at a 45-degree angle, down a 21-story building (*Who Am I?*, 1999). It's just as much fun to watch him skitter, barely keeping his balance, across an array of clay bowls while his kung fu teacher takes swipes at his legs with a pole in *Fearless Hyena* (1979), contorting his way through a maze of playground equipment while simultaneously battling bad guys in *Police Story 2* (1988), or defeating an opponent using the "eight drunken fairies" technique in *Drunken Master.*

Beginning with *Fearless Hyena*, his first film as a director, Chan turned himself into a one-man industry, which now includes an American animated

television series and stints as the public face of the Hong Kong Tourism Board and as a UNICEF International Goodwill Ambassador. As he developed as a director, he increasingly integrated his action scenes more seamlessly into the plots of his films while at the same time refining his onscreen persona from the trickster fool of the early films to the regular guy/hero of the *Police Story* and *Project A* movies and the many that followed. These plots often seem at once paper thin and overcrowded with incident, serving primarily as skeletons to be fleshed out with stunts and gags. He also became increasingly global as he went along, filming *Armour of God* in Eastern Europe; *Operation Condor* (1991) on locations in Asia, Europe, and Africa; *Rumble in the Bronx* (1995) in, well, Vancouver; and *First Strike* (1996) in Russia and Australia, just to name a few.

Even as he dominated the Hong Kong film industry, Chan remained for a long time a cult figure in the West. *Rumble in the Bronx*, his first attempt to conquer the American market, failed to make much of an impression beyond the circle of kung fu film junkies. It was only by teaming up with Chris Tucker for *Rush Hour* that he finally became a mainstream star in the United States, which led to the formulaic strategy of casting him beside American comic actors: Tucker again in *Rush Hour 2* and *3* (2001 and 2007), Owen Wilson in *Shanghai Noon* and *Shanghai Nights* (2003), and Jennifer Love Hewitt in *The Tuxedo* (2002). As busy as ever, Chan continues to work simultaneously in Hong Kong, mainland China, and Hollywood.

THE NEW WAVE

Until the 1990s, Hong Kong cinema was, for Americans, synonymous with kung fu and martial arts. But there has always been more to Hong Kong movies than that. During the 1970s, for instance, the Hui brothers—Michael, Ricky, and Sam—delighted local audiences with a string of slapstick comedies, among them 1974's *Games Gamblers Play*, *The Private Eyes* (1976), and *Security Unlimited* (1981). Michael Hui, who directed their movies, is also credited with virtually single-handedly resurrecting the Cantonese film industry. A former employee of the Shaw Brothers, Hui moved on to the Golden Harvest studios to make *Games Gamblers Play* in Cantonese, which immediately became a box office smash and paved the way for the likes of Stephen Chow (best known for 2004's *Kung Fu Hustle*), whose early films are a genre unto themselves,

relying on nonsensical Cantonese wordplay. (Translating them into English would be like trying to render the rapid-fire punning of the Marx Brothers into another language.)

In the late 1970s, while the Hui brothers were making their mark, a new breed of directors was also emerging. Cosmopolitan, educated in art and film schools, and often coming to film from television work (where experimentation and low-budget ingenuity were valued traits), these filmmakers, including Tsui Hark, Ann Hui, and John Woo, brought a new, worldly sophistication to Hong Kong's staple genres and instigated a few of their own. More important, they managed to create a personal, auteurist cinema within the impersonal, machinelike Hong Kong film industry.

The hindsight consensus is that the new wave began in 1979 with the release of Tsui Hark's *The Butterfly Murders*. Tsui, who was born in Vietnam, grew up an avid film fan, making 8 mm shorts when he was a kid and graduating from film school at Southern Methodist University in Texas. *The Butterfly Murders* blends the *wuxia* genre with a murder mystery plot and touches of Hitchockian horror thanks to a swarm of bloodsucking butterflies. That same year, Ann Hui, who had studied film in London and worked briefly as an assistant to King Hu, released *The Secret*, a multilayered murder mystery about hauntings and madness. Hui established one of the hallmarks of the new wave by setting her film amid the bustle, confusion, and dueling cultural influences of contemporary Hong Kong, for which the mysterious relationship between the victim, her murderer, and her surviving friends serves as a synecdoche.

As their careers took off, Tsui, Hui, and other new wavers like Allen Fong, Yim Ho, Ringo Lam, and Ronny Yu divided their time between depicting the reality of modern Hong Kong through crime thrillers and the like, reinventing tried-and-true martial arts genre formulas, and branching off into more personal realms. Hui explored immigration and the Asian diaspora in films such as *The Boat People* (1982), which many consider her masterpiece, and *Song of the Exile* (1990) while simultaneously working in horror, action, and fantasy genres with films like *The Spooky Bunch* (1980) and *Romance of Book and Sword* (1990). She eventually moved into delicately nuanced films about personal relationships, among them *Summer Snow* (1995), *Eighteen Springs* (1997), and 2001's *July Rhapsody*, which was released the same year as her return to horror, *Visible Secret*, a film whose posters were so disturbing they were removed from the Hong Kong subway.

Tsui Hark's films are all about energy, velocity, and pushing the envelope of whatever genre he's tinkering with. In this, they are quintessential Hong Kong. *Zu: Warriors from the Magic Mountain* (1983) whips deliriously between slapstick comedy and *wuxia* action while employing state-of-the-art Hollywood special effects and a plot involving magical swords and evil demons. *Peking Opera Blues* (1986) is at once about Chinese aesthetics, politics (it's set during the democratic revolution of 1913), and role-playing in life and on the stage. Its overstuffed plot is carried along by brilliantly choreographed action scenes edited for maximum impact. The hyperactivity of Tsui's films is balanced by his feel for rhythm and movement, which keeps his fight scenes from seeming gratuitous or clumsy. Instead, they heighten the exhilarating quality of his films. Even in his less manic movies like *Once Upon a Time in China* (1991), which gave action star Jet Li his start, he amps up classic kung fu fighting with new levels of energy until it verges on the absurd. After working steadily through the boom years of the 1980s and early 1990s, Tsui spent some time in Hollywood, making two Jean-Claude Van Damme vehicles, *Double Team* (1997) and *Knock Off* (1998), before returning to Hong Kong to make *Time and Tide* (2000), a return to form that makes exquisite use of Hollywood-style special effects (at one point the film nearly comes to a halt to explore all the details of an explosion frozen in time, through the magic of CGI—computer generated imagery.)

The energy of Tsui's films is a reflection of his own restlessness. In addition to directing, he runs his own production company to make films by other directors in the Tsui Hark mold. One of the beneficiaries of his business acumen was John Woo, whose films introduced the Hong Kong new wave to America. Tsui produced Woo's *A Better Tomorrow* (1986), which announced at full volume Woo's now-ubiquitous action aesthetic. David Bordwell notes in *Planet Hong Kong* that many new-wave directors worked in the gangster genre because its simple rules of good

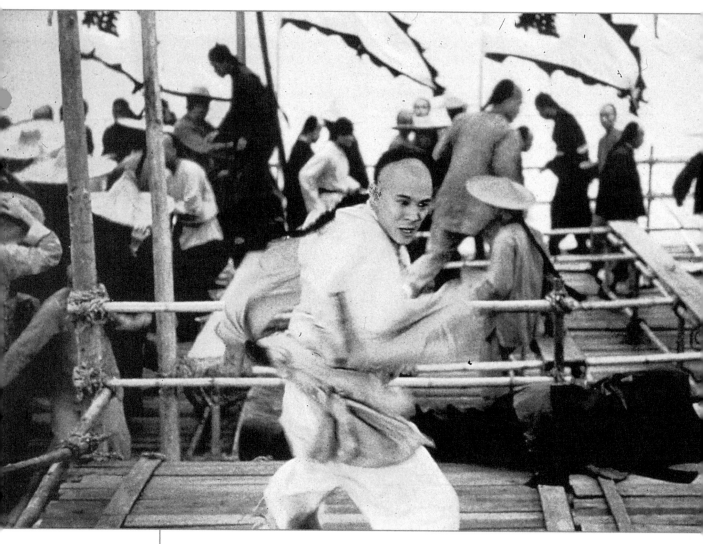

guys versus bad guys gave them plenty of room for stylistic experimentation. Woo's films are parables about loyalty, brotherhood, and the fine line between good and evil, told with high body counts, plenty of blood, and lots and lots of bullets. His aesthetic is almost the antithesis of Tsui's. His action scenes are less manic than balletic, alternating bursts of activity with tense standoffs and slow-motion sequences that fetishize guns and ammo. His plots are elegant in their simplicity: a gangster wants to pull off one last job before retiring, or take revenge on comrades

who betrayed him. Just as Woo slows down the action to ponder the beauty of pure movement, he slows down his stories to savor the relationships between his characters. But he also knows how to design his action scenes for maximum shock and awe, as when, in 1992's *Hard Boiled*, Chow Yun-fat shoots his way out of a hospital while cradling a baby in one arm and blasting away at a legion of attackers with the other.

The surfaces of Woo's films are colorful and cool, and the best ones star the unflappably cool Chow Yun-fat. When Hollywood action films relied on muscle-bound, monosyllabic stars Arnold Schwarzenegger and Sylvester Stallone, Woo's had a star whose suave charisma approached that of Cary Grant. Chow, in a minor part, stole *A Better Tomorrow* with his slick charm and ability to shoot down bad guys while stylishly decked out in a trench coat, and the films that followed featured him ever more prominently. *The Killer* (1989), perhaps the apogee of Woo's Hong Kong career, had a successful run in the United States and opened the floodgates for a slew of other Hong Kong gangster films. Chow plays a hit man who accidentally blinds a nightclub singer and vows to do one final job so he can pay for the surgery to recover her sight. He is chased by a cop who realizes that they have more in common than not. Woo treats this almost cliché plot with such gravity, and pulls it off with such style, that it has the weight of tragedy.

Just as Jackie Chan and Bruce Lee's movies made kung fu a requirement in Hollywood action movies, the films of Woo and other new-wave action directors made poetic bloodshed a must. The influence shows in the slow-motion cascade of empty shells from a trench-coated Keanu Reeves's machine guns in *The Matrix*, for example. Woo has also had a relatively successful Hollywood career himself, bringing his recognizable touch to such films as *Broken Arrow* (1996), *Mission Impossible 2* (2000), and *Windtalkers* (2002).

Hui, Tsui, and Woo by no means constitute the entire new wave, merely some of its most visible players. During the boom years of the 1980s and 1990s, exciting films were contantly reinvigorating old genres and reinterpreting the Hollywood action formula. But it wasn't all about action. One of the most respected directors to come out of the new-wave years was Stanley Kwan, crafter of elegant dramas like *Rouge* (1987), about the ghost of a 1930s courtesan searching for unrequited love in contemporary Hong Kong, and *Center Stage* (a.k.a *The Actress*, 1992), a compelling mix of documentary interviews and dramatic reenactments of the tragic life of the 1930s movie star Ruan Lingyu.

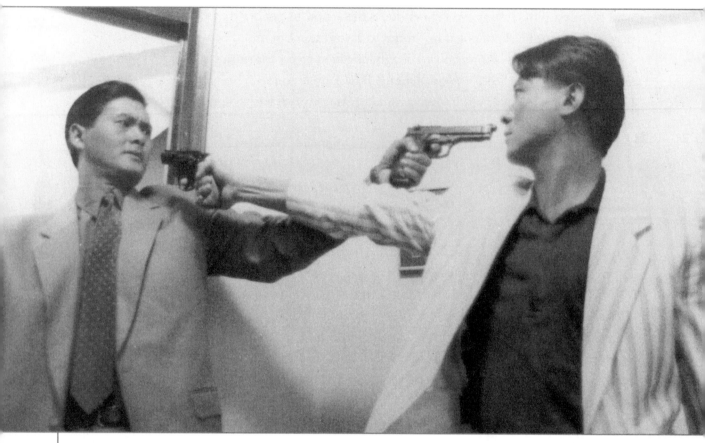

CHOW YUN-FAT WITH DANNY LEE
IN *The Killer*

Later, Kwan turned to the present and his own life with films like *Yang ± Yin: Gender in Chinese Cinema* (1996), a documentary about cinematic sexuality in which he revealed his own homosexuality, and *Lan Yu*, (2001), a drama about a gay relationship. He returned to the mists of history for his 2005 *Everlasting Regret*, which covers several decades in the life of an ambitious actress in Shanghai, from the glamor of the 1930s to the privations of the 1980s.

A MAN APART: WONG KAR-WAI

Right now there is only one Hong Kong director regularly mentioned alongside other masters of our time such as Taiwan's Hou Hsiao-hsien and Iran's Abbas Kiarostami, even as his style differs greatly from theirs.

Innovative and stylish, Wong Kar-wai's films straddle the line between art and popular cinema, and they inspire downright infatuation from his fans. Influenced by Jean-Luc Godard and the other French new-wave directors, along with such photographers as Robert Frank and Henri Cartier-Bresson, Wong has a distinct visual panache. His films are soaked in neon colors, full of slow motion and other subtle effects, and make brilliant use of experimental narrative structures. His first two films—the gangster romance *As Tears Go By* (1988) and *Days of Being Wild* (1991), which stars Leslie Cheung as a brooding rake pitting two women against each other for his affections—earned praise and awards with their seductive atmosphere and moody stylishness. He followed their success with *Ashes of Time* (1994), an ambitious, existential martial-arts epic, featuring interwoven multiple voice-overs, oddly introverted heroes, and fight scenes staged in the vast desolation of the Gobi Desert.

The making of *Ashes* was fraught with troubles, and ultimately took more than two years, during which, amazingly enough, Wong made a whole other film, *Chungking Express* (1994), which launched his international reputation into an orbit it has yet to leave. It also established a working method for him that he has refined with increasingly interesting results. *Chungking* was filmed essentially without a script. Composed of two linked stories, it was shot on the fly, mostly at night, with Wong supplying his actors with dialogue as they went along. It feels at

Chungking Express

once freewheeling and controlled. In the first story, a cop, realizing his girlfriend has left him, strikes up an acquaintance with a mysterious woman in a blonde wig. In the other, another cop falls for a quirky woman who works behind the counter of a fast-food joint he frequents. It all seems inconsequential, but the desire is in the details. *Chungking* pulses with longing, and its evocation of nighttime Hong Kong, thanks in part to the extraordinary cinematography of Christopher Doyle, is revelatory. It's the kind of movie that inspires obsession. One of its most enthusiastic admirers, Quentin Tarantino, made it the first release for his boutique distribution company, Rolling Thunder.

A storyline intended to be part of *Chungking* became the backbone of 1995's *Fallen Angels*, another fractured tale of neon-soaked romance. Wong's next film, *Happy Together* (1997), was a departure, depicting the tumultuous, at times violent, relationship between a gay couple from Hong Kong living in exile in Argentina.

IN THE MOOD FOR LOVE • All of Wong Kar-wai's films inspire devotion, but nothing like the cultlike devotion his 2000 breakthrough *In the Mood for Love* evokes. Its story is slight, but ambiguous enough to inspire endless speculation, and its atmosphere of saturated colors and suppressed lust is an ocean of melancholy big enough to drown in. In an earlier era, a movie like this might have played in out-of-the-way movie houses for years on end, but in the DVD era, fans can cozy up to it any time they want in the privacy of their own homes.

Wong's improvisational working method—sometimes the actors don't know what they'll be doing from day to day—combined with his gift for lush atmosphere and affinity for spare plots based on repetition and coincidence, came together to create something magical with his 2000 *In the Mood for Love*, one of the few movies that is almost universally adored. Set in a dreamlike early 1960s Hong Kong, it benefits from the charisma of its stars, Tony Leung and Maggie Cheung, who play neighbors whose philandering spouses cause them to come together themselves. An elegant tale of doomed love, it won awards at several festivals, including Cannes and Hong Kong, and became an international art-house hit.

It took him four years to follow up on *In the Mood*. When he did, he created *2046*, an ambitious, experimental piece of narrative cinema that works as a series of beautifully modulated, hauntingly romantic variations on *In the Mood*'s themes. The number 2046 represents many things, among them, the hotel room

ZHANG ZIYI AND TONY LEUNG
IN *2046*

where Tony Leung spends his time writing, the year before Hong Kong officially loses its autonomy to China, and a place in the future where people can go to forget their memories. It is a lush fantasia, a wash of color and visual spectacle in which narrative strands emerge and disappear—the epitome of Wong's experimentation with cinematic form. Wong has called it a retrospective of his work, containing hidden references to his previous films that enrich it even more.

Lately, Wong has moved beyond Hong Kong, making a road movie, *My Blueberry Nights* (2007), in America with an all-star cast that includes Jude Law, Norah Jones, and Natalie Portman.

POST 1997

The 1997 handover of the island from Britain to China had a severe impact on Hong Kong's film industry. On the one hand, many big talents, among them Jackie Chan, Tsui Hark, John Woo, Jet Li, and Chow Yun-fat, fled to Hollywood in case China failed to keep its promise to let business continue as usual. On the other, reuniting with China meant that the industry's movies could be produced more cheaply on the mainland, which is exactly what happened. Hong Kong cinema suffered an identity crisis to go along with the financial one. The heyday of the 1980s and early 1990s, when Hong Kong directors were regularly topping their Hollywood counterparts with freewheeling entertainments packed with action and innovation, was long gone. The landscape of Hong Kong cinema today has fewer hard-hitting action movies and more melodramas, romantic comedies, and standard-issue ghost stories, partly in order to appeal to the huge, newly available market on the mainland, where censorship is more strict.

But Hong Kong continues to produce good movies. Samson Chiu's 2002 *Golden Chicken*, for instance, is a comedy, overstuffed with garish period detail, tracing the recent history of Hong Kong through the eyes of a prostitute (played with pizzazz by Sandra Ng). Corey Yuen's *So Close* (2002) is a sleek take on the global girls-kicking-ass trend, starring Karen Mok as a cop on the trail of a pair of sexy assassins played by Shu Qi and Zhao Wei. *Infernal Affairs* (2002), by the directing team of Andrew Lau and Alan Mak, rejuvenated the gangster saga with an ingenious premise—a cop who's spent years undercover as a gang member faces off with a gang member who's spent the same amount of time impersonating a cop— along with compelling performances from stars Tony Leung and Andy Lau (not to

So Close

be confused with director Andrew Lau). It was reworked into *The Departed*, a star-studded affair directed by Martin Scorsese that won the Oscar for Best Picture in 2007. Slapstick master Stephen Chow, formerly the star of Cantonese "nonsense comedies," has turned himself into a worldwide phenomenon with *Shaolin Soccer* (2001) and *Kung Fu Hustle* (2004), which mix together CGI effects and Chow's Buster Keatonesque stone-faced acrobatics into daft comedies that resemble a deranged blend of Bugs Bunny, Jerry Lewis, and Bruce Lee.

The astonishingly prolific Johnny To, who has been active as a director since 1980, has become a film industry unto himself, specializing in impeccably constructed action movies. Films like *The Mission* (1999) and *Fulltime Killer* (2001) grow from the same thematic root as John Woo's earlier efforts, using the gangster film to explore issues of loyalty and betrayal. Others, like *PTU* (2003)

THE DEPARTED • When it was released, Andrew Lau and Alan Mak's 2002 thriller *Infernal Affairs* was hailed as an original twist on the Hong Kong action formula. Its premise—a cop and a gangster spend years undercover in each other's organizations—is the perfect seed for a compelling crime drama. Perhaps this is what Martin Scorsese saw when he agreed to direct the American remake. There are key differences between his version, *The Departed*, and the original, but both are great movies in their own right. What is more significant, the remake represents a phenomenon coming full circle. Where Hong Kong filmmakers used to take Hollywood ideas and give them their own original spin, now the opposite is happening. And it looks as if the trend will continue. The American remake rights to Lau and Mak's 2006 film *Confession of Pain* have already been sold.

and 2004's *Breaking News* (which opens with an eight-minute long Steadicam shot that ranks with the opening shots of Orson Welles's *Touch of Evil* and Robert Altman's *The Player* for sheer artistic audacity), push the genre into comedy and social satire. The highly regarded *Election* (2005) and its 2006 sequel *Triad Election* mix action with comedy and political commentary. To also collaborates with younger directors, most often Wai Ka-fai, to branch out into lighter but no less well-crafted fare, such as *My Left Eye Sees Ghosts*, *Turn Left, Turn Right*, and *Running on Karma* (all 2003).

As on the mainland, an independent movement has grown up over the past few years. Its most notorious exponent is Fruit Chan. The inverse of those of Hong Kong's mainstream industry, Chan's films are gritty, filled with pitch black humor, and sometimes quite obscene. His handover trilogy, *Made in Hong Kong* (1997), *The Longest Summer* (1998), and *Little Cheung* (2000), looks at the anxiety surrounding the 1997 handover from the point of view of the bottom of society,

a dangerous world of gangs, abused kids, and disaffected veterans of the Chinese army. He followed this award-winning trilogy with two films about Hong Kong's sex industry, *Durian Durian* (2000) and *Hollywood Hong Kong* (2001), which are as disturbing as they are sensitive to the plight of the sex workers they depict. Chan next made *Public Toilet* (2002), a globe-trotting, improvised narrative shot on digital video that takes place, for the most part, in public bathrooms ranging from Beijing to Hong Kong to Seoul to India and New York. At times nauseating, it is at heart quite moving, concerning, as it does, a group of characters in search of cures both metaphysical and medical. Never have the bodily and the spiritual been linked on film in such an oddly powerful way. Similary twisted, but also concerned with the pursuit of longevity, is *Dumplings* (2004), a feature-length version of a short he made, as part of a pan-Asian horror omnibus called *Three . . . Extremes*, in which a woman makes special health-promoting dumplings with a secret ingredient: human fetuses.

Hong Kong cinema is in a profound period of adjustment. With the gradual opening of China to foreign business, East Asia has become a land of coproductions, with Taiwan, China, Hong Kong, Japan, and Korea regularly collaborating on big-budget films. Peter Chan's lavish 2005 musical extravaganza *Perhaps Love* is set on the mainland and features production numbers designed by Bollywood choreographer Farah Khan. New-wave veterans Tsui Hark and Ann Hui have of late taken a similar route. Tsui's *Seven Swords* (2005), a China/Hong Kong/Korea coproduction, marks his return to large-scale martial arts territory; set in Shanghai and made in the Mandarin language, Hui's *The Postmodern Life of My Aunt* (2006) mixes whimsy and melancholy to tell the story of a middle-aged woman from the provinces trying to negotiate city life, and contains a hilarious cameo by Chow Yun-fat, making fun of his own charming image.

Hong Kong is still finding its place on the new map of East Asia. Once identified almost entirely with martial arts and action movies, its film industry has, of necessity, become broader in its offerings, even if it has lost some of its unique identity.

RISING FROM THE ASHES OF HISTORY

HISTORICAL BACKGROUND

A small peninsula suspended between China and Japan, Korea's history is bound up with influences—not to mention invasion and subjugation—from both of those nations. Thus, no discussion of Korea would be complete without a look at the concept of "han," often claimed to be at the same time untranslatable and the key for understanding the Korean way of life (although many younger Koreans regard it as an outdated notion). Scholar Suh Nam-dong calls it a "feeling of unresolved resentment against injustices suffered, a sense of helplessness because of the overwhelming odds against one" resulting from centuries of tyrannical rule, and transferred on a personal level to a deep, abiding sadness. Han is, perhaps, the reason for Korean cinema's long history of tragic, melodramatic works.

Japan's 1592 invasion of the peninsula was the beginning of centuries of strife between the two nations, and of a lingering bitterness that has only just begun to abate. Centuries later, after Korea had closed its borders and become known as the "Hermit Kingdom," Japan invaded again and annexed it in 1910. During the

occupation, Japan made every attempt to stamp out Korean culture, outlawing the Korean language and forcing Koreans to take Japanese names. During World War II, many were conscripted into forced labor, including the thousands of "comfort women," who were forced to service Japanese soldiers as prostitutes.

Japan was forced to withdraw after World War II, and the Korean peninsula, which was regarded as strategically important by both the Soviet Union and the United States, was divided along the 38th parallel into USSR-backed North Korea and U.S.-occupied South Korea. In 1950, the North Korean army streamed across the border, igniting the Korean War, the most traumatic event in a horribly traumatic twentieth century for Korea. Seoul, which changed hands four times during the war, was flattened, the landscape and infrastructure were devastated, millions lost their lives, and millions more were left homeless. By the end, the country was split at almost exactly the same place it had been at the beginning, and became two hostile nations divided by the demilitarized zone (DMZ) established just north of the 38th parallel.

Because of the destruction caused by the Korean War, much of Korean film history is lost, but tantalizing pieces occasionally turn up. A recently discovered batch of films made during the Japanese occupation give a peek into Korean society at the time, while revealing a strong Japanese influence both in technique and at times in propagandistic subject matter.

Between 1961 and 1988, the South was ruled by military dictators. It was under one of these, Chun Doo-hwan, that thousands of Koreans were killed or injured when a 1980 student protest was brutally suppressed in what has become known as the Gwangju Massacre, a major turning point in the democratization of Korea.

South Korea continued to modernize (at such a rapid rate that its rise has been deemed the "Korean Economic Miracle") and open up under Chun's democratically elected successors, and even to make gestures toward reconciliation with the North.

South Korea today is a completely modern economic and cultural power, having adapted to and embraced technology in ways most other nations haven't. Seoul is the most wired city on earth, and Korean pop culture, in the form of movies, music, and television shows, has swept East Asia (even Japan), in what has become known as *hallyu*, or the "Korean Wave."

THE BEGINNINGS OF KOREAN CINEMA

While films were shown in Korea possibly as early as 1903, the first Korean film was made in 1919, under the Japanese occupation. Most of the films made before the Korean War are believed to have been destroyed. As of this writing, fewer than twenty are known to survive (though new discoveries keep popping up), including the earliest known surviving Korean film, Yang Joo-nam's 1936 *Sweet Dream*. However, thanks largely to the efforts of the Korean Film Council, the Korean Film Archive, and the Pusan International Film Festival, films from the early days are being rediscovered, preserved, shown throughout the world, and occasionally released on DVD.

The first Korean film, *The Righteous Revenge* (1919), was a "kino-drama," in which actors performed in front of projected images. In 1923, the first Korean silent film was produced, and production companies began to crop up. The most famous director of this era was Na Un-kyu, who, at only twenty-five years old, directed, produced, and starred in *Arirang* (1926). A bold statement against the Japanese occupation, it took its title from a folk song that would become the anthem of the Korean resistance, and depicted a man driven mad by torture at the hands of the Japanese authorities. It inspired others to make similar cinematic calls for independence, which led to stricter censorship from the Japanese authorities, who by 1930 were approving only films with safe subjects, such as melodramas, costume dramas, and pro-Japanese propaganda. Films that didn't meet their strict criteria were banned and destroyed. Korea's first sound feature was made during this period with financing from the Japanese government. *Ch'unhyang-jun* (1935) was based on a famous folktale—a sort of Korean *Romeo and Juliet*—which has since been put on film more than a dozen times, most recently by the contemporary master Im Kwon-taek, whose version, entitled *Chunhyang* (2000), became an art-house hit in the United States.

When Japan invaded China in 1937, the Korean film industry was converted wholesale into a pro-Japanese propaganda machine, and in 1942 Korean-language films were banned entirely from being produced.

Of the handful of films known to have survived from the period between 1945 and the end of the Korean War (1953), two provide a window into the truncated period of hope that followed the end of the Japanese occupation. Choi Un-gyu's populist hit *Chayu Manse!* (*Hurrah! Freedom*, 1946) celebrated Korean

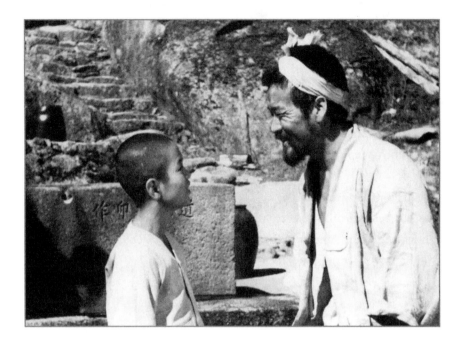

patriotism with a strong anti-Japanese message. On the other hand, Yoon Yong-kyu's lovely *A Hometown in Heart* (1948), a delicate drama about a mischievous orphan, a monk, and a widowed young mother set in a Buddhist temple high in the mountains, now feels like the calm before the storm. It's hard to look at the film's serene landscapes without thinking about the destruction that would follow two years later.

THE GOLDEN AGE

The war completely destroyed Korea's film industry. In an attempt to revive it, the president of South Korea, Rhee Syngman, declared cinema exempt from all taxes. This incentive, combined with foreign aid programs that brought in much-needed technology and equipment, stimulated a rebirth of cinema in South Korea in the 1950s. Many of the early films were genre staples: action movies and melodramas for the most part, but they built an audience for homegrown cinema.

The early 1960s saw the emergence of several talented and original auteurs. Heavily influenced by the Italian neorealist movement, which emerged out of

similar conditions in post–World War II Italy, a number of Korean directors began to examine their own country's struggle to recover and modernize. Yu Hyon-mok's 1961 *Aimless Bullet* paints a stark portrait of Seoul's postwar industrialization as seen from the point of view of a family struggling to make ends meet. His 1963 *Daughters of Pharmacist Kim* tells the story of four sisters whose very different ways of adapting to the modern world are at odds with their tradition-obsessed, widowed father. Another significant film from this period is *The Coachman* (Kang Dae-jin, 1961), which won the Silver Bear at the 1961 Berlin International Film Festival. It was the first Korean film to win a major award overseas. Similar in theme to Yu's *Daughters*, it is a portrait of another elderly widower whose very profession is becoming obsolete and whose grown children are also grappling with the rapid changes in Korean society.

Aimless Bullet

Thanks to the efforts of the Korean Film Archive and the Pusan International Film Festival, which annually presents restored films in its Korean Retrospective program, many important directors from the classic era are receiving a new round of appreciation. The differing styles and concerns of three of them provide a tantalizing window into this fertile period of Korean cinema.

The versatile, prolific, and astonishingly talented Lee Man-hee directed some fifty films between 1961 and his death, at age forty-five, in 1975, of cirrhosis of the liver. (After coughing up blood and collapsing while editing his final film, he begged his doctors to keep him alive just long enough to finish it.) In Korea he is probably best remembered for patriotic war movies like *The Marines Who Didn't Come Home* (1963), a valorization of those who fought the Korean War, and *0400-1950* (1972), which is named for the morning North Korean troops streamed across the 38th parallel. But Lee, with his unerring feel for film language, could work well in any genre. His gothic horror movie *The Devil's Stairway* (1964) is a Hitchcockian brew of betrayal, murder, and paranoia about a doctor who turns to killing to solve his romantic entanglements and is driven mad by the consequences. His gangster films *Black Hair* (1964) and *Starting Point* (1967) revel in film-noir atmosphere and bracing plotting. He is often at his best at his most eccentric: the fable-like *Water Mill* (1966), a startling vision of nature at its most tumultuous and human emotions at their most extreme, depicts jealousy and superstition in

a small village when a stranger comes to town and falls for a local widow. His last film, *A Way to Sampo* (1975), can best be described as a ribald road movie, equal parts Samuel Beckett and Abbott and Costello.

Kim Ki-young is one of the great eccentrics of world cinema. Nicknamed "Mr. Monster" for his floridly melodramatic, deliriously grotesque films, he occupies a place in the pantheon of Korean directors analogous to that of Samuel Fuller or Nicholas Ray in the United States. Like them, his intensely personal, out-of-left-field sensibility inspires cultlike devotion from his fans. His films seem to flow directly from the darkest reaches of his subconscious, unencumbered by the conventions of good taste or traditional narrative structure. Babies are devoured by rats; the bones of a two-thousand-year-old Mongolian virgin rattle to life. There are blue severed heads and a hysterical murderess kept docile by pink candies erotically hand-fed to her by the woman escorting her to prison. It is rare that a film from 1960 can amaze twenty-first-century filmgoers the way Kim's *The Housemaid* does. Set in a labyrinthine house that might have sprung from the fevered imagination of Edgar Allan Poe, it features a psychotic title character who becomes obsessed with her employer, a straitlaced husband and father whose family is increasingly at the mercy of her insanely jealous whims, in which she is able to indulge thanks to easy access to the family supply of rat poison. Add to this

a surreal coda in which the father jocularly informs the men in the audience that what they have just seen is a cautionary tale about marital infidelity, and the overall impression is of something out of a parallel universe of film history.

One reason for this is that Kim's films remained relatively unknown outside of Korea for so long. Film scholars consider him something of a modernist because he consistently shatters filmmaking conventions. But his modernist impulses feel more freewheeling and instinctive than the work of someone like Jean-Luc Godard, whose jump cuts and jarring juxtapositions are part of an intellectual agenda. In Kim's case, they erupt from the same wellspring as his films' diabolically perverse plots. *The Housemaid* still uses a classical narrative structure, but such conventions were increasingly abandoned as his career progressed, while its psychodramatic atmosphere served as a thematic template for later films like *Woman of Fire* (1971, remade in 1982), *The Insect Woman* (1982), and his last film, 1984's *Carnivore.*

"He's five hours late," muses the ex-con heroine of Kim's hallucinatory *Promise of the Flesh* (1975), "should I commit suicide or go back to prison?" No one does anything halfway in a Kim Ki-young movie, including the director. *Promise*'s soundtrack is thudding prog-rock, occasionally turned up to ear-splitting volume and mixed with harsh, dissonant drones. Filmed with a woozy zoom lens, it feels like a fever dream, and it epitomizes Kim's cinema of mental chaos.

Shin Sang-ok has long been regarded as one of Korea's greatest directors. Once hailed as Korea's answer to Orson Welles for his modernizing influence, he is even more famous for having been kidnapped by North Korean leader Kim Jong-il for his talents.

Shin's early masterpiece, *A Flower in Hell* (1958), was notorious for including an onscreen kiss, which was still considered somewhat scandalous at the

A Flower in Hell

time, but it is significant for far more important reasons than that. Filmed on location in and around Seoul in a striking neorealist style, it stars Shin's wife, Choi Eun-hee, as a prostitute, plying her trade to the servicemen at a United States military base, who is torn between two brothers who are in love with her—one the ringleader of a gang that steals supplies from the Americans, and the other an innocent young man who came to Seoul in search of his brother. It is unflinching in its portrayal of Seoul's postwar squalor and the tension between Korea's people and the American military presence.

In addition to his mastery of precise, sophisticated mise-en-scène, Shin also contributed to the maturation of Korean popular cinema by introducing depth and complexity to the standard melodramatic plots that characterized the movies of the time. Another of his important films, the Jean Renoir–influenced *The Houseguest and My Mother* (sometimes called *The Mother and the Guest*, 1961), lifts to the level of fine art what could have been a standard-issue melodramatic plot about a young widow who falls in love with her tenant. Full of Shin's characteristically precise imagery, it tells its story through the eyes of the widow's young daughter, emphasizing the subtle gestures of courtship between the two would-be lovers kept apart by the strictures of Confucian society.

The Houseguest and My Mother made Shin's reputation as a master director. It won the Best Picture award at the 1962 Asian Film Festival and remains a respected classic. His career flourished throughout the 1960s. He and Choi Eun-hee formed a very successful production company, Shin Films Co., Ltd. Throughout the decade he made an average of two films a year, many of them starring Choi, and together they became known as the prince and princess of Korean cinema.

By the late 1960s, Shin was focusing on historical themes, creating, in films such as *The Phantom Queen* (1967), *The Women of the Yi Dynasty* (1969), and *One Thousand Year Old Fox* (1969), erotically charged, visually splendid period movies awash in bright colors that made veiled references to contemporary politics. *Eunuch*, the most popular Korean film of 1968, is considered the pinnacle of this period of Shin's career. A tale of forbidden love between the eunuch of the title and one of the many concubines in a Chosun dynasty–era king's palace, it has a lurid, hothouse atmosphere of repressed desire.

Shin's career fell on hard times (along with the rest of the South Korean film industry) in the 1970s, which led to the notorious incident that is probably more famous than any of his movies. In 1978, Shin and Choi were kidnapped by North Korean agents. They were held separately for five years, until they were finally reunited and lavished with huge budgets to turn out propaganda films. After making some seventeen films in the North, they made a daring escape during a state-sponsored visit to a film festival in Vienna, and eventually made their way to Hollywood, where Shin, under the name Simon Sheen, worked as a producer-director whose primary contributions to American cinema were two sequels to *The Three Ninjas* (1992). One film from his North Korean period, an even more rubbery variation on *Godzilla* titled *Pulgasari* (1985) circulates among cult-film

aficionados on poor-quality video. Shin and Choi later returned to Korea, where Shin died in 2006.

DECLINE AND RECOVERY

Government censorship and interference increased throughout the 1960s, and this, combined with the rise of television as a popular entertainment medium in the early 1970s, drove the South Korean film industry into a steep decline. The worst blow came in 1973, with the military government's revision of the Korea Motion Picture Act, which introduced an even tougher censorship process. Ironically, the revision resulted in a creative atmosphere not unlike that of the Japanese occupation years. Korean filmmakers were for the most part forced to make either blatant propaganda or innocuous genre flicks. Audiences, accustomed to the more sophisticated fare of the 1960s, increasingly turned to other forms of entertainment.

The 1970s are regarded as Korean cinema's lowest point, but the decade was not without a few bright spots. Kim Ki-young unleashed some of his most outrageous creations. Lee Jang-ho, who would rise to prominence in the 1980s, made his debut feature, *The Hometown of Stars*, in 1974. Lee Man-hee, one of the great directors of the golden age, made his final film, *The Road to Sampo*, in 1975. And despite strict censorship, the gifted Ha Kil-jong managed to release *March of Fools* in the same year. Filmed in a jazzy, restless style, *March* is a veiled commentary on the oppression and sterility of life under military rule disguised as a college comedy about a pair of rebellious students who spend more time getting into trouble than going to class. It would prove to have a great influence on Korean filmmakers in the 1980s, who advanced its radical agenda in more forthright terms. Five years later, Lee Jang-ho would follow a similarly subversive route with *A Good Windy Day*, which was recently voted the best Korean film of

the 1980s by a Korean critics group. Lee's film follows three lovable losers with dead-end jobs and big dreams. A charming and ultimately moving film, it has an undeniable undercurrent of frustration at South Korea's economic situation that struck a chord with domestic audiences.

One of the most important Korean filmmakers of the 1980s and 1990s directed some seventy features before finding his artistic stride. Best known in the West for his recent international hits *Chunhyang* (2000) and *Chihwaseon* (titled *Painted Fire* in the United States, 2002), Im Kwon-taek made his debut feature, *Farewell to the Duman River*, in 1962. By his own admission, the younger Im regarded filmmaking not as an artistic enterprise but simply as a way to support his family. By the early 1970s, after cranking out more than fifty genre films of little distinction, Im decided he should devote himself to more serious work. As he put it, "One day I suddenly felt as though I'd been lying to the people for the past twelve years. I decided to compensate for my wrongdoings by making more honest films."

The result of this crisis of conscience was *The Deserted Widow* (1973), a realistic portrayal of the hardships facing a widow after the Korean War, which he financed himself. It flopped at the box office, but it did earn him the respect of his peers. He struck a deal with his producers whereby the profits from his popular films would finance his more personal ones, which were not expected to make money.

After he had gained international recognition, Im drew comparisons to the likes of John Ford and Akira Kurosawa. There is a humanist streak in his work much like theirs, and like them, he paid his dues by learning his craft in a commercial context before discovering his artistic vision. But Im also had an ideological tightrope to walk during the oppressive 1970s. His 1978 film *Genealogy*, for instance, drew on his own memories of the Japanese occupation to tell the story of an old man who defies the authorities by refusing to change his Korean family name into a Japanese one. While its story could easily be read as a critique of the type of political oppression the current South Korean government was practicing, its condemnation of the Japanese occupation could also be seen as inherently patriotic.

Im's political pragmatism perhaps shouldn't be read as mercenary. The horrible treatment his family received in his youth for his father's leftist sympathies destroyed them financially and seems to have implanted in Im a pragmatically

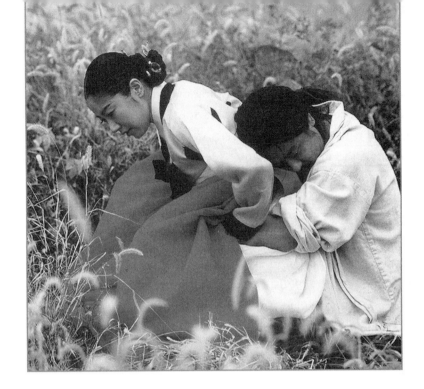

Chihwaseon (A.K.A *Painted Fire*)

distrustful view of government in general. As he said in an interview, "I am tired of ideologies. The problem with ideologies is that the application methods have caused untold misery to mankind." Political compromises are a necessary evil for the artist in Im's view, a position that he illustrates in allegorical form in *Chihwaseon*, his portrait of the famous nineteenth-century Korean artist Jang Seung-up, whom he portrays as torn between pursuing his talent and pleasing his patrons, government or otherwise, against a backdrop of constant political strife.

But although Im sees his career as moving in two parallel paths, one commercial, the other artistic, the line between the two is not always so clear. As film scholar David E. James points out, Im's profitable action film *The General's Son* (1990) and its sequels have much in common with his art films, and *Sopyonje* (1993), which is regarded as his masterpiece, was at the time the most financially successful movie in Korean history.

As Im's "honest" side emerged more fully in the 1980s, his reputation rose as well. A true classic of Korean cinema, 1981's *Mandala* views the influence of Buddhism on Korean culture by portraying the differing paths of two monks, one who pursues his faith in a temple, the other out in the world. Continuing to work at his usual feverish pace of anywhere from one to three films a year, Im made a number of highly regarded movies over the next decade, including *Surrogate*

Woman (1987), *Adada* (1988), and *Aje Aje Bara Aje* (clumsily titled *Come Come Come Upward* in English, 1989). With ferocious passion and deep respect for Korea's history, landscape, and traditional culture, 1993's *Sopyonje* tells the story of a family of wandering *pansori* singers stubbornly carrying on their tradition against the background of a rapidly changing, post–Japanese occupation Korea. It is also a fascinating crash course in *pansori*, a form of Korean folk opera that can last up to three hours and requires physically demanding vocal techniques.

This director of nearly one hundred films finally got his American breakthrough in 2000 with *Chunhyang*, his sumptuous retelling of the famous Korean folktale. It also uses *pansori* singing, but in a more innovative way. *Chunhyang* weaves a *pansori* performance into its narrative, with the singer narrating the action in the same way the singers of old would tell epic tales in villages and taverns. Today Im is probably the best-known Korean director internationally, a testament to his longevity, his talent, and his ability to engage foreign audiences with traditional Korean subjects.

THE GWANGJU MASSACRE • In May 1980, in the small city of Gwangju, students and local citizens demonstrating against the recent military coup were attacked by soldiers in a shocking display of force that left between five hundred and two thousand people dead. Although democratic reforms didn't begin for another seven years, Gwangju became symbolic of a burgeoning democratic movement. The massacre was dealt with directly in films such as Jang Sun-woo's *A Petal*, but the spirit of rebellion and sense of tragedy it engendered also rippled more broadly through South Korean cinema as it developed in the 1990s.

The relaxation of censorship laws that allowed Im the freedom to develop his mature style opened up new avenues for Korean filmmakers in general. Park Kwang-su's 1988 debut feature, *Chilsu and Mansu*, was the first film to truly take advantage of the newly unrestricted atmosphere. Based on a story by banned Taiwanese writer Huang Chunming, it used popular cinema to reflect the tensions of the day in ways that would have been unheard of the previous year. Inspired in part by the international attention focused on Korea because of the Seoul Olympic Games that year, 1988 saw massive street demonstrations seeking social change and protesting the military government's labor policies. The title characters of Park's film, a duo of down-at-their-heels billboard painters, embodied the frustrations many working-class Koreans felt about their economic disenfranchisement at the time.

Throughout the 1980s an underground movement was growing that would produce some of the country's most exciting filmmakers, Park Kwang-su among them. As early as 1982, Park was making underground films protesting the government's policies. When he came aboveground with *Chilsu and Mansu*, he dedicated himself to making political movies that appealed to a large audience. *To the Starry Island* (1993) achieves his goals with devastating precision. At the same time earthy, ethereal, and pointedly political, it depicts a tragic rift that develops in an isolated island village during the Korean War and resonates all the way to the present day. The ghosts of history invade the present, and tradition haunts even the film's most modern, urbanized characters.

Jang Sun-woo is also a product of the dissident underground of the 1970s and 1980s. A political activist as a student, Jang was imprisoned for his activities for six months in 1980. After college, he began working in the Korean film and television industry as a script writer, collaborating on an underground independent film called *Seoul Jesus* with fellow writer-director Won Sun-u. Didactic and gritty, it was completed in 1986 but wasn't released until two years later, when it provided a more committed counterpoint to Park's *Chilsu and Mansu*. Jang's career has since followed a willfully idiosyncratic path, veering from the scathing satire of Korea's rapacious business culture in *Age of Success* (1988) to the raw, explicit sexual battles in *Lovers in Woomuk-baemi* (1989) and his film most widely seen in the United States, 1999's *Lies*, which concerns the sadomasochistic relationship between a thirty-eight-year-old-artist and an eighteen-year-old schoolgirl. Occupying the middle ground are his Buddhist fable *Hwa-um-kyun* (1993) and his equally fable-like but also anguished reaction to the Gwangju massacre, *A Petal* (1996), a brutal, incantatory work that conjures up a post-Gwangju landscape of physical and emotional torment, channeled through a young girl driven mad after witnessing the massacre.

At yet another extreme is Jang's big-budget sci-fi braintwister *The Resurrection of the Little Match Girl* (2002), which reimagines the Hans Christian Andersen tale as a futuristic video game. A synergy of state-of-the-art technology and philosophical musings on existence, this remarkable (and remarkably expensive) collision of sensibilities failed at the box office. Financial disaster aside, it is a bold gambit, mixing action and philosophy with a video-game-inspired narrative structure.

While the easing of censorship freed South Korean filmmakers to make more challenging films, another 1988 government policy change easing import restrictions on foreign films made it harder for them to compete at the box office. Films from the United States and Hong Kong flooded the market, and by 1993 Korean films accounted for only 16 percent of ticket sales.

A POPULAR RENAISSANCE

Over the last couple of decades, Hollywood films have increasingly taken the lion's share of the market in all but a few countries. Some, like France, imposed quota systems to protect their own film industries. India, a nation with several official languages, numerous diverse cultures, and a popular film industry that dwarfs even America's, has proven impenetrable. Korea stands alone as the only nation to have recovered its own box office after having seen it decimated by Hollywood product. South Korea's screen quota system, which was established in 1966 and required theaters to devote 146 days per year to showing Korean films, aided the recovery by giving screen space to films that might otherwise be overshadowed by American movies, with their large advertising budgets. In early 2006, the United States forced South Korea to reduce the quota to 72 days as a prerequisite to free-trade talks, inspiring public demonstrations and protests by Korean filmmakers. Even with the reduced quota, Korean cinema continues to do well at the local box office, a testament to its continuing quality.

Even more amazing than the economic recovery is the diversity and high artistic quality of the films being produced.

Many trace the beginnings of the Korean film renaissance to 1992, when Kim Ui-seok released his debut film, a romantic comedy titled *Marriage Story*, to enormous critical and popular success. The story of a wife who begins a march toward personal independence when she realizes that her husband is an unsatisfying lover, Kim's film became one of the most popular of the "sex war" comedies, a genre that began with Lee Myung-se's *My Love, My Bride* (1990), which depicts, in high screwball fashion, the rocky beginnings of a young couple's marriage.

The sex-war genre has proven to be a durable one, and the popularity of South Korea's romantic comedies has recently begun to expand beyond its boundaries. In much the same way that Jackie Chan, John Woo, and other Hong

Kong action-movie directors in the 1980s reinvigorated Hollywood formulas with their own original stylistic flair, sex-war films inject the romantic comedy form with a wit and freewheeling energy not seen in the American variety since the screwball heyday of the 1930s and 1940s. *My Sassy Girl* (Kwak Jae-young, 2000), a slapstick free-for-all about a young man's unexpectedly danger-fraught courtship of an eccentric girl he meets one drunken night on the subway, was an audience favorite at international film festivals. *Please Teach Me English* (Kim Sung-soo, 2003), another festival hit and a box office sensation at home, is a zany blend of mangled sentences in two languages, fantasy sequences, and animated interludes. The classroom has also proven to be fertile ground for comedy in Kim Tae-gyun's *Volcano High* (2001) and Jo Geun-shik's *Conduct Zero* (2002), both of which mine martial arts and high school social battles for gags.

Korea's corporate leaders took particular notice of *Marriage Story*'s success. The film was made under the auspices of Samsung, one of Korea's major business conglomerates (known as *chaebul*), and when it proved profitable, others soon went into the moviemaking business. Major corporate money made for bigger budgets, more sophisticated productions, and better promotion. Today, Korea's big-budget blockbusters equal Hollywood's and Hong Kong's in technical polish and often exceed them in range and depth.

The watershed year was 1999, when Kang Je-gyu's *Shiri*, an espionage thriller about a North Korean agent trying to plant a bomb at an inter-Korean soccer match, broke the box office record held by James Cameron's *Titanic* (1997), becoming the highest-grossing Korean film ever. Korean producers also began pursuing overseas markets, and Korean films have since received increased distribution around the world.

The *Shiri* phenomenon was just the beginning. By the time *Friend*, Kwak Kyung-taek's autobiographical drama about four childhood pals bound by tragedy later in life, broke *Shiri*'s box office record in 2001, Korean films were for the first time taking a larger share of the overall domestic market than American ones.

Shiri is a world-class thriller, as tense and action-packed as anything coming out of Hollywood, and has the distinction of being the first major Korean film to directly address the continuing tensions with the North. (Its star, Kim Yun-jin, later became a star on the hit American TV show *Lost*.) Three years before that, Kang Je-gyu broke box office records in 1996 with *The Gingko Bed*, a crowd-pleasing ghost story. He looked back to the Korean War for his 2004 blockbuster, *Tae Guk*

Gi: The Brotherhood of War. Like *Shiri*, it eschews politics in favor of a compelling narrative about two brothers who become separated during the conflict. These two films, which take on big issues through human stories, earned Kang comparisons to Steven Spielberg, another director known for putting a human face on political strife and war.

South Korean war movies traditionally followed a prescribed patriotic formula of vilifying North Korea and celebrating the heroism of South Korean soldiers, but *Tae Guk Gi* and Park Chan-wook's *Joint Security Area* (2000), both major box-office successes, view the war as a tragedy for people on both sides of the North-South divide, reflecting changing attitudes in Korean society. The big hit of 2005, Park Kwang-hyun's *Welcome to Dongmakgol*, in which South Korean soldiers, North Korean soldiers, and one American soldier stumble upon a village so remote that its residents aren't even aware of the war, is openly pacifist, albeit with a distinct anti-American undercurrent. The corruption and repression of the decades following the war come under scathing attack in Song Jae-ho's acidic *The President's Last Bang* (2005), which paints former Korean president Park Chung-hee and his cronies as decadent thugs, and treats Park's assassination with bitter comedy.

What's striking about Korean cinema's ongoing success is its diversity. Hong Kong's global success in the 1980s and 1990s rested on its action films. Taiwan's

major auteurs receive worldwide attention, but the products of its popular cinema industry haven't broken through internationally. Korean cinema has been successful on many levels. There's the hard-edged realism of Bong Joon-ho's *Memories of Murder* (2003), which works on one level as an expertly crafted suspense film and on another as an indictment of the oppressive nature of life in early 1980s South Korea. This story of the pursuit of Korea's first serial killer ends on an unshakably creepy note: the killer hasn't been found to this day. Bong followed this triumph with *The Host* (2006), which quickly became one of the most popular Korean movies of all time. A monster movie that transcends the genre, it concerns a slimy, deadly, but somehow graceful monster that emerges from Seoul's Han River to terrorize the populace. Like *Memories of Murder*, it works on a number of levels. Beneath its expertly deployed suspense and thrills is a rather scathing indictment of the United States' continuing military presence in Korea (the monster's birth is attributed to an actual event in which the U.S. Army dumped formaldehyde in the Han River). Its very structure is a swaggering refutation of Hollywood action movie clichés: traditional conventions are overturned, and the expected hero who usually saves the day is replaced by a ragtag family that battles both the monster and the authorities on their own terms. It also may be the only monster movie to become the subject of a cover story in *Artforum* magazine.

 Korea's rustic past and high-tech present meet in Lee Jeong-hyang's *The Way Home* (2002), a guilelessly touching film about a spoiled brat sent to

spend the summer with his mute octogenarian grandmother. If the theme isn't original, the way it's handled and the glorious mountain scenery of its setting render it pleasingly effective. Jeong Jun-hwan's brilliantly loopy directorial debut, *Save the Green Planet!*, made the same year, whipsaws between daft comedy, sci-fi surrealism, and moving pathos as it tells the story of a young man, scarred by the past, who is convinced of an impending alien invasion. Its apocalyptic absurdism recalls that of the Stanley Kubrick of *Dr. Strangelove*.

THE HOST • Bong Joon-ho's devilishly clever 2006 film *The Host* is perhaps the most subversive monster movie ever made. The monster's birth is attributed to the U.S. military's dumping of toxic chemicals into Seoul's Han River, and increasingly oppressive measures taken by both Korean and American authorities to kill the beast and counter growing unrest cause only more problems. In the end, it's not a Hollywood-style action hero or a crack team of elite soldiers who save the day, but a squabbling, ragtag family.

A desire to transcend time and memory figures prominently in a whole range of recent Korean films. A science-fiction action movie by Lee Si-myung, *2009: Lost Memories* (2002), imagines an alternate future in which Japan rules Korea, and uses this conceit to engage the deeply ingrained tensions between these two nations. Moon Seung-wook achieves a form of existential science fiction in *Nabi* (a.k.a *Butterfly*, 2001), which is set in a near-future where a tourist industry has evolved around a virus that erases memories. The three women in Song Il-gon's achingly sad *Flower Island* (2001) go in search of the mythical island of the title in the hope of erasing the emotional scars of the past. The seaside house in Lee Hyun-seung's *Il Mare* (2000), filmed in misty, impressionist tones, serves as the meeting place for two lovers separated in time. Taking a more eccentric tack, Kim Dae-seung, in *Bungee Jumping of Their Own* (2001), has a teacher's deceased wife come back reincarnated as a male student for whom he finds himself having the same feelings of love. Two other recent films starring the brilliant actress Moon So-ri show the effects of the past on relationships in less otherworldly ways. In the guise of a melodrama, Kim Tae-young's *Family Ties* (2006) uses an innovative flashback structure to explore the fragmentation of a family and their reconciliation into a new kind of clan with bonds that go beyond blood. In Lee Ha's *Bewitching Attraction* (2006), secrets from the past emerge to interrupt the lives of two former lovers.

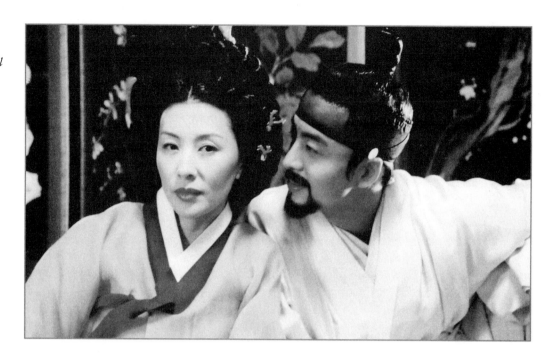

Love, or, more specifically, its failure, is the subject of two engrossing experimental narratives by Park Ki-yong. Shot in black and white on digital video, *Camel(s)* (2001) captures, with a calm voyeurism reminiscent of Andy Warhol's films, the details of a businessman and a pharmacy clerk on a weekend tryst. The neon-saturated *Motel Cactus* (1997) brings four couples to the motel of the title, and unsparingly examines their longings, desires, and battles. Im Sang-soo's take on love is even more jaded in *A Good Lawyer's Wife* (2003), in which a housewife, bored with her feckless husband, seduces a teenage boy. Sexy, cruel, and powered by an unforgettable performance from Moon So-ri in the title role, it has much in common with the cynical, erotic guilty pleasures of Lee Je-yong's *Untold Scandal* (2003), which transposes the debauched treacheries of *Les Liaisons Dangereuses* to eighteenth-century Korea. Lee continues his interest in sexual shenanigans in *Dasepo Naughty Girls* (2006), a broad, silly, brightly colored comedy about omni-sexual lust among the randy students (and teachers) at No Use High.

Like Japan's, Korea's horror movies are also gaining in popularity. From the amnesiac mindgames of *Flower Island* director Song Il-gon's *Spider Forest* (2004), to the haunted house and evil stepmother in Kim Ji-woon's *A Tale of Two Sisters* (2004), the best Korean horror films enliven the requisite creepy atmospherics and mysterious plots with innovative story concepts. Kim is a versatile director

comfortable in multiple genres. In the humor realm, he made the black comedy *The Quiet Family* (1998), about an innocent-seeming family whose country inn keeps collecting corpses, and *The Foul King* (2000), a sometimes tender, sometimes painful romp about a humble bank clerk who transforms himself into a professional wrestler to avenge his daily humiliations. Most recently he made the handsomely crafted and oddly affecting gangster film *A Bittersweet Life* (2005), which adds substance to generic formula through a tragically conflicted protagonist.

Park Ki-hyung's horror movies drip with atmosphere while steering away from conventional shocks. In *Whispering Corridors* (1998), *Secret Tears* (2000), and *Acacia* (2003), he's more concerned with restless ghosts, secrets that refuse to remain buried, and the mysteries of the supernatural. *Whispering Corridors*, which takes place in a haunted girls' high school, has spawned a unique franchise that has grown to four films so far. Instead of being sequels, each is a variation on the theme, made by a new director and cast, in which the intense emotions, fierce competition, and cruel powerplays of Korean high school life are almost as scary as the supernatural elements. In the first edition, a teacher discovers a ghost that has been appearing in yearbooks for years, who soon takes form among the current group of students. *Memento Mori* (1999), codirected by Kim Tae-young and Min Kyu-dong, features a secret diary about an affair between two students,

one of whom has committed suicide. As the title suggests, Yun Jae-yeon's *Wishing Stairs* (2003) is about a staircase rumored to grant wishes, but of course wishes can easily become curses. In Choi Equan's *Voice* (2005), a spirit trapped between the living and the dead can be heard by only one student, who must unravel the ghost's secrets.

The Korean film industry also produces endless variations on the action movie. Jang Jin slices and dices the genre, throwing in comedy, action, hints of the supernatural, and flashes of stylistic pyrotechnics in *Guns and Talks* (2001) and *Murder: Take One* (2005), the latter of which makes fun of the global phenomenon of reality TV: cops have to perform a murder investigation in front of the television cameras. Choi Ho's *Bloody Ties* (2006) incorporates cynical humor, high-octane violence, and debauchery into the story of a drug dealer and a cop teaming up to take down a crime lord.

THE NEW AUTEURS

Korean cinema's early 1990s success story resulted in not only a thriving popular cinema but a no-less-diverse art cinema community.

The two most prominent members of this group are a study in contrasts. The slow-working, film-school-educated Hong Sang-soo makes intimate dissections of human relationships that are subtle in their structural complexity, while the prolific and largely self-taught Kim Ki-duk, the most controversial director of his generation, is a dedicated brutalist whose films reflect an uncompromisingly grim view of human nature.

Hong made his debut in 1996 with *The Day a Pig Fell into the Well*, which cleverly weaves together storylines about four separate characters who turn out to be romantically linked to one another. The film introduces two of the main facets of his work: an interest in narrative experimentation and a preoccupation with hapless men whose insecurities doom their relationships with women. *Pig* garnered Hong immediate success, winning awards abroad at the International Film Festival Rotterdam and the Vancouver International Film Festival, and at home where he won Best Director at the Blue Dragon Awards. His second film, 1998's *The Power of Kangwon Province*, represents a further refinement of his aesthetic, following a man and a woman, who once had an affair, on separate trips to the resort area of the title, where their paths almost, but don't quite, intersect. *Kangwon* further

develops Hong's keen interest in landscape and ambience. As a filmmaker, he is fully alive to the effects of weather, the seasons, and his characters' surroundings, whether it be the cold streets of wintertime Seoul or the clean air of the mountains in summer, which adds even more richness and depth to this films.

Like Michelangelo Antonioni (to whom he has been compared), Hong creates an air of melancholy using carefully composed long takes, and like those of Krzysztof Kieslowski, his plots hinge on chance meetings and fateful encounters that take on an almost mystical dimension. He intentionally values narrative structure over dramatic resolution. Second and third viewings of his films often reveal that what may have seemed an unsatisfactory ending is in fact the perfect solution to the structural underpinning of the film. Like *The Day a Pig Fell into the Well*, the provocatively titled *The Virgin Stripped Bare by Her Bachelors* (2000) dissects a relationship from multiple angles, in this case a love triangle between a young woman and two older men, which is presented differently according to the memories of two of the characters.

Hong's structural experiments have grown even more subtle in his recent films. Inspired by Hong's interest in the concept of reincarnation and employing

repetition as a subtle narrative motif, 2002's *Turning Gate* follows a young actor on an aimless journey to the country, where he tries to connect with two different women. As is implied by the title, *Woman Is the Future of Man* (2004), weaves an equally subtle structure out of moving backward and forward—through time, through life, through levels of emotional maturity—to tell the story of two old friends, a recent film-school graduate and an art professor, who in a drunken moment decide to seek out the woman they both loved years ago. *A Tale of Cinema* (2005) employs a more radical structural conceit. Revolving around the concept of artistic theft, it contains yet another rivalry between two flawed male protagonists. The plot hinges on a surprising intellectual twist that extends the concept of theft outward to the movie's very construction. Hong's most whimsical film to date, 2006's *Woman on the Beach* also uses a bifurcated structure to tell the story of a roguish filmmaker, working on a script at a seaside resort in off-season, who manages to entangle himself with two women who end up getting the better of him. As with Hong's other films, its realistic exterior conceals a deceptively complex structure and an underlying philosophy about the inevitably fleeting nature of human relationships.

Subtle is not a word that would ever be applied to Kim Ki-duk. His disenchanted view of humanity is expressed repeatedly and forcefully in his films. What saves them from being empty exercises in shock tactics is that they are, at their best, honest expressions of Kim's worldview, often made with great skill.

Kim made his feature debut in 1996 with *Crocodiles*. It and his second film, *Wild Animals* (1997), are violent portrayals of alienated young people, as is *Real Fiction* (2000), an experimental feature, shot in real time using several cameras, about a tormented artist exacting revenge on a gang of thugs he believes have done him wrong. Youthful rage also drives 2001's *Address Unknown*, which is set in and around a U.S. Army base and examines the painful legacy of the Korean War through three troubled teens. His third feature, *Birdcage Inn* (1998), introduced another recurring theme—prostitution, which Kim seems to regard as the normal state of affairs between men and women. A prostitute is also the central character of *The Isle* (1999), the film that brought him international notoriety of a somewhat infamous sort. The story of a fisherman who develops an obsessive relationship with a mute prostitute, who works at a resort comprised of cabins floating on a lake, its picturesque setting and eerie erotic tension have been overshadowed in the press by its more disturbing images.

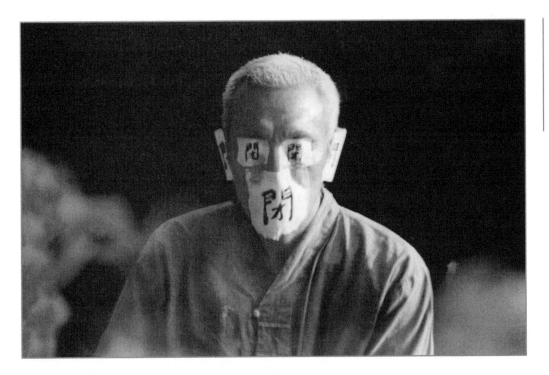

Kim did nothing to dispel his reputation with his next film, *Bad Guy* (2001). Either the pinnacle or nadir of his confrontational aesthetic, depending on one's opinion of him, it tells the story, in painfully drawn-out terms, of a mute thug who forces a college girl into prostitution after she refuses to kiss him. *The Coast Guard* (2002), the story of a young military recruit who goes mad after accidentally killing an innocent man, is equally unsparing but does have much to say about the brutality of military life and the psychological stresses on young men serving in an army constantly on a war footing.

Kim's career took its strangest turn with *Spring, Summer, Fall, Winter . . . and Spring* (2002). Set amid the natural beauty of a lake nestled in the mountains, on which floats a small monastery, it presents itself as a Buddhist fable in which a young monk is mentored over a period years by an elderly one. *Spring* represents a turning point for Kim in that it channels his more disturbing impulses into a form that expresses them with a new kind of power. Its serenity, mystical aura, and ostensible concern with Buddhism made it appealing to international distributors as well as a target for critics at home, who accused him of catering to Western tastes for "exotic" Asian fare. But it would seem that Kim got the last laugh. Raised Christian himself, he made up the rituals in the film, many of which go against

Buddhist beliefs, suggesting that his real intention might have been to subvert Orientalist tastes all along.

Kim tends to work at a frenetic pace. In 2003 he made two more films. *3-Iron*, a further tempering of his brutalism, is about a thief who assists, with the aid of the golf club of the title, a woman escape her abusive marriage. *Samaritan Girl* is a surprisingly touching film about a teenager atoning for the death of her best friend—a prostitute—by sleeping with her former clients and returning their money, while her father, unbeknownst to her, tracks them down and beats them.

Kim's films are defended and attacked with equal ardor in Korea, so much so that Kim, in reaction to the vicious criticism directed against him, once publicly announced that he would no longer distribute his films there. (He has since changed his mind.) In a way, the contentiousness surrounding his films is unresolvable. Are his depictions of women misogynist or allegories of a misogynist culture? It's ultimately up to the viewer to decide where they stand. Kim even comments on his controversial reputation in his films. The opening of *3-Iron*, in which a golf ball violently slaps against a net in front of a reproduction of the Venus de Milo, can be read as a witty response to accusations of his cruelty toward women. And the beginning of his 2006 plastic-surgery psychodrama *Time*, which features a gruesome montage of operating-room footage followed by a woman bursting through a double door that is adorned with a bisected photograph of a woman's face, comments humorously on the violence in his work.

After the much-debated Jury Prize Park Chan-wook won for the baroquely violent *Oldboy* (2003) at the 2004 Cannes Film Festival, and the film's subsequent release in the United States, Park briefly became nearly as controversial as Kim Ki-duk.

Park is unique among the current crop of auteurs in that he makes pop cinema with an intellectual bent. He first hit it big with the harrowing thriller *Joint Security Area*, in 2000. It tells the story of two groups of soldiers, one from the South and the other from the North, who are posted on opposite sides of a remote section of the DMZ and secretly become friends, until tragedy brings their brief idyll to an abrupt end. A commercial and artistic success, *Joint Security Area*'s deeply human and mature treatment of North-South relations resonated with audiences at a time when political relations were thawing between the two Koreas. Park's next film was a departure. *Sympathy for Mr. Vengeance* (2002) bears some similarities to Kim Ki-duk's work in its melancholy tone and chillingly distanced depictions of

Lady Vengeance

violence and cruelty (some of *Sympathy*'s more excruciating set pieces rival the ear-removal scene in Quentin Tarantino's *Reservoir Dogs*). But where Kim is interested in the intimate cruelties of people in sometimes twisted relationships, Park works with a much broader canvas. On the surface a "kidnapping-gone-wrong" film, *Sympathy* is more about how ordinary people can become monsters when plunged into desperate circumstances. Desperation and revenge spread through all the characters in the film like a virus, and the cruel irony of its conclusion shows where these all can lead.

 Sympathy is the first in a trilogy of films on the theme of revenge. The second, *Oldboy*, is about a businessman mysteriously imprisoned for fifteen years who, upon his release, picks up the trail of the ones who locked him up, in the process uncovering a secret from the past. Like its predecessor, it contains some disturbingly violent set pieces, along with a stronger dose of black humor. In one scene that combines both, the hero, equipped with nothing but a hammer, battles a battalion of better-armed but increasingly exhausted thugs. It's like a Goya painting come to life, and throughout, the editing and images are crisp and sleek. The third film in the trilogy, *Lady Vengeance* (2005), applies the same doses of style and dark comedy to the story of a female prisoner who spends her time on parole tracking down those who have done her wrong.

Some critics see Park as yet another director cashing in on the public's current taste for blood and mayhem, but Park, a former philosophy student, underpins his films with deeper questions. He has claimed a longtime fascination with the Greek playwright Sophocles, whose *Oedipus Rex* influenced the vengeance trilogy. The influence of Hitchcock can also be seen in his deft manipulation of audience sympathy. The violence in his films is meant to be disturbing, not for the body counts and gore, but for the questions it raises about human cruelty. Their crisp, colorful, images recall graphic novels, and like the best of them, his films distill philosophical concepts into tight pop narratives.

Another important director—though his films have yet to receive much attention in the United States—is Lee Chang-dong. A former novelist, Lee cowrote the scripts for two of Park Kwang-su's films, *To the Starry Island* and *A Single Spark*, before becoming a director himself. His debut, *Green Fish* (1997), which won awards at the festivals in Rotterdam and Vancouver, critiques contemporary South Korean society through the story of a young man who joins a crime syndicate out of economic desperation. *Peppermint Candy* (2000), a broader and more bitter view of recent Korean history, covers twenty years in the life of a man whose various failings lead him to a sad end. Like Christopher Nolan's *Memento*, the story is told backward, not as a narrative trick but as a way of addressing the mistakes of the

past. Abandoning explicitly historical themes, his third film, *Oasis* (2002), tells the story of a relationship between a mentally handicapped man and a woman with cerebral palsy, and features outstanding performances from its leads, Moon So-ri and Sol Kyung-gu. After taking time off from filmmaking to serve as South Korea's Minister of Culture and Tourism in 2003–2004, Lee returned to directing with *Secret Sunshine* (2007), a novelistic consideration of love, religion, and suffering that premiered to critical accolades at the 2007 Cannes Film Festival.

A number of talented Korean women directors have emerged in the past few years. The list includes Jeong Jae-un, whose debut feature, *Take Care of My Cat* (2001), treats the life trials facing a group of young Korean women with great tenderness, and Park Chan-ok, director of the meticulously observed relationship drama *Jealousy Is My Middle Name* (2003). Byun Young-joo tells the story of Korean "comfort women" with deep respect and sympathy in her groundbreaking trilogy of documentaries, *The Murmuring* (1995), *Habitual Sadness* (1997), and

MOON SO-RI • A captivating screen presence, Moon So-ri is one of Korea's most talented, fearless, and versatile actresses. She made her debut in 2000, in Lee Chang-dong's *Peppermint Candy*, but it was her performance in Lee's 2002 *Oasis* that earned her widespread notice. Twisting her body into painful contortions, Moon portrayed a woman stricken with severe cerebral palsy, with agonizing verisimilitude. At the other end of the spectrum, she displays an irresistible sexy swagger as the title character in Im Sang-soo's 2003 *The Good Lawyer's Wife*, in which she seduces and abandons a teenage neighbor. And in Kim Tae-young's *Family Ties*, she brilliantly steers her character from a humble, put-upon loner to a heartily eccentric middle-aged troublemaker.

My Own Breathing (1999). She also directed a feature, *Ardor* (2002), about the sexual awakening of a young wife.

The increased visibility of female directors, critics, and film scholars, and an increased attention to women's issues in South Korean movies is just one of the many encouraging trends in a rapidly growing film industry. South Korea's emphatic embracing of technology means that DVDs of even current films are readily available, and Web sites devoted to criticism and fandom proliferate, making it easy to explore one of the world's most dynamic film industries.

A NOTE ON THE NORTH

It is well known—and the regular subject of jokes—that North Korean leader Kim Jong-il is a movie buff. He apparently has tens of thousands of movies in his personal collection, and even authored a book in 1973, titled *Theory of Cinematic Art*, designed to instruct North Korean directors in making properly patriotic fare. It has been reported that the North's film industry makes some forty films a year, but only a few have been seen outside of the country. One exception is *Pulgasari*, a version of Godzilla directed by Shin Sang-ok during his time there, which was even released theatrically in South Korea in 1999.

The Pusan International Film Festival, after months of negotiations, managed to screen a handful of North Korean films in 2003, and it is hoped that as the relationship between North and South warms, more will be seen in the future. In the meantime, aspects of life in what could now be called the "Hermit Kingdom" can be seen in a number of Western documentaries. British filmmaker Daniel Gordon has documented everything from the North Korean soccer team's surprising success in the 1966 World Cup in *The Game of Their Lives* (2002), preparations for the annual "Mass Games" in *A State of Mind* (2005), and, perhaps most intriguingly, the lives of American Korean War defectors who still live in the North in *Crossing the Line* (2006). Dutch filmmaker Peiter Fleury's *North Korea: A Day in the Life* (2004), provides a glimpse, albeit a tightly controlled one, of life in Pyongyang. Ethnic Korean filmmaker Yang Yong-hi, who was born in Japan, explores her Osaka-dwelling parents' unwavering devotion to North Korea in *Dear Pyongyang* (2006), which exposes the little-known North Korean loyalist community in Japan, and shows aspects of daily life in Pyongyang few other directors have been able to capture.

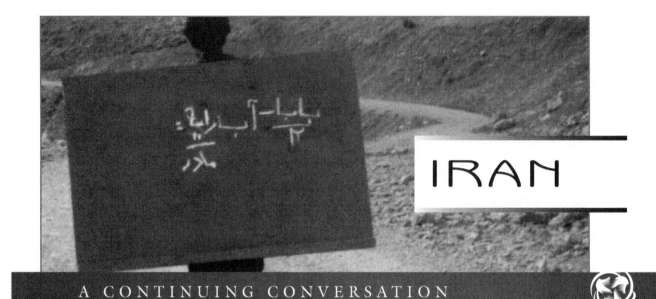

IRAN

HISTORICAL BACKGROUND

The area that is now Iran is but a part of the region stretching from central Asia to the Middle East that was once populated by the many shifting kingdoms and dynasties of the ancient world. Iran (or Persia) doesn't become an entity unto itself until 546 BC, when Cyrus the Great united the Median and Persian civilizations. The expansion of the Muslim world in the seventh century led to conflicts between Islamic caliphates and native Persians that lasted until the sixteenth century, but it also produced a flourishing culture.

The renowned Persian poets of the time, among them Omar Khayyám, Rumi, and Háfez, developed a sophisticated, sensuous style that equated the ecstasy of devotion to Allah with the intoxications of wine and romantic love. Poetry remains central to Iranian culture today, and the importance of linguistic creativity can be seen in the sometimes comically stubborn arguments and long philosophical conversations characters get into in many Iranian films. *The House Is Black* (1963), one of the most important touchstones of Iranian cinema, was made by the famous modern poet Forough Farrokhzad. One could even say

that contemporary filmmakers, working under strict censorship, have inherited the aesthetic of the Persian poets by creating subtle works deliberately open to multiple interpretations.

Dynastic rule began to crumble in the twentieth century, owing to a combination of local unrest and foreign influence from Britain, Russia, and the United States, all of whom had their eyes on Iranian oil. Russian and British troops occupied the country during both world wars, and in the 1950s, the CIA and Britain's MI-6 secretly backed a coup that installed a sympathetic leader, Mohammad Reza Shah, of the Pahlavi royal family.

Mohammad Reza Shah's liberalizing gestures and attempts to modernize the country met with stiff resistance from conservative quarters, and he was overthrown in the 1979 Islamic Revolution, under the powerful Muslim cleric Ayatollah Ruhollah Khomeini, that included, of course, the Iran Hostage Crisis, which led the United States to sever diplomatic ties with the new regime. In 1980, Iran entered into an eight-year-long war with Iraq, the scars of which are often depicted in Iranian films.

Iran is an Islamic state, with rules placed on its citizenry based on strict interpretation of Muslim law. Power is balanced between Islamic mullahs and an elected government, meaning that the pendulum between tolerance and intolerance is constantly swinging. The conservative Mahmoud Ahmadinejad was elected president in 2005, and has since been involved in a prolonged standoff with Western powers over reviving Iran's nuclear program.

What gets lost in the tumult of Iran's recent history is its long tradition of cultural achievement. Iran's contributions to the world include Persian classical music—with its virtuosic improvisation—beautifully wrought artifacts from its early cultures, architectural marvels, a legacy of miniature paintings of exquisite beauty and detail, and great accomplishments in poetry and literature—in all a unique aesthetic code that is both suggestive and allusive.

BEFORE THE REVOLUTION

Cinema began in Iran as a diversion for the shah's court. In 1900, Muzaffar al-Din Shah of the Qajar dynasty saw motion pictures while on a trip to Paris and immediately ordered his official court photographer, Mirza Ebrahim Khan Akkabashi, to buy the necessary equipment to make movies back

home. Akkabashi filmed religious ceremonies, royal activities, and other wonders, which were shown in the royal palace and in the houses of dignitaries to celebrate important occasions.

Iran's film industry developed slowly. The shahs, who viewed movies as diversions for the ruling elite, didn't bother to support the kind of infrastructure required to make them on a large scale. Among the public, there were also strong cultural and religious objections against movies, which were believed to lead to moral corruption. Ebrahim Khan Sahafbashi, an antiques dealer, set up the first public movie theater in the backyard of his shop in 1905, but it was eventually shut down because of his political activities. Around the same time, another early cinema enthusiast, Khan Baba Motazedi, bought motion picture equipment in Paris and used it to make filmed entertainments for the pleasure of his friends and family, but he was later ordered to use his talents in the court of Reza Shah. A few tantalizing glimpses of early Iranian cinema can be seen in Mohsen Makhmalbaf's 1992 short documentary *Images of the Qajar Dynasty.*

Political events also hindered the growth of cinema. Reza Shah, after he was installed by a British-backed coup in 1921, preferred to import films from Europe, the United States, and Russia rather than support a homegrown industry. The first Iranian fiction film, Avanes Ohanian's *Abi and Rabi*, a silent comedy about the adventures of two men, one tall and one short, inspired by a Danish serial, didn't appear until 1930. The first Persian-language sound feature, *The Lor Girl*, was released in 1933. It was directed by Ardeshir Irani, who has the distinction of directing the first sound feature in India as well. The Iranian film industry was able to grow over the following decades, as foreign films were subjected to increasingly strict censorship. But the productions were mainly melodramas, thrillers, and comedies recasting the essence of those foreign films within the local rules of representation.

Things began to change in the 1960s. Reza Shah's modernization efforts and Iran's rich, oil-fed economy led to a general cultural flowering that soon found its way to cinema. In 1963, the poet Forough Farrokhzad made her first and only film, *The House Is Black*, which became a touchstone for the talented directors of the Iranian new wave that emerged later. Iran is a country steeped in poetry, where the great Sufi poets Háfez, Rumi, and Omar Khayyám, who were active nearly a thousand years ago, are still avidly read. Farrokhzad, perhaps Iran's greatest twentieth-century poet, had the status of a rock star in her day—a female, Iranian

equivalent of Bob Dylan at the height of his influence—whose poems contain elements of eroticism and celebrate her life as a self-liberated woman. Her legend only grew with her tragically early death in a car accident in 1967, at the age of thirty-two. *The House Is Black*, an impressionistic documentary about a leper colony, welds the poetic sensibility to cinema in a way that has rarely been achieved before or since. Its delicately composed black-and-white images are combined with a poetic narration that depicts leprosy victims with a wealth of sympathy and humanism, traits she shares with Abbas Kiarostami, whose 1999 film *The Wind Will Carry Us* is named for one of her poems.

The late 1960s saw the birth of an Iranian new wave fueled by the emergence of film schools in the early part of the decade and increasing state investment in cinema. In 1969 Dariush Mehrjui, who had studied cinema and philosophy at UCLA, released *The Cow*, a landmark film that was for years voted the greatest Iranian film by Iranian critics (until it was dethroned by Mehrjui's own *Hamoun* in 1990). Set in a remote village, *The Cow* is a fable of rural life in which a man, after his beloved cow dies, takes on the animal's physical and spiritual characteristics. This strange story, which could easily have become comedy, is played with great dramatic intensity by the talented cast, and the imagery—which contrasts the village's bright white walls in the blazing sun with the surrounding landscape awash in misty light, framing characters within small windows or against the vastness of the land around them—complements the cast's performances with raw visual intensity.

Mehrjui's film found great success in international film festivals, inaugurating a repeating pattern for artistic filmmakers in Iran. Its production was state-sponsored, but it was banned after it was made because of its realistic depiction of the hardships of rural life. The ban was lifted only after its international success. It has also been rumored that a screening of *The Cow* convinced Ayatollah Khomeini to allow film production to resume after the Islamic revolution.

The new wave included other filmmakers who have received only limited exposure beyond Iran's borders. Masoud Kimiai's *Caesar* (1969) rethought the Iranian thriller genre by linking it to Persian culture. The stripped-down style of Sohrab Shahid Saless in films like *A Simple Event* (1973) would influence Abbas Kiarostami's early films. Parvez Kiamiavi, a witty and innovative stylist, compared the coming of television to the Mongol invasion in *The Mongols* (1973). And Bahram Beizai has had a long career distinguished by films, such as *Bashu, the Little Stranger* (1989) and *Travelers* (1992), that engage Persian history and culture through a wealth of cinematic idioms. Amir Naderi, who has maintained a fruitful career as an expatriot living in New York, inspired what would become the Iranian new wave with *The Runner* (1985), a film that combines stark realism with a poetic sensibility.

REVOLUTION AND REBIRTH

The leaders of the Islamic revolution saw cinema as a sign of the shah's modernization activities and the creeping Westernization that came with it. During the early days of the revolution, movie theaters were burned to the ground, including one in Abadan in 1978 whose torching resulted in the deaths of four hundred people. When film production finally did resume, strict rules were put in place that still hold today. Women may show only their faces and hands onscreen. The rest of their bodies must be covered by loose-fitting clothing. Touching, tender words, jokes, and looks exchanged between men and women that could be interpreted as desirous are forbidden. Naturally, jokes at the expense of the police or the army, as well as obscene words, are also banned, as is the depiction of villains wearing beards (which would make them look too much like the ruling mullahs), and any Western music. Scripts and crew members have to be approved before production begins, and once a film is completed, it is scrutinized once again and the decision is made to release it, demand cuts, or ban it altogether.

Iranian filmmakers have found ways to turn these restrictions to their advantage. Just as the Sufi poets, forbidden by Islamic law to write about earthly love or the pleasures of wine, used them as metaphors for the praise of Allah, creating evocative, sensuous imagery that yields multiple readings, Iranian

filmmakers embrace subtlety, metaphor, and creative use of mise-en-scène to make films of great depth and humanity.

Over the years, the relationship between filmmakers and the authorities has become increasingly complex. As Iranian cinema became a sensation around the world, rules have sometimes been relaxed, some filmmakers are granted more leeway than others based on their stature, and previously forbidden subjects are occasionally allowed to be shown, which in turn allows the Iranian government to appear tolerant. Iranian directors must play a tricky game in order to get their films made and distributed, and it would seem that only the most resolute and talented are able to get their artistic visions across relatively uncompromised.

KIAROSTAMI

The most famous of Iran's many distinguished directors is Abbas Kiarostami. Although he and others had been making respected films for years, it wasn't until his *Taste of Cherry* shared the Palme d'Or with Shohei Imamura's *The Eel* at the 1997 Cannes Film Festival that Iranian cinema began to receive the widespread recognition it enjoys today. Like the artist Marcel Duchamp, Kiarostami believes that a work of art is only partially completed by its maker. Viewers finish it by experiencing and interpreting it for themselves. His films are full of ellipses, hints, things deliberately left unexplained, allowing for each viewer to arrive at his or her own interpretation. In this way, they are interactive intellectual exercises that invite a kind of cerebral audience participation, an engagement with Kiarostami's own philosophy and poetics. He experiments with film form, blending fiction and documentary. And he is also an accomplished poet and landscape photographer; indeed it could be said that his films lie in the intersection of poetry and landscape. The multifaceted, open nature of his works is a source of enduring fascination and extensive analysis by film scholars.

A painter by training, Kiarostami founded the film department of the Institute for the Intellectual Development of Children and Young Adults in Tehran in the early 1970s, where he made a succession of short films for kids and, not long after, his first feature, *The Traveller* (1974), the story of a young boy who skips school and travels to Tehran on his own to see a soccer game. It is an early example of a repeated theme in his films, the journey, and it is made with the patient skill and attention to visual detail that would come to full flower in his later works.

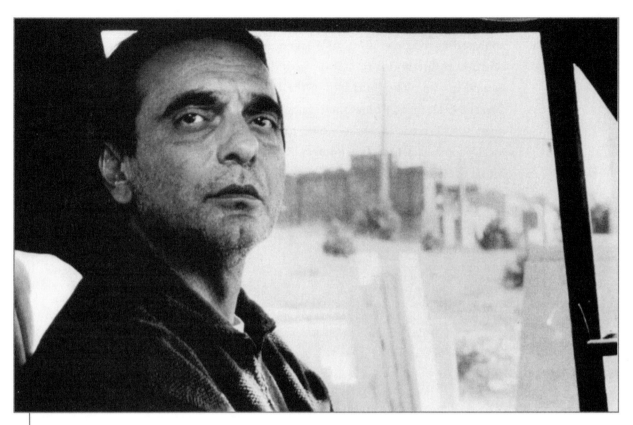

Taste of Cherry

A child's journey is also the plot of *Where Is the Friend's Home?* (1987). In this film, a young boy brings his classmate's workbook home by mistake, and embarks on an odyssey to find the friend's house so the friend won't receive a failing grade from the teacher the next day. It marks the beginning of Kiarostami's mature phase, in which ostensive simplicity gives way to larger questions. The young hero's journey across the barren countryside puts him in contact with a variety of grown-ups, and those interactions (especially a lovely nighttime walk through the village with an elderly craftsman of doors) constitute an education for him, and for the audience.

Where Is the Friend's Home? would become the first in a trilogy of films known as the Earthquake Trilogy. After Koker, the town where it was filmed, was devastated in a 1990 earthquake, Kiarostami returned to make *And Life Goes On*

(1991), in which a director and his son return to Koker to look for the actors who appeared in the previous film. A signature example of Kiarostami's investigation of truth, reality, and fiction, it is also a document of human survival in the face of natural disaster. The third film in the trilogy, the breathtaking *Through the Olive Trees* (1994), further blurs these lines, and adds even more magnificent landscape images. A director comes to Koker to make a film called *And Life Goes On* using local people as actors, but finds it impossible to wrestle the complexity of their actual lives into the context of his fiction. These films elevate daily life into the stuff of art. As in his other films, Kiarostami uses non-actors, whose natural performances ground the films' musings on representation and truth in real life.

TASTE OF CHERRY • Iranian cinema, especially the films of Abbas Kiarostami, began to become a major presence at international film festivals in the 1990s, but Kiarostami's 1997 *Taste of Cherry* was even more of a global breakthrough. After sharing the Palme d'Or with Shohei Imamura's *The Eel*, it received a significant commercial release in the United States. Its allegorical plot, touching on philosophical questions of life and death, proved intriguing to critics and cinemagoers, and its popularity spurred wider interest in the films of Kiarostami and other directors associated with the New Iranian Cinema.

Between the first and second films in the trilogy, Kiarostami explored the same themes in a different way in *Close-Up* (1990). Employing a trope that would be used to great effect by other Iranian directors as well, the film has real people reenacting actual events from their lives, in this case the strange story of a man who impersonated Iranian filmmaker Mohsen Makhmalbaf. It is both playful and surprisingly sympathetic to its hapless hero, who embarks on his deception on the spur of the moment to impress a woman he meets on a bus, and then finds himself so trapped in the character of Makhmalbaf that he becomes hopelessly entwined with the woman's family and even begins planning the film he claims to be making.

Kiarostami's brilliant manipulation of film form, his quest for truth through fiction, his exploration of the gray area where they intermingle, started getting him recognition in Europe, particularly in France. Around the time that *And Life Goes On* came out, Jean-Luc Godard famously declared, "Film begins with D. W. Griffith and ends with Abbas Kiarostami." *Through the Olive Trees* nearly became his breakthrough film in the United States as well, but its release was mishandled by its distributor Miramax.

Taste of Cherry, which finally brought him the widespread recognition he deserved, extends his preoccupations in new directions. An allegory that, in the end, becomes a provocative meditation on cinema and representation, it follows a middle-aged man, who has decided to commit suicide, as he drives through a landscape of red dirt hills outside of Tehran looking for someone willing to bury him after he does the deed. We never learn why he has made this decision, and each person he meets tries to talk him out of it from the perspective of his or her own philosophy of life. The audience becomes creatively engaged in the film—in the end, we are left to our own conclusions, ultimately as alone with ourselves as the protagonist is. It concludes with a formally radical coda that adds another interpretive level hinging on the representational forces of cinema.

Less allegorical but perhaps even more deeply metaphysical is *The Wind Will Carry Us*. For reasons that are deliberately unclear, but have to do with the impending death of a one-hundred-plus-year-old woman, a man called the Engineer and his staff (who are often heard but, like the old woman, never seen) travel to a remote Kurdish village, where the Engineer, between running back and forth up a nearby hill to try to catch a cell-phone signal, interacts with the villagers and waits for whatever it is he's come there for. Infused with droll humor, *The Wind Will Carry Us* is also deeply, mysteriously, poetic, playing on the beauty of the landscape and a dialectic between the seen and the unseen, a potent motif that is played out throughout the film.

Although *Taste of Cherry* and *The Wind Will Carry Us* brought Kiarostami nearly unanimous praise as one of the world's great film artists, he has refused to rest on his laurels. His restless inclinations have taken him down a more experimental path. In 2001, he was invited by the United Nations International Fund for Agricultural Development to make a documentary about AIDS in Uganda. Using a digital video camera, he made *ABC Africa* (2002), a stylistic departure that only further emphasizes his creativity and boundless empathy. Refusing to turn his subjects, mostly children either suffering from the disease themselves or orphaned by it, into objects of abstract suffering, he includes them in the filmmaking process by letting them play with the camera and by participating in their games. Joy and sorrow are mixed in a profoundly humanist document.

Since that film, Kiarostami has continued to explore the possibilities of digital video, which, as he says in his self-portrait documentary *10 on Ten* (2004), allows the filmmaker to become like a painter, an individual artist rather than one

burdened by the expense and cumbersome logistics of working with film. In *Ten* (2002), he consciously tried to erase his presence as a director, a process that calls to mind not only Duchamp but Andy Warhol. It is composed of ten sequences, all shot by cameras fixed within a moving car driven by a divorcée, played by Mani Akbari, as she goes about various errands around Tehran. Conversations with her rebellious son, an old lady on her way to a mosque, a prostitute, and a close friend explore a subject Kiarostami hadn't tackled before: the lives of women in Iranian society. Even though it lacks the magnificent landscapes of his previous work, it still carries considerable emotional and philosophical weight. In its most powerful scene, the friend, in an act meant to rid herself of the pain of a broken relationship, removes her head scarf to reveal that she has shaved off her hair. The sequence both challenges and cleverly skirts the taboo of showing a woman's hair in Iranian films, and creates an indelible image of both sorrow and liberation.

Two other recent films are even more provocatively austere. His *10 on Ten* is made up of ten shots of Kiarostami driving through the hills where he made *The Wind Will Carry Us* and talking about his technique. It is full of nuggets of wit and wisdom, and provides an important look into his creative process. A tribute to the great Japanese director Yasujiro Ozu on the centennial of his birth, *Five: Dedicated to Ozu* (2003) is entirely devoted to looking at landscape and movement. It is made up of five extended static shots filmed by the Caspian Sea, each one a mini visual narrative. One follows the eccentric movements of a herd of ducks. Another simply observes the movement of a piece of driftwood on the water. The most challenging of his films, it also reveals the essence of his technique and what he wishes to inspire in audiences: thoughtful contemplation of the world.

In addition to making his own films, Kiarostami is generous in lending his writing talents to others. He collaborated with Alireza Raisian on *The Journey* (1994), a look at the psychological deterioration of a family displaced by war, and *Deserted Station* (2002), about a couple whose car breaks down in a remote village. Kiarostami's influence is evident in the stark narrative, but it is blended with Raisian's stylistic concerns and exploration of the psychology of the woman, whose previous problems with having children drive her to help the kids in the village.

He has also worked with Jafar Panahi on two highly successful endeavors. *The White Balloon* (1995), like Kiarostami's *Where Is the Friend's Home?*, follows the adventures of a child, in this case a little girl, whose journey to buy a new

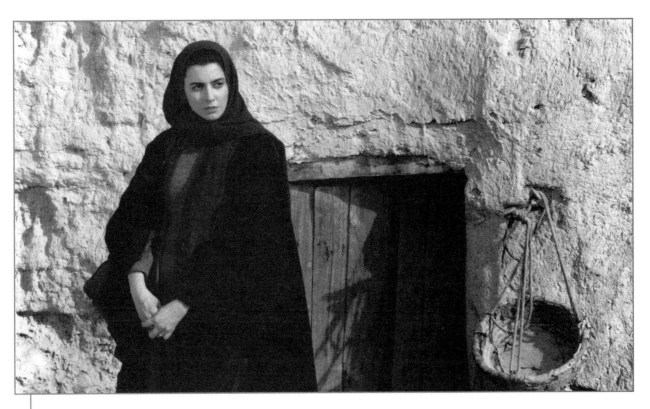

Deserted Station

goldfish is fraught with adult interference. The dark, seething *Crimson Gold* (2003) reveals class differences rarely seen in Iranian cinema, through the eyes of a pizza deliveryman whose job takes him from his own poor circumstances to the homes of the elite, and whose desperation drives him to a shocking act of violence. Its disturbing extended opening shot, a tour de force of visual choreography, displays Panahi's formidable filmmaking gifts.

MAKHMALBAF FILM HOUSE

Kiarostami's rise to prominence was paralleled by that of his friend Mohsen Makhmalbaf. Like Kiarostami, he is artistically adventurous and interested in expanding film form. He is also as committed to political justice as he is to cinema. As a teenager he took part in the Islamic revolution, and at age seventeen he stabbed and wounded a police officer while struggling over a gun. Originally sentenced to death, he was given a prison term instead due to his

youth, and was released after more than four years when the shah was overthrown in 1979.

Makhmalbaf's early films burn with a commitment to social justice. *Boycott* (1986) is a fictionalized account of his time in prison. Majid Majidi, who would become a major director in his own right, plays the main character, who begins to question whether the cause that landed him in a prison full of sadistic guards and mad cellmates was worth it. *The Peddler* (1987) looks at the plight of the urban poor through three connected stories. At the heart of these movies is Makhmalbaf's rage at man's inhumanity to man, which is also the theme of the most artistically accomplished of these early, angry films, *The Cyclist* (1979). In it, an Afghan refugee, a former champion cyclist, agrees to ride a bicycle for seven days straight to raise money for medical care for his sick wife. He is exploited by everyone from the gamblers who arrange it, to the cynical doctors who demand cash daily to continue his wife's care, to politicians and the media, yet he maintains his dignity in the face of this array of uncaring forces. Ironically, it was the popularity of *The Cyclist* that inspired a hapless conman to exploit his resemblance to Makhmalbaf, which eventually led to him becoming the subject of Kiarostami's landmark *Close-Up*.

Makhmalbaf later turned his attention to cinema itself as a subject. *Once Upon a Time, Cinema* (1992) is an affectionate look at the history of Iranian film, employing an array of clever tricks, some of them as old as the silent era, to mix vintage film clips with contemporary footage in a whirlwind love letter to the medium. In *The Actor* (1993), a comedian tries to outgrow his persona and make serious films, only to achieve the opposite. In honor of the centennial of the invention of motion pictures, Makhmalbaf made *Salaam Cinema* (1995), a semifictional account of a casting call he put out, which documents the resulting interviews with actors and non-actors alike.

An unexpected event during the casting sessions captured in *Salaam Cinema* led to a new artistic direction for Makhmalbaf. One of the aspiring actors who showed up was Mirhadi Tayebi, the very policeman he had stabbed some twenty years earlier. *A Moment of Innocence* (1996) documents Makhmalbaf's collaboration with Tayebi on a film about the event. Their wrangling over both casting and their contrasting views of the fateful event (Tayebi regarded it as the end of his own innocence) provides both comedy and a moving examination of the way the fateful moment influenced the course of both men's lives. For Makhmalbaf, it

is a reconciliation with both his victim and his past. Artistically, it is one of his finest achievements, blending narrative experimentation with a thoughtful consideration of the paths lives can take.

The same year that Kiarostami's *Taste of Cherry* won the Palme d'Or at Cannes, Makhmalbaf's *Gabbeh* (1996) became only the second Iranian film (after Panahi's *The White Balloon*) to receive widespread distribution in the United States. A colorful fairy tale told in ravishing colors and lush landscapes, *Gabbeh* takes its title and its multiple, interlocking plots from a type of traditional Persian carpet that has figures and stories woven into the design. Its success helped to pave the way for more Iranian films to make their way to the West. The visual flair he displayed in that film is put to quite different use in *The Silence* (1998), which translates the interior life of a blind boy into a sensuous world of color and sound.

This represents only a fraction of Makhmalbaf's output. By the end of the 1990s, he was a major cultural force in Iran, having made fifteen features as well as numerous shorts and documentaries and, along the way, found time to publish some twenty-eight books. And it doesn't end there. When his teenage daughter Samira expressed a desire to leave school and study film, Makhmalbaf, unable to find a film school for her to attend, applied for funds from the government to start one of his own, but was rejected. In the wake of the censorship troubles surrounding *A Moment of Innocence*, they feared such a school would only turn out rebels like him. Undaunted, he mortgaged his home to establish Makhmalbaf Film House, whose first students were the members of his own family.

Samira has turned out to be his star pupil. At the age of eighteen, she became the youngest director ever invited to the Cannes Film Festival, for her debut film, *The Apple* (1998), which she made when she was only seventeen. It recreates the true story of two developmentally disabled girls who were locked in their Tehran home by their father for the first twelve years of their lives. The members of the family play themselves, and the most moving scenes show the girls' first adventures out in the real world. With a tremendous generosity of spirit, Makhmalbaf even inspires sympathy for the father, a poor man with a blind wife who simply couldn't think of another solution to his problems.

The first film by an Iranian woman to receive widespread international distribution, *The Apple* was invited to film festivals in over a hundred countries. Her second film, *Blackboards* (2000), was even more successful, giving Samira the

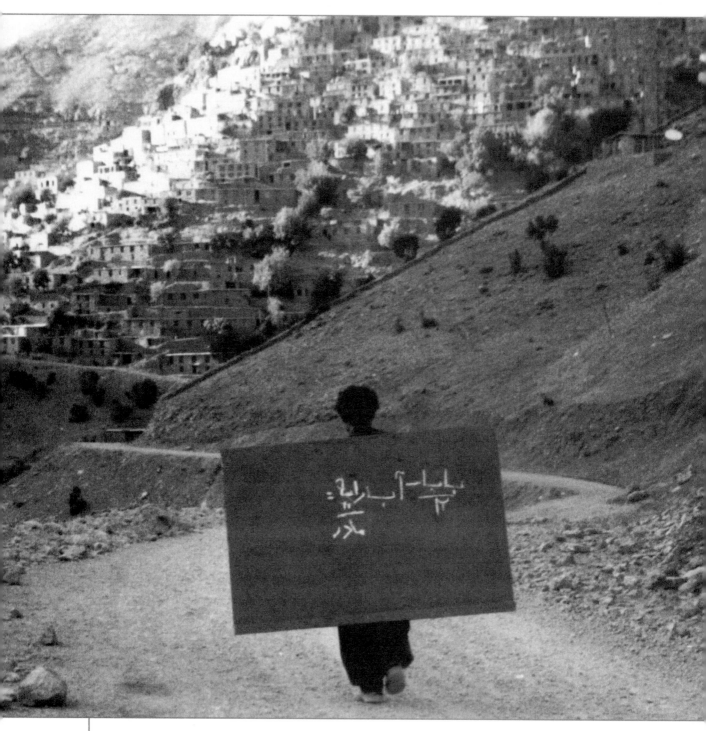

Blackboards

distinction of being the youngest director ever to win the Jury Prize at Cannes. Makhmalbaf the Younger shares with her father a concern for social justice and adds to that a talent for channeling that passion into moments of astonishing emotional and visual power. *Blackboards*, the story of two itinerant teachers traveling with a group of nomadic Kurds during a time of war, is replete with such moments, such as a Kurdish woman's sudden, passionate rebuff, with a single line of dialogue infused with poetic intensity, of one of the teachers' romantic advances, and the repeated image of the blackboards strapped to the backs of their owners as they are carried with a flood of humanity through a rocky, forbidding landscape. Makhmalbaf's run of achievements continued with *At Five in the Afternoon* (2003), one of the first films made in post-Taliban Afghanistan, which won her a second Jury Prize at Cannes. Ostensibly the story of a woman's dream of becoming the first female president of Afghanistan, it addresses the nation's struggle to recover from Taliban rule by focusing on the dynamics of a single family living among refugees in a ruined palace. The family includes a cruel, conservative father who can confess his inner pain only to his horse, and a sister determined to look for a better life, which leads to the film's second half, a harrowing family journey across the desert that at times rises to emotional heights that are almost unbearable.

The rest of the Makhmalbaf family have their share of achievements as well. Samira's younger siblings have each made documentaries about her working process, brother Maysam with *How Samira Made the Blackboard* (2001), and sister Hana with *Joy of Madness* (2003), an account of the making of *At Five in the Afternoon* that charms with its undertone of sibling rivalry. (Hana was a mere fourteen when she made it.) Mohsen's wife, Marziyeh Meshkini, is also a graduate of the film house. Her 2000 debut feature, *The Day I Became a Woman*, is a look at the situation of women in Iran through three allegorical tales. Her second film, *Stray Dogs* (2003), stands beside her daughter's *At Five in the Afternoon* as a powerful account of desperation and survival in post-Taliban Afghanistan.

Mohsen Makhmalbaf shares with the rest of his family an interest in Afghanistan. In 2000, he made *Kandahar*, a film that is startling in its impassioned concern for Afghan refugees and its moments of surprising beauty, composed as they are of women in colorful burkas or amputees receiving aid from the Red Cross. It began to receive widespread attention after September 11, 2001, for its prescient depiction of the issues facing Afghan society.

WOMEN FILMMAKERS IN IRAN

The women of the Makhmalbaf family are far from being the only active female directors in Iran. Interestingly, in a country with a reputation for subjugating women, there are comparatively more successful women directors working there than there are in the American film industry. Following in the footsteps of the pioneering Forough Farrokhzad, these women often make films that directly address women's lives and roles in society. Maryam Shahriar's *Daughters of the Sun* (2000) is a prime example. Using a very Kiarostamian mix of sensitive landscape photography and understatement, it is a barely concealed allegory on the position of women in Iran, told through the story of a woman forced to disguise herself as a boy and work for a cruel weaver in a remote village.

Rakhshan Bani-Etemad, perhaps the most accomplished female filmmaker in Iran, first made her mark with *Narges* (1992), a groundbreaking film about a love triangle among thieves that challenges notions of the traditional Iranian woman, and in one scene brilliantly subverts the ban on men and women touching with a carefully choreographed struggle over a purse. Bani-Etemad is a supreme constructor of narratives, able to weave complicated issues into the forward momentum of her storylines. *The May Lady* (2000) is a multilayered examination of female consciousness that seamlessly mixes fiction, documentary footage, and a compelling voice-over narration. The main character, a divorced documentary filmmaker, is forced to examine her relationship with her teenage son while making a film about women less fortunate than herself. Her 2001 film *Under the Skin of the City* confronts social problems with surprising candor as a mother tirelessly tries to keep her family together despite her son's ambition to leave the country, an ambition that leads him into a world of drugs and crime. She has also taken on big issues, such as women's role in politics in her kaleidoscopically constructed 2002 documentary *Our Times* and in her tragic feature about the Iran-Iraq War's toll on a poor rural family, *Gilaneh* (2005, codirected by Mohsen Abdolvahab).

In 2001, Tahmineh Milani made international headlines when she was imprisoned over the content of her film *The Hidden Half*. Her crime, which could have carried the death sentence, was exposing a dark period in recent Iranian history, the so-called Iranian Cultural Revolution of the 1980s, when universities were closed down because of student unrest. The main character, a death-row prisoner, recounts in flashbacks her radical political activities to the political appointee she

hopes will save her. The film blends melodrama and fierce feminist content, as does Milani's earlier *Two Women* (1999), about a village woman who rebels against her arranged marriage.

Milani's imprisonment triggered worldwide condemnation of the Iranian authorities, who saved face by releasing her with the caveat that they could still arrest her at any time. Her situation illuminates the vagaries of the Iranian censorship system and the forces that run it. Despite the possibility of serving time again, Milani, one of Iran's most popular filmmakers, continues to make politically challenging films. *The Fifth Reaction* (2003) couches in a thriller plot a woman's attempts to battle patriarchal authority after the death of her husband; and in *The Unwanted Woman* (2005), a woman is forced to go on a trip with her cheating husband and his new lover, only to meet a murderer on the run. It's possible that the authorities allow Milani's continued outspokenness because it lets them to appear tolerant to the world. Nevertheless, few other directors in Iran are able to get away with such upfront social criticism in their films.

THE CONTINUING CONVERSATION

Women's lives have become popular subjects for films by male directors as well. Witness Kiarostami's *Ten* and Jafar Panahi's *The Circle* (2000). Panahi, whose *The White Balloon* and *Crimson Gold* were discussed earlier, is a politically committed director with a great feel for structure. *The Circle's*

LEILA HATAMI
IN *Leila*

title ingeniously forms the shape of the film's narrative, which weaves together the stories of several women on the bottom rung of society, pointing out how their desperation leads to transgressions that inevitably return them to punishment. Dariush Mehrjui also made a powerful film about the Iranian tradition of allowing a man to take a second spouse if his wife is unable to conceive. *Leila* (2000) is almost painful in its depiction of the emotional intimacy of a couple in that situation, with a performance by Leila Hatami in the title role that is marvelous in its nuances.

LEILA HATAMI • Leila Hatami was born into a cinema family—she is the daughter of director Ali Hatami and actress Zari Khoshkam—but she got into acting only after pursuing studies in electrical engineering and French literature in Switzerland. Her intellectual curiosity is apparent in the emotional complexity she brings to the characters she plays, beginning with the title role in Dariush Mehrjui's *Leila*. Playing a woman whose husband is searching for a second wife, she uses the subtlest of facial expressions to reveal the pain she's suffering, even as she encourages him in his quest.

In the wake of Kiarostami and Makhmalbaf's international success, more and more Iranian films have found their way to the West, many of them cloaking their political and social statements in allegory and blends of fiction and documentary techniques. An astonishing number of them are impressive in their visual poetry as well. Majid Majidi is one director of such films. In *Children of Heaven* (1997), *The Color of Paradise* (1999), and *Baran* (2001), among other films, he convincingly portrays the world from the perspective of children without pandering or denying the importance of their lives. A stolen pair of running shoes in *Children of Heaven* leads a poor brother and sister into increasingly elaborate schemes to conceal their loss, culminating in its famous footrace scene. It became the first Iranian film to be nominated for an Academy Award. *The Color of Paradise*, the title of which aptly describes the beauty of the natural world it depicts, has at its center a blind boy enduring a family tragedy whose sensitivity to the world around him is delicately emphasized through Majidi's ingenious use of sound. *Baran* leaves paradise for the world of Afghan day laborers in Tehran, but its story is no less powerful, even as it veers from social commentary to romantic comedy.

Bahman Ghobadi, a Kurdish Iranian who starred in Samira Makhmalbaf's *Blackboards*, has made two powerful films about war and its toll on his people, whose territory straddles the borders of Iran and Iraq and who have been subject to oppression by both countries. *Marooned in Iraq* (2002), which takes place at the end of the Iran-Iraq War, manages to mine bits of comedy from the essentially tragic story of an elderly musician determined to find his wife, a famous singer who fled to Iraqi Kurdistan. His immensely powerful *Turtles Can Fly* (2005) is set during the war in Iraq, in a Kurdish village devastated by war, where the residents, through sheer ingenuity, manage to make the most of what is available to them. Its hero, a teenager with a talent for scheming, gives the film a charismatic center—a symbol of survival in a war-torn world where even Iraq's "liberation" at the hands of the United States may not provide hope for the future.

In traveling film series and at film festivals throughout the world, new Iranian films continually appear, and continue to impress audiences. The source of their continued interest for global audiences lies in the necessity that they veil in allegory and fable whatever could be construed as subversive. The sinking ship where a community has established itself in Mohammad Rasoulof's *Iron Island* (2005), for instance, can easily be interpreted as a ship of state, with its captain standing in for Iranian officialdom, but its story also references classic tales from Persian literature and poetry. Techniques such as this, as well as their consistently high level of visual artistry, give Iranian films a touch of the universal. Both elusive and allusive, they engage the world in a way that few national cinemas have.

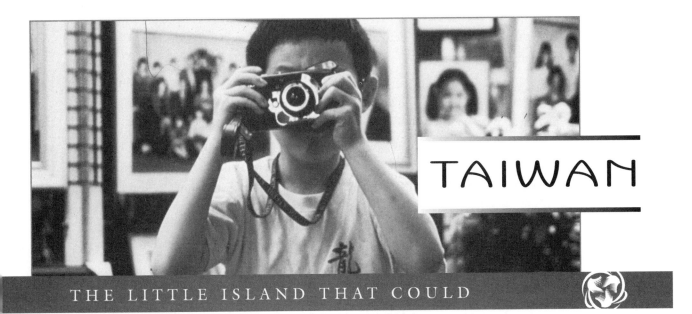

TAIWAN

THE LITTLE ISLAND THAT COULD

HISTORICAL BACKGROUND

A small, mountainous island off the southeast coast of China, Taiwan has a history that has been marked by its often contentious relationship with its much larger neighbor China, which still does not regard it as a sovereign country. In fact, from the seventeenth century until after World War II, Taiwan was almost continually occupied by foreign powers, beginning with the Netherlands, which was followed by China and finally Japan, which controlled the island from 1895 to 1945, during which much of its modern infrastructure was built. As we will see, the question of a Taiwanese national identity would become one of the central preoccupations of the New Taiwanese Cinema movement that emerged in the 1980s.

At the end of World War II, the Allied powers agreed to let China occupy Taiwan on their behalf. The Taiwanese were at first grateful to be rid of the Japanese, but the rule of Chiang Kai-shek's Kuomintang (KMT) political party soon became brutally repressive. Tensions came to a head on February 28, 1947, when KMT officials beat a woman they suspected of selling black market cigarettes and shot

a passerby who tried to help her, setting off an island-wide revolt that ended on March 8 after KMT troops had slaughtered over twenty thousand people. Known as the February 28 Incident, it is the most traumatic event in modern Taiwanese history.

In 1949, China's long-running civil war ended when the Communists under Mao Tse-tung finally defeated Chiang Kai-shek's KMT. Chiang fled to Taiwan with what was left of his regime, and established martial law, which wasn't fully lifted until 1987. Although Taiwan today is fully democratic and Taipei, its capital, a humming high-tech metropolis, tensions still exist between the island's natives and the descendants of those who came over from China with the KMT.

THE EMERGENCE OF TAIWANESE CINEMA

During its occupation of Taiwan (which began, coincidentally, in 1895, the same year as the birth of cinema itself), Japan imposed strict controls on filmmaking, much of which was limited to propaganda efforts. Only about ten features were produced in Taiwan during the entire occupation, all made either by Japanese film crews using the island as a location or as joint Taiwanese-Japanese collaborations. One of these, *Watching the Spring Wind Blowing* (1938), was surprisingly successful. Produced by a company founded by a Taiwanese theater owner, it featured Taiwanese dialogue, and even traditional music. But soon after, as part of their "Japanization Movement," implemented during the invasion of China, the occupiers banned the use of the Taiwanese language on the island.

When Taiwan was handed back to China after World War II, the KMT quickly established production studios. Chinese and Japanese films were banned, and much of what was produced well into the 1950s was blatant anti-Communist propaganda.

The Japanese had built a sophisticated infrastructure for film exhibition, but production facilities were still relatively primitive, so Taiwanese filmmakers had, in a sense, to reinvent cinema. As in the earliest days of silent movies in the West, they began by simply filming plays performed in the Taiwanese language, with no attempt to create the illusion of reality. But the industry grew up quickly, producing over a thousand Taiwanese-language films between 1955 and 1972. And soon directors like He Jiming and Lin Bochiou were making sophisticated films dealing with subjects specifically tailored to Taiwanese filmgoers. For

instance, He's *Bloodstain on a Green Mountain* (1957) depicted an aboriginal uprising during the Japanese occupation; and Lin's *Heartbroken Night on May 13* (1965) condemned traditional Chinese values that oppressed women. One of the greatest directors of this period was Xin Qi, whose films include the social drama *Dangerous Youth* (1969) and an adaptation of *Jane Eyre* charmingly titled *Bride from Hell* (1965). Many of Xin's films have been restored lately, and he was given a lifetime achievement award at the 2000 Golden Horse Film Festival in Taipei.

The popularity of these films worried KMT officials, whose unofficial policy was to suppress the Taiwanese language in favor of the mainland Mandarin dialect. Inspired by the polished and popular movies coming out of Hong Kong as well as by the Italian neorealists, the state-run Central Motion Picture Company (CMPC) began producing "Healthy Realistic" films. These were essentially very well-made propaganda movies that focused on the virtues of rural life while clearly emphasizing the government's role in providing a great future ahead.

The 1960s also saw a wave of Hong Kong talent coming to the island to take advantage of its large Mandarin-speaking audience. Hong Kong's Li Hanxiang, whose hugely popular *The Love Eterne* (1963) started a trend toward films based on the Chinese opera form known as *huangmei diao*, established a production company in Taiwan. King Hu, whose graceful *wuxia pian*, or swordplay films, continue to dazzle audiences today, moved to Taiwan in 1967. His first Taiwan-made feature, *Dragon Inn* (1967), proved to be hugely influential. Its popularity inspired numerous Taiwanese swordplay films over the following decades. And two of the most distinguished directors of a much younger generation would pay tribute to it in very different ways with *Crouching Tiger, Hidden Dragon* (Ang Lee, 2000) and *Goodbye, Dragon Inn* (Tsai Ming-liang, 2003).

In the early 1970s, Taiwanese- and Mandarin-dialect films battled at the box office. The CMPC scaled back on the heavy propaganda in its "Healthy Realistic" productions and began making films in a popular style (often melodramas with pop songs on the soundtrack), aimed at the island's growing urban population. This trend resulted in at least one film that is considered a masterpiece, Bai Jingrue's *Goodbye Darling* (1970), which managed to sneak social criticism into its plot about a love affair between a funeral band leader and a truck driver. The popular rise of Bruce Lee's Hong Kong–made kung fu movies, which coincided with Japan's cutting off diplomatic relations with Taiwan after the KMT's government-in-exile was expelled from the United Nations, touched off a slew of Taiwanese

Crouching Tiger, Hidden Dragon

imitations in which the bad guys were often none too subtle metaphorical stand-ins for the island's former occupiers.

Meanwhile, in response to souring relations with both China and Japan, the KMT imposed strict censorship on film content, with the result that the 1970s were dominated by harmless fare such as kung fu movies and melodramas, and war films designed to inspire patriotism.

All of this changed in the early 1980s, however, with the rise of the New Taiwanese Cinema.

NEW TAIWANESE CINEMA:
THE MAKING OF A NEW WAVE

Because of the Japanese occupation, Taiwan's long struggle with China, and the commercial and economic strength of Taiwan's neighbors, it took a long time for Taiwan's film industry to mature. But in the 1980s, Taiwanese cinema burst onto the world scene, thanks primarily to the innovative films of Edward Yang and Hou Hsiao-hsien, which began garnering awards at major film festivals and critical raves around the globe. As if overnight, this small nation with a historically weak film industry was consistently producing cinema of the highest order, and references were being made to the "New Taiwanese Cinema." How did this happen?

Major film movements tend to spring from a confluence of like-minded, aesthetically adventurous filmmakers with a political and cultural climate that allows and inspires them to investigate their nations' histories. These movements depend, to a certain extent, on a nation being willing to question itself, as was the case with the late 1950s France that spawned the *nouvelle vague*, and the 1960s and 1970s that inspired new wave movements in Japan, Germany, and, to a lesser extent, the United States.

In Taiwan, this questioning began in 1983 with the release of two omnibus films produced by the CMPC. The first, *In Our Time*, was a collaboration between Jim Tao, Edward Yang, Ko Yi-cheng, and Chang Yi, each of whom directed an episode. While the episodes are essentially unrelated (and stylistically quite varied), they are linked by the theme of coming-of-age, as it relates to the characters in the episodes and to Taiwan itself. Each episode takes place in a different decade,

spanning the 1950s to the 1980s, and the social transformation of the nation is reflected in the personal transformations the characters go through. The second, *The Sandwich Man*, was a collection of three adaptations, by Hou Hsiao-hsien, Zhuang Xiang-zeng, and Wan Jen, of writer Huang Chunming's tales of growing up in the 1960s. Both films were reactions against the genre-based, escapist fare that had dominated the Taiwanese film industry until that time. They launched the New Taiwanese Cinema in general and the careers of Hou and Yang in particular, each of whom released features in the same year that would become touchstones of the movement: Hou's *The Boys from Fengkuei* and Yang's *That Day, on the Beach* (both 1983).

THE GROWTH OF TAIPEI • In the early 1960s, Taiwan's economy was driven by agriculture. By the early 1980s, it was driven by technology. This period of rapid growth vaulted Taiwan into the global economy and transformed its capital, Taipei, into a sprawling modern metropolis. The Taiwanese filmmakers who came into their own in the 1980s and 1990s saw these changes firsthand, and the changing city around them became both the backdrop and the subject of their work. In Edward Yang's *Mahjong* (1996), Taipei is the hunting ground for international opportunists looking to make a quick killing in the new economy. For Tsai Ming-liang, it's a place of alienation and anonymity, where emotional connections are nearly impossible to make.

One big reason for the movement was the KMT's 1983 decision to relax censorship restrictions in response to public calls for democratization. Taiwan was moving toward a national identity after decades of colonization. These films were a first step toward forging that identity by focusing on the daily life of Taiwanese people in a truly realistic way (as opposed to the "Healthy Realism" of the past).

While there was the expected tension between the filmmakers of the New Taiwanese Cinema and conservative elements within the government, it is interesting to see how much support they were given. The CMPC instituted a "newcomer policy" to encourage the work of these young filmmakers, with the stated expectation that they win awards at international film festivals. Of course, awards, and even acceptance into festivals, were out of the hands of both the CMPC and the directors themselves, but the considerable talents of Hou and Yang were soon recognized on the world stage.

Although the success of these two filmmakers can be partly attributed to a combination of training, talent, and early support from the CMPC, there is another factor at play as well. Fredric Jameson, in "Remapping Taipei," an essay

on Yang's *The Terrorizers* (1986) writes: "Taiwan is somehow within the world system as its citizens are in their city boxes: prosperity and constriction all at once." Fueled by the Asian economic boom, Taipei in the 1980s and 1990s was growing at a tremendous rate (in the films of Yang and Tsai Ming-liang, the city often seems to be eternally under construction). Just as Taiwan was beginning to think of itself as a nation, the traditional Confucianism and rural life of its past were giving way to a hypermodern capitalist present, with Taipei serving as the model of the contemporary world megalopolis: crowded, new, fast-paced, and with as much in common with Hong Kong, Tokyo, or Los Angeles as with the rest of Taiwan. The quest for a national identity became an identity crisis for Taipei's new urbanites as they were rushed headlong into a global economy where local cultural influences are drowned in a flood of advertising and pop culture (much of it American) and nature was rapidly giving way to concrete, traffic, and skyscrapers.

What Jameson suggests is that the situation of Taipei's denizens—rootless, bombarded by advertising and media, cut off from tradition, and without even a collective cultural identity to cling to—is shared by people all over the industrialized world, but Taiwan's polyglot culture and tangled history put it in a unique position and prepared directors like Yang to see these swift-moving global changes from a particularly compelling vantage point. For the filmmakers of the New Taiwanese Cinema, this abrupt change, taking place at a time of national self-questioning, provided fertile subject matter.

Hou Hsiao-hsien was the first to receive widespread international recognition. Widely regarded one of the world's greatest living directors, he is regularly compared to Robert Bresson and Yasujiro Ozu, and shares with them an ability to transform the small events and gestures of everyday life into resonant images with lasting emotional power. Until the late 1990s, his films were concerned almost exclusively with issues of Taiwanese history and identity as seen through the eyes of ordinary people. He has since turned his gaze to both historical and contemporary topics while continually retooling his contemplative, elliptical style.

Hou was born in China's Guangdong Province in 1947, and emigrated to Taiwan with his family in 1948. His first three films, *Cute Girls* (1980), *Cheerful Wind* (1981), and *The Green, Green Grass of Home* (1983), were light, commercial comedies hardly indicative of what was to come. It was only after he joined the CMPC that he had the artistic freedom to develop his mature style. After contributing the most well-known episode to the omnibus film *The Sandwich*

Man, he quickly followed with *The Boys from Fengkuei*, the film that introduced the themes that would characterize his films well into the 1990s.

Suffused with a mood of sadness and loss but still retaining some of the light humor of his early commercial films, *The Boys from Fengkuei* follows the exploits of a group of teenagers from a small fishing village who move to the city and fall prey to the pitfalls of urban life. The tension between country and city, family and independence, and the sad inevitability of growing up are among the thematic elements that would continue to crop up in Hou's films of this period. *Boys* is also an early display of Hou's great affection for wayward youths, petty criminals, and other societal misfits. In this film and in later ones such as *Goodbye, South, Goodbye* (1996) and *Millennium Mambo* (2001), he treats them with a degree of respect and understanding that is genuinely touching. His next film, *A Summer at Grandpa's* (1984), still hews to the narrative conventions he would soon abandon. Told from the point of view of eleven-year-old Ting-Ting, who is sent, along with his sister, to live with their grandfather while their mother is ill, it is a coming-of-age story that refuses to condescend to its young protagonists.

As successful as the two previous films were, Hou's breakthrough was 1985's *A Time to Live and a Time to Die*. Both deeply personal and formally daring, it tells the story of a family that (like Hou's own) moves to Taiwan from mainland China and is unable to return after the Communist takeover. While the parents and grandmother deal with the pain of exile, the children struggle to find their place in a country that both is and isn't theirs, and over time the younger generation has to face the passing of the older one. This sketch of *Time*'s plot barely hints at what makes it Hou's first masterpiece, because with this film he truly becomes a poet of daily life. His meticulously composed long takes and meandering narrative structure reflect the rhythms of small-town existence, the rituals of family interactions, and the events that can suddenly change the course of a life. Few films so movingly depict the way the currents of history change the lives of everyday people, and it rang particularly true for Taiwanese audiences, who could readily identify with this story about a displaced generation passing on its sense of impermanence to their children. It was also Hou's first international success, winning awards at the Berlin International Film Festival and the International Film Festival Rotterdam, and earning him comparisons to Satyajit Ray and Robert Bresson from international critics.

A Summer at Grandpa's, A Time to Live and a Time to Die, and Hou's

next film, *Dust in the Wind* (1987), have come to be seen as a trilogy about growing up in a troubled society. Based on incidents from the life of the film's screenwriter, Wu Nien-jen (a frequent Hou collaborator who also directed the acclaimed *A Borrowed Life* [1994] and would later star in Edward Yang's international hit *Yi Yi* [2000]), *Dust* employs Hou's distinct visual language to tell the tale of a pair of high school sweethearts who leave the mining town where they grew up to make a life together in Taipei. Hou's distanced long takes emphasize the relationship between people and the landscape, while repeated shots from moving trains give a sense of transience to the events that affect the film's characters in ways that are, for them, matters of life and death. Again, history is more than a backdrop, as the characters become pawns in Taipei's rapid industrialization.

Three later films, *City of Sadness* (1989), *The Puppetmaster* (1993), and *Good Men, Good Women* (1995), form another trilogy, one that develops an even more panoramic view of Taiwanese history than the first one. These films cemented his international reputation.

His most ambitious project yet, *City of Sadness*, finally put the New Taiwanese Cinema on the world map, winning the prestigious Golden Lion at the Venice Film Festival. It takes place during the years 1945–1949, the most traumatic period in modern Taiwanese history, a time during which Chiang Kai-shek's KMT took control of the island and brutally suppressed its people during the notorious February 28 Incident, and Mao's Communist revolution took over China. Hou looks at these events through the effects they have on a single extended family, once again powerfully emphasizing the effects of historical events on the everyday people who become caught up in them. This theme is a particular obsession of Hou's, and the aesthetics of his filmmaking reflect his convictions. He makes masterful use of narrative ellipses and offscreen space (reinforcing the idea that history happens elsewhere but its effects are felt everywhere) and employs his customary style of long takes, this time heavily influenced by Chinese landscape painting. It is the perfect synthesis of form and function.

The Puppetmaster reaches back even further into Taiwan's history. A masterful blend of documentary and fiction, it looks at the years of the Japanese occupation through the eyes of Li Tianlu, a famous puppeteer (and, according to Hou, "a living encyclopedia of Chinese tradition") who also regularly acts in Hou's films. The film moves between interview footage of Li and reenactments of episodes from his remarkable life during the Japanese occupation, when he

had to walk a tightrope between resisting the occupying authorities and catering his performances to their tastes. Hou brilliantly weaves together three distinct narrative elements: the interview footage, the reenactments, and performances spanning the history of Chinese theatrical tradition, creating a mesmerizing contemplation of performance, representation, and the role of the artist in society. Hou's achievement was rewarded at the Cannes Film Festival, where it won the Jury Prize.

Hou continued his radical formal experimentation in the third film in the Taiwan trilogy, *Good Men, Good Women*. Ostensibly about an actress preparing for a role in a film about freedom fighters during the KMT's brutal late-1940s crackdown, it develops a complex film-within-a-film structure that parallels the troubled life of the modern-day actress with the nation's troubled past. Its dense narrative and continuous movement back and forth in time further develop Hou's continuing dialectic between the individual and history.

His next film, *Goodbye, South, Goodbye* (1996), was a marked change in stylistic and thematic direction. Full of movement and employing a contemporary, pop-based soundtrack, it follows the exploits of a bunch of small-time gangsters. As in *A Time to Live and a Time to Die* and *Dust in the Wind*, Hou pins his narrative pacing to the rhythms of his characters' lives, alternating between the stasis of hanging out, the simple ecstasy of riding motorcycles on the open road, and sudden outbursts of violence. Hou's fascination with gangsters stems from his youth. They were a major presence in the town where he grew up (Olivier Assayas, in *HHH*, his documentary on Hou, films him going back home to hang around with some of them), and like the lost and alienated youths who often crop up in his films, they are for him an inevitable symptom of Taiwan's development. Left behind by modernity and cut off from tradition, they turn to organized crime as a way of making sense of the world.

With *Goodbye*, Hou broke away from what people had come to expect from him, but *Flowers of Shanghai* (1998) was an even more radical departure. Set entirely within the brothels (or "flower houses") of nineteenth-century China, it depicts the intertwining relationships of a group of prostitutes and their wealthy clients. Lit in golden, lamplit hues, the film unfolds slowly in an atmosphere of suppressed desire and a haze of opium smoke. His first film set outside of Taiwan and entirely indoors, it also represents an even more significant change in his style. As opposed to the mainly static shots of his previous films, *Flowers* is shot with a

SHU QI IN *Millennium Mambo*

constantly moving camera, which subtly sways throughout the film. The effect is a dreamlike, floating world, and it makes for an absorbing experience.

This floating camera would again figure in *Millennium Mambo* (2001). As we have seen, Hou has a deep, abiding affection for what might be called the losers of the world: petty gangsters, alienated teens, bargirls, and the like. *Mambo* stars the pan-Asian movie star Shu Qi as Vicky, a high school dropout who works as a hostess in a seedy bar and lives with her abusive boyfriend. Every bit as hypnotic as *Flowers*, it uses the voice-over device as a way of experimenting with narrative registers. Vicky's narration is often modified or enhanced by its depiction. The result is a moving character study that moves from the squalid milieu of cheap Taipei apartments and seedy bars to a lovely epiphany in the snows of northern Japan.

In honor of the centenary of the birth of Yasujiro Ozu (a major influence on him), Hou dedicated his next film, *Café Lumiere* (2003), to the Japanese master. Utilizing a style that pays tribute to Ozu's while retaining the hallmarks of his own, it also hinges on a theme both directors often treat: the tension between familial duty and independence. Yoko, the protagonist, is a Japanese reporter, doing research on the real-life Taiwanese composer Jiang Wenye, who discovers that she is pregnant by her Taiwanese boyfriend. In the course of her work, she befriends a reclusive bookstore owner obsessed with trains. Their growing relationship is developed using the favored techniques of Hou and Ozu: an elliptical narrative structure, compelling use of offscreen space, and a feeling of serenity and acceptance. It is both a worthy tribute to Ozu and a satisfying addition to Hou's evolving canon.

Millennium Mambo's Shu Qi is also the muse of *Three Times* (2005). She stars with Chang Chen in three love stories, set in 1966, 1911, and 2005. Each vignette is a reflection on the constraints these eras place on the lovers. In

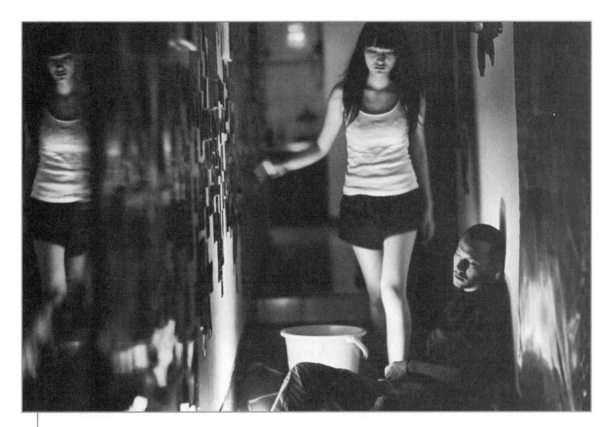

Three Times

its obsession with time and memory, its display of all of Hou's formal gifts, it functions as a dreamlike crystalization of his career thus far.

If Hou is the poet of Taiwan's ordinary people, its working class, its gangsters and bargirls, Edward Yang, who died of cancer in 2007, is the chronicler of its cosmopolitan middle and upper classes. Like Hou, Yang was born in 1947 in China (Shanghai, in his case) and moved to Taiwan with his family when he was two years old. He shares with his colleague a predilection for careful, precise mise-en-scènes and long takes, but his subject matter from the beginning mostly concerns present-day urbanites, and his plots are densely novelistic, packed with characters whose lives intertwine in complicated ways. His first film, *That Day, on the Beach*, introduced what would become a recurring theme in his work, the depiction of societal changes through their impact on couples and families, and like his later work, it oscillates between humor and pathos.

Yang followed it with *Taipei Story* (1985), one of the most important films of the New Taiwanese Cinema and a marked stylistic advance for him. Yang's friend Hou Hsiao-hsien stars as Lon, a former baseball star, now working as a salesman (which Hou actually did for a time), who is torn between committing to his longtime girlfriend and pursuing his dream of moving to the United States. Yang's mastery of visual metaphor fully emerges with this film. America is evoked as both a promised land and a place fraught with danger when Lon, while standing beside a poster of Marilyn Monroe, describes the shooting of his brother in a convenience store; and in a famous sequence his ambivalence about moving is symbolized by a runner caught between bases in a baseball game he's watching on television. Repeated imagery of traffic, construction, and technological devices relates Lon's ambivalent position to that of Taipei itself as a metropolis torn between progress and tradition.

Darker and even more ambitious, *The Terrorizers* (1986) weaves together the stories of six major characters whose lives intersect because of a prank phone call. Yang's use of chance encounters to bring his plot into motion and the film's pervading atmosphere of alienation often draw comparisons to Michelangelo Antonioni (particularly *Blow-Up*), but his intriguing use of dream imagery that becomes indistinguishable from real life evokes Chinese aesthetic traditions as well.

Yang broadened his narrative canvas even more with the nearly four-hour-long *A Brighter Summer Day* (1991), which was inspired by a famous 1961 murder case that deeply affected Yang as a child. Ingeniously setting up a dialectic between darkness and light that plays out not only in the film's visual scheme but in its plot as well, Yang paints early 1960s Taiwan as a polyglot society pulled in all directions by a number of influences. From kids in thrall to American pop music (the title is a mangled version of a line from an Elvis Presley song) to an older generation realizing that it is permanently cut off from its Chinese roots, every character is motivated by a tension between the darkness and light that Yang sets up as the film's central motif. His first masterpiece, *Brighter* is a fully integrated cinematic work, and a truly immersive experience.

Yang switched gears with the comedy of manners *A Confucian Confusion* (1994). Set in the demimonde of Taipei's yuppies, it is a whirlwind of romantic and professional double-crosses taking place over the course of two days. Yang deftly satirizes the tension between the characters' newfound wealth and the Confucian

teachings they grew up with. A lighter and more intricate variation on the themes brought up in *Taipei Story*, it manages to be both charming and challenging.

The satire turned vicious in his next film, *Mahjong* (1996). Yang uses the game of the title as a metaphor for the interactions of its characters, a mix of Asians, Europeans, and Americans, each of whom is on the make in a rapacious criminal underworld that finally erupts in a moment of chillingly cathartic violence.

Perhaps Yang's most beloved film, *Yi Yi* (2001) is every bit as densely woven and artistically accomplished as his previous movies, but it is much warmer. Yang often resists creating characters that are immediately sympathetic, preferring to maintain a distance from them that can come across as chilly. By contrast, *Yi Yi*'s plot is driven by an adorable eight-year-old shutterbug whose snapshots reveal more about the older members of his extended family than they care to admit. Where *Mahjong* is structured like the game from which it takes is title, *Yi Yi* (the rough English equivalent of which is "A one and a two . . .") works like a complex dance, with the family's relationships coming together, growing apart, and occasionally colliding before the eyes and camera of the young boy. This film is a crowd-pleaser in the deepest sense because it is so richly human. His most successful effort, it won awards at several festivals, including the Best Director award at the Cannes Film Festival. It is also the only one of his films thus far to receive a commercial release in the United States, where it was named Best Foreign Film by the Los Angeles and New York film critics associations.

THE SECOND WAVE

In the 1990s, Taiwan relaxed import restrictions on films, with the result that foreign movies began to flood the market, weakening homegrown cinema considerably. On the other hand, the government's commitment to cinema through the CMPC in the 1980s and the international success of the New Taiwanese Cinema planted the seeds of a thriving film culture. It is, perhaps, too early to begin ascribing "second" or "third" wave status to the generation of filmmakers who emerged in the 1990s (though these terms are frequently employed in attempts to categorize them). Suffice it to say that Taiwanese cinema has diversified, a fact exemplified by the radically different styles of the two most internationally successful directors to have emerged since the New Taiwanese Cinema: Ang Lee and Tsai Ming-liang.

Yi Yi

Of the two, Tsai's work bears the strongest resemblance to that of Hou, Yang, and their contemporaries. Like them, Tsai uses long takes, minimal dialogue, and precise visual compositions. He is, however, less concerned with Taiwanese history and identity. His characters are more like symptoms of Taiwan's postmodern dilemma, which is never addressed head-on. His is a hermetic world of urban alienation laced with pitch black comedy, and his style is probably more the result of his immersion in European art cinema (Antonioni, Rainer Werner Fassbinder, and François Truffaut are major influences) and avant-garde theater than the affect of any local sources.

LEE KANG-SHENG • According to Tsai Ming-liang, Lee Kang-sheng forced him to entirely rethink how to direct actors. Early on in their artistic relationship, Tsai tried to get Lee, then a nonprofessional actor, to walk faster during a scene, and Lee refused, saying, "That's just how I am!" After that, Tsai decided to let Lee be Lee rather than impose his own desires on his performances. Lee's quietly eccentric screen presence has been at the heart of almost all of Tsai's films, making him one of the strangest, but most compelling, leading men in world cinema. In 2005, Lee directed his own film, *The Missing*, which shows the influence of his mentor, but also bears the hallmark of Lee's distinct personality.

Tsai's films are united by a network of motifs: symbolic images of water, a melancholy atmosphere, and the repeated presence of a handful of actors, most notably Lee Kang-sheng, an untrained actor and uniquely instinctive performer whom Tsai met on the street one day and has subsequently cast in all of his films to date. Lee has a particular talent for portraying what might be called aloneness. Long stretches of Tsai's films are often devoted to scenes of Lee, by himself, doing things that are at once absurd and completely understandable, like casually dangling his leg through a hole left in the floor of his apartment by a plumber in *The Hole* (1998) or, in *Vive L'Amour* (1994), lovingly caressing a melon before carving holes into it and bowling it into a wall. Lee's gift for aloneness works perfectly with Tsai's voyeuristic style, in which the long takes of Hou and Yang become almost uncomfortably intimate (and therefore compulsively watchable) views into the lives of the eccentrics who populate his films.

Tsai's first film, 1992's *Rebels of the Neon God*, is his most conventional narrative. A tribute of sorts to Nicholas Ray's *Rebel Without a Cause*, it stars Lee as a troubled teenager who becomes obsessed with a charismatic hoodlum. Although it introduces some of the themes of Tsai's later work, along with some of the actors

Vive L'Amour

who would show up in later films, it is much grittier and rougher than what would follow.

His next film, *Vive L'Amour*, represents a bold aesthetic leap forward. The story of a real estate broker, her street-vendor lover, and an eccentric loner who are all using the same vacant apartment for their own secret purposes, unbeknownst to one another, it opens with twenty mesmerizing minutes during which not a word of dialogue is spoken, and ends with a seven-minute long take of actress Yang Kuei-mei crying in an empty urban park that is a tour de force of acting and directing. Its subtle humor and atmosphere of urban alienation feels like a strange combination of Antonioni and Buster Keaton, and it earned Tsai the Golden Lion at the 1994 Venice Film Festival.

Tsai continued in this minimalist vein with his next two films, but added layers of allegorical significance. In *The River* (1997), Lee Kang-sheng's character is afflicted with a mysterious neck ailment after floating in a polluted river while playing a corpse in a film being made by Hong Kong director Ann Hui (who makes a cameo appearance). The theme of tortured family relationships that runs through *Rebels of the Neon God* crops up here as well, culminating in a scene so controversial that some of his more vocal critics, in an unsuccessful attempt to block the film's nomination for Best Picture at Taiwan's Golden Horse Film Festival, questioned his Taiwanese citizenship.

He followed *The River* with *The Hole* (1998), a bizarre, dour musical about millennial anxiety, set in an eternally rained-upon Taipei that is being ravaged by a mysterious plague on the eve of the millennium. In typical Tsai fashion, the story plays out entirely within an apartment building that has been evacuated but for a few tenants, one of whom (Lee again) becomes obsessed with the woman in the apartment below (played by Tsai regular Yang Kuei-mei) when a plumber leaves a hole in his floor through which he can observe her increasingly strange behavior.

If there is such a thing as a "commercial" Tsai film, it is 2001's *What Time Is It There?* A metaphysical comedy in which Lee Kang-sheng's character tries to turn every clock in Taipei to Paris time after meeting a woman who is moving there, its themes of displacement and reincarnation were inspired by the death of both Tsai's and Lee's fathers. It also features a cameo by the famous French actor Jean-Pierre Léaud, in tribute to François Truffaut, one of Tsai's cinematic heroes.

Goodbye, Dragon Inn (2003) is both a daring departure and a further refinement of the minimalist aesthetic Tsai has pursued throughout his career. Set

Goodbye, Dragon Inn

inside a crumbling movie palace on its last night in business, it depicts the sometimes haunting, sometimes hilarious interactions of the theater's few remaining denizens during a screening of King Hu's classic martial arts film *Dragon Inn*. Tsai's most experimental work, *Goodbye, Dragon Inn* is cinema distilled to its essence.

Where *Goodbye, Dragon Inn* is austere, *The Wayward Cloud* (2005) enlivens its narrative of longing and loneliness with colorful musical numbers and absurdist comedy. The main female character from *What Time Is It There?* returns to Taipei, which is suffering from a drought that the government seeks to mitigate by encouraging the citizenry to eat watermelons. Meanwhile, Lee Kang-sheng's character has become an actor in pornographic movies in which watermelons are put to an entirely different purpose.

A departure in more ways than one, Tsai's next film, *I Don't Want to Sleep Alone* (2006), is set in his native Malaysia, amid the world of "guest workers" left behind by Asia's economic boom. Much of the movie takes place in a cavernous abandoned factory, allowing for Tsai's ravishing use of light, and the story—

I Don't Want to Sleep Alone

featuring Lee Kang-sheng in a double role—treats desire more tenderly than in much of his work.

It would be difficult to find a director more different from Tsai Ming-liang than Ang Lee, and yet he represents an equally strong populist trend in post–New Taiwanese Cinema filmmaking. Where Tsai comes from an avant-garde background and is committed to experimentation, Lee makes traditional narrative films that aim at a more general audience.

Born in 1954 in Pingtung, Taiwan, Lee received his film education in the United States, at the University of Illinois Urbana-Champaign and New York University. His first three features form a trilogy about generational conflict. Like Hou Hsiao-hsien's early films, they view the struggle between tradition and modernity through the prism of family dynamics, but they approach this theme in a style that aimed for—and found—a large popular audience.

Supported by the CMPC, Lee's first feature, *Pushing Hands* (1992), was also the first Taiwanese film to receive distribution in the United States. In it,

CROUCHING TIGER, HIDDEN
DRAGON • Conventional movie business wisdom has always held that American audiences shy away from subtitles, so when Ang Lee's *Crouching Tiger, Hidden Dragon* grossed over $120 million in the United States in 2001, Hollywood was taken by surprise. Its success is perhaps the result of a confluence of cultural trends that had until then been flying under the radar. Stars Chow Yun-fat and Michelle Yeoh were well-known to the growing cult of Hong Kong movie fans, and an entire generation had grown up watching *wuxia pian* swordplay films on television (albeit not during primetime). And Lee's direction added a sophistication and grace that appealed to the core audience of fans of foreign films. When other subtitled movies failed to live up to *Crouching Tiger's* numbers, it came to seem like a fluke, but 2006, which saw the success of subtitled films like *Babel*, *Letters from Iwo Jima*, and *Pan's Labyrinth*, may signal that Americans are more willing than ever to embrace foreign language cinema.

a retired tai chi master leaves China to move in with his son and his American wife in a suburb of New York City. The wife, a blocked novelist, finds the old man a nuisance, but the gradual reconciliation among the three characters—two modern and cosmopolitan, the other wise but unaccustomed to the modern world—develops into warmhearted comedy of manners. *Pushing Hands* displays Lee's gift for balancing humor and drama in sophisticated ways that ring true to life.

Critical and commercial success, both in Taiwan and abroad, came with Lee's second film, *The Wedding Banquet* (1993). A comedy set once again in the environs of New York, it concerns a gay Taiwanese man who, under pressure to marry from his traditionally minded parents (who are unaware of his sexual preference), concocts a scheme to marry a Chinese woman who happens to be his neighbor and is in need of a green card to stay in America. The comedy in this film is leavened with poignant moments but never dips into melodrama, and represented a significant maturing in Lee's direction. A box office smash in Taiwan, it won five awards at the Golden Horse Film Festival, the Golden Bear at the Berlin International Film Festival, and received an Academy Award nomination for Best Foreign Language Film.

Lee followed the success of *The Wedding Banquet* with *Eat Drink Man Woman* (1994). His first film set in Taiwan, it revolves around the Sunday-family-meal rituals of a family composed of a widowed master chef and his three thoroughly modern daughters. Generational conflicts play out against the backdrop of mouth-watering feasts of traditional Chinese cooking, in which food metaphorically

The Wedding Banquet

expresses the emotions the characters cannot articulate. Like Lee's previous films, it is rich in humor and humanity, and it earned him his second Academy Award nomination.

After *Eat Drink*, Lee began making films outside of Taiwan on a regular basis. His skill with comedies-of-manners served him well in his 1995 adaptation of the Jane Austen novel *Sense and Sensibility*, as did his sensitivity to family dynamics in *The Ice Storm* (1997). He did return to Asian themes in 2000 with his majestic tribute to classic martial arts films, *Crouching Tiger, Hidden Dragon*. An impeccably mounted international coproduction (it was made with funding from Taiwan, China, Hong Kong, and the United States), it features a trio of pan-Asian superstars in Chow Yun-fat, Michelle Yeoh, and Zhang Ziyi. With its graceful wirework, charismatic stars, and classic story of honor and betrayal, it was a hit around the world and won four Academy Awards, including Best Foreign Language Film. Since then, Lee has worked consistently in America, delving into the psychology of a comic book hero in 2003's *Hulk* and directing *Brokeback Mountain*, the story of an affair between two cowboys, in 2005.

TAIWANESE CINEMA TODAY AND TOMORROW

Twenty-odd years ago the New Taiwanese Cinema laid the groundwork for the national cinema Taiwan had never had. Today, some young directors continue in the style of Hou and Yang, making auteur cinema that attempts to look at the Taiwanese people's place in the world and in their own culture. Others, taking a cue from Ang Lee, make comedies and melodramas aimed at popular audiences. Taiwanese cinema's emergence in the 1980s and 1990s depended on both domestic support and international interest, and festival programmers and critics have since set their sights on other filmmaking centers, while the likes of Hou Hsiao-hsien and Tsai Ming-liang continue to make challenging work, thanks to their well-established reputations. Today, Taiwanese filmmakers have to rely on the home market for their audiences, and the facts of the marketplace have meant that the power has shifted from directors to producers, who increasingly influence style and subject matter in an effort to make movies appeal to the broadest possible audience. It remains to be seen how successful this strategy will ultimately be.

NEW
PLAYERS

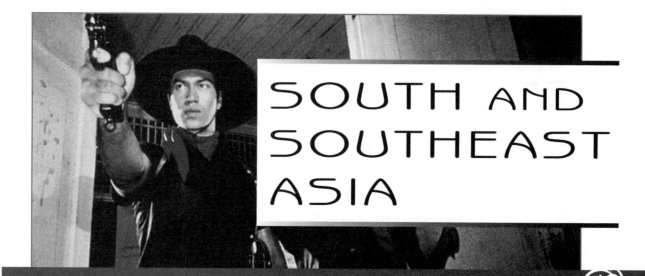

SOUTH AND SOUTHEAST ASIA

BANGLADESH

The small country of Bangladesh shares linguistic and cultural roots with the Indian state of Bengal. Its borders were created in 1947 during Partition, when it became the eastern section of Pakistan. After a fierce war, Bangladesh became independent in 1971. Bangladesh produces more than sixty films per year, which show in over twelve hundred theaters. Aimed almost exclusively at the local population, Bangladeshi popular cinema resembles India's in style and themes, but beyond its borders, its films are almost completely overshadowed by the gargantuan film industry of its close neighbor.

Bangladesh also has a history of independent and art films, many made with state support, that sit firmly in the rich intellectual tradition of Bengali culture. Major directors include Alamgir Kabir, Kazi Hayat, and Mohammad Hussain. Although few Bangladeshi films are seen beyond the country's borders, there have been some signs of change in the past few years. London hosts an annual Bangladesh Film Festival focusing on shorts, documentaries, and independent features, and two recent films have received a measure of acclaim at international

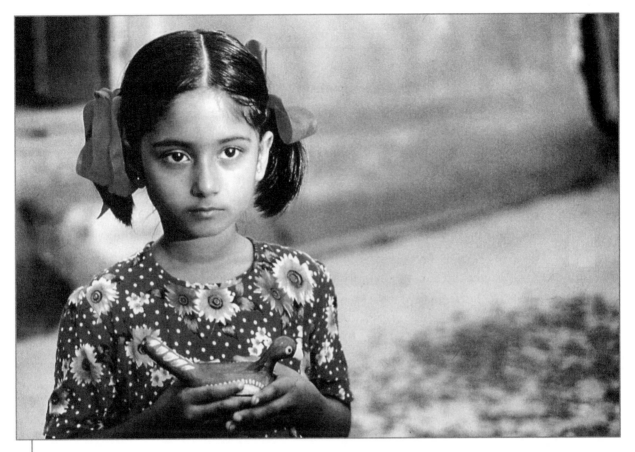

The Clay Bird

film festivals. Tareque Masud's *The Clay Bird* (2002) takes on the timely issue of Islamic fundamentalism through the story of an orphan boy caught up in Hindu-Muslim religious strife on the eve of Bangladesh's independence. Humanist in outlook, beautiful to look at, and rich in traditional Bengali music, it refuses to demonize its characters regardless of their sometimes hateful beliefs. It won the International Critics Prize at the Cannes Film Festival and became the first Bangladeshi film to be released in the United States. *A Tree Without Roots*, Tanvir Mokammel's 2002 seriocomic study of religious chicanery by a phony Muslim cleric in a poor village, also received some exposure at international film festivals.

BHUTAN

The kingdom of Bhutan, a small, isolated country nestled in the Himalayas, with a culture based on Tibetan Buddhism, may not seem like a candidate to become a world-cinema powerhouse. Its economy relies on subsistence agriculture, the national sport is archery (a version in which getting drunk and taunting one's opponents is part of the game), and foreign influence and tourism are strictly regulated.

Bhutan can, however, boast of having had two films find their way to international popularity. Dzongsar Jamyang Khyentse Rinpoche, better known as Khyentse Norbu, is a Buddhist lama recognized as the third reincarnation of the founder of the khyentse tradition of Tibetan Buddhism and a film buff, who caught the directing bug while working as a consultant on Bernardo Bertolucci's *The Little Buddha* (1993). Norbu's first film, 1999's *The Cup*, is a warm comedy about a soccer-mad teenage monk's attempts to find a way to watch the World Cup. It was made in Tibet with a nonprofessional cast. His second, *Travellers and Magicians* (2003), has the distinction of being the first film made in Bhutan itself. Also using nonprofessional actors, it is a parable-like story of a young man who longs to travel to the United States but, when his journey is interrupted, learns about the charms of his home country from a stranger who befriends him along the way.

CAMBODIA

Considering the vast suffering that dictator Pol Pot inflicted upon his own people in the 1970s and 1980s, when some 1.7 million Cambodians were murdered in killing fields for being deemed "enemies of the people," it's no wonder that Cambodia, a land of astonishing natural and ancient man-made wonders, barely has a film industry at all. During the 1960s, then Prince Norodom Sihanouk (he later became king), an avid cinema-lover, supported a thriving industry, and later even went on to make films on his own in the 1990s. It's been a slow climb, but Cambodia is restoring the film industry Pol Pot's Khmer Rouge destroyed along with everything else.

Cambodia's natural landscape and rich folklore provide ready-made cinematic material. Fay Sam Ang's *The Snake King's Child* (2001), one of the first

big productions to be made since the fall of the Khmer Rouge, combines both, telling an ancient legend in a lush jungle setting—and even outfitting its very patient lead actress with a headdress made of live snakes. It remains to be seen if Cambodia can rebuild a national cinematic culture. In addition to investment in film education and handsome productions like *The Snake King's Child*, another promising sign is the work of Rithy Panh, a documentary filmmaker who has made a project of exploring his nation's troubled past through the lens of the present.

In *The Land of Wandering Souls* (2000), he follows workers laying fiber-optic cable, as part of Cambodia's modernization, and discovering remains from the Khmer Rouge's genocidal campaign in the course of their work. His most powerful film, 2003's *S21: The Khmer Rouge Killing Machine*, revisits a Phnom Penh prison where torture and genocide were carried out and includes chilling interviews with former guards who are all too willing to reenact their daily routines. It's a horrifying document of how human beings can easily become monsters, and especially timely, considering the current debates about the use of torture in Iraq and elsewhere.

RELIGION IN SOUTHEAST ASIA • The trading routes that have run through Southeast Asia over the past two millennia made it a crossroads of world religious traditions. Buddhism and Hinduism have existed in Malaysia, Indonesia, Cambodia, and Thailand for nearly two thousand years. Islam arrived in the region with Muslim traders in the fourteenth and fifteenth centuries, and trade and conquest also brought Christianity, which took hold most strongly in the Philippines, during the Spanish occupation starting in the sixteenth century. This variety of faiths is reflected in the films of the various Southeast Asian countries.

INDONESIA

A nation comprising over 18,000 islands (6,000 inhabited), with literally hundreds of ethnic groups, languages, dialects, and religions, Indonesia was a Dutch colony—known as the Dutch East Indies, a center of the spice trade—from the seventeenth century until it declared independence in 1945. In the early 1950s, directors such as Usmar Ismail, Armjin Pane, and D. Djayakusuma made important films about Indonesia's transition from colony to independent country, but the film industry quickly went into decline because of continuing political instability. In the mid-1960s, Haji Mohammad Suharto, an army general, overthrew President Sukarno, who had ruled since independence,

Whispering Sands

and established a military regime known as the New Order. During Suharto's reign, which lasted until 1998, movies were subject to strict censorship and received no support from the state. Political content was not allowed, but sex and violence were, so movies reverted to the universal language of soft-core porn, action, and slapstick comedy.

Amid constant political unrest, the 1990s saw the rise of a few independent voices in the cinema, among them that of Garin Nugroho. The first Indonesian director to receive serious attention at international film festivals, Nugroho blends traditional culture with experimental technique and focuses on Indonesian history and identity in films such as *Letter to an Angel* (1994) and *And the Moon Dances* (1995). His films range from the low-tech—2002's *Bird-Man Tale* was shot on handheld video—to the magnificent—his 2006 film, *Opera Jawa*, spectacularly combines modern dance, ancient myth, and sets designed by contemporary Indonesian visual artists.

Suharto's notoriously corrupt regime began to unravel in the late 1990s, which emboldened a group of four young filmmakers to defy governmental regulations and make the landmark independent omnibus film *Kuldesak* (1996), directed by Mira Lesmana, Nan Achnas, Riri Riza, and Rizal Mantovani. Unlike the cheap erotica and imitative genre output of the approved film industry, *Kuldesak* addressed real-life social concerns, and became a surprise hit at the box office. Its directors have gone on to become some of Indonesia's most important contemporary filmmakers. Riri Riza, for instance, most recently made a biographical feature, *Gie* (2005), based on the life of one of Indonesia's most beloved cultural

heroes, the political activist and environmentalist Soe Hok Gie. Nan Achnas is now Indonesia's most prominent female director. Her films include the mysterious *Whispering Sands* (2001), which mixes folklore, magic, and the harsh reality of a mother and daughter trying to make ends meet in the forbidding landscape of a windswept beach village.

Indonesia just might be one of the best-kept secrets in world cinema at the moment. Production has increased in the last few years from a mere two or three films a year to almost fifty. Achnas, Riza, Rudi Soedjarwo, and others are consciously forming a new national cinema, one that directly addresses the concerns of ordinary Indonesians.

MALAYSIA AND SINGAPORE

Cradling the South China Sea in its two territories, Malaysia is made up of the southern end of the Malay Peninsula, south of Thailand, and the islands of Sarawak and Sabah, across the sea to the east. Once governed by various local kingdoms, it was later occupied by Great Britain and, during World War II, Japan. Malaya gained independence from England in 1957, and became known as Malaysia in 1963 when Sarawak and Sabah joined what was then called the Federation of Malaya. In 1965, Singapore, a small island off the southern tip of the Malay Peninsula, elected to become an independent city-state.

The mixing of cultures in the area is evident in the films produced there. The first Malaysian movie, *Laila Majnun* (1933), was based on Persian folklore, directed by an Indian (B. S. Rajhans) and featured actors from *bangsawan*, a form of Malay popular opera. Shaw Brothers, from Shanghai by way of Hong Kong, set up a film studio in Singapore in 1938 that produced films based on Chinese stories, but again using *bangsawan* performers. Directors from the Philippines were also brought in to work in the film industry. Perhaps the only good thing to emerge from Japan's World War II–era imperialist ambitions in the area was the importation of films by the likes of Akira Kurosawa, Kenji Mizoguchi, and Yasujiro Ozu.

The films of Kurosawa, in particular, had a great influence on the multitalented P. Ramlee, Malaysia's most beloved entertainer, who moved from performing to directing with 1955's *The Trishaw Puller*. Ramlee's films, which range from dramas to comedies, combine entertainment value with religious and

Perth

class issues. They funnel trans-Asian influences into an aesthetic that gets to the heart of Malay culture.

This fertile mixing of influences, and the financial muscle of companies like Shaw Brothers and its main competitor, Cathay-Keris Film Productions, led to thriving film industries in Singapore and the Malaysian city of Kuala Lumpur. Notable directors from this 1950s and 1960s golden age include M. Amin, Salleh Ghani, and Hussein Haniff. The decline of both film industries in the 1970s and 1980s led to government investment in them in both Malaysia and Singapore. Film festivals were established in both regions, and filmmakers were given state support.

These investments have begun to pay modest dividends in the past decade or so. As yet, no Hou Hsiao-hsien or Edward Yang has emerged, but a number of interesting films and filmmakers have begun making the international festival rounds. Singapore's Eric Khoo made his directorial debut with *Mee Pok Man* (1995), the story of a noodle seller who becomes obsessed with a prostitute. Its gritty milieu was of great interest to Singaporeans, who had rarely seen realistic portrayals of working-class life since the golden age of the 1950s and 1960s. Khoo has gone

on to make several more features, most recently the intriguing documentary/ fiction hybrid *Be with Me* (2005), which veers between a fictional story of two teenage girls' obsessive love for each other and documentary sections about a blind-and-deaf woman's determination to live a normal life. Occupying the same urban underworld as *Mee Pok Man* is Roystan Tan's hyperative *15* (2003), which stars real street kids cruising Singapore's rarely seen seedy underbelly. This is also the milieu of the director known as Djinn's 2004 *Perth*, a dark, nocturnal drama about a middle-aged security guard who dreams of moving to Australia, until he loses his job and has to work as a driver for a Vietnamese prostitute employed by a violent gang.

Malaysian films are becoming more of a presence on the international film festival circuit. Amir Muhammad released two well-regarded films in 2005, *Year of Living Vicariously*, a behind-the-scenes look at the making of Indonesian filmmaker Riri Riza's *Gie*, and *Tokyo Magic Hour*, a city symphony blending a poetic voice-over, experimental music, and digitally manipulated imagery. In 2006, he made two documentaries investigating Malaysian politics and history, *The Last Communist* and *Village People Radio Show*, that combine interviews with a painter's eye for the lush Malaysian countryside. Muhammad is part of a tightly knit community of young filmmakers who often work on one another's films and have fully embraced the potential of digital video technology. Just as prolific as Muhammad is James Lee, who explores his main theme, romantic love and its consequences, with wry humor and a compelling, minimalist aesthetic in films such as *The Beautiful Washing Machine* (2004), *Before We Fall in Love Again* (2006), and *Things We Do When We Fall in Love* (2007). Another member of this group is Tan Chui-mui, whose ironically titled *Love Conquers All* won awards at the 2007 Rotterdam and Hong Kong Film Festivals.

At the other end of the spectrum, there's Saw Teong Hin's *The Princess of Mount Ledang* (2004), an epic costume-drama retelling a famous Malaysian tale of doomed lovers, replete with sumptuous imagery and plenty of swords and sorcery.

NEPAL

Home to Mount Everest, the world's tallest mountain, Nepal is a landlocked nation squeezed between China and India. It is the world's only Hindu state, ruled by a constitutional monarchy often under threat from an entrenched Maoist insurgency. Because of its proximity and close cultural ties to India, Nepal's movie screens are dominated by Bollywood films, but it has an industry of its own, nicknamed Kollywood (after Katmandu, where most films are made), which valiantly releases a few movies per year, virtually none of which have been seen outside of the country.

Nepal's awesome mountainous landscape, and the rugged life of those who live there, can be seen in French director Eric Valli's Oscar-nominated *Himalaya* (1999), which was made with a Nepalese cast and crew, and sets its narrative around an actual annual journey made by villagers across the unforgiving mountains to trade salt for grain. The first entirely indigenous Nepalese film to make a bid for international recognition is Gyanendra Bahadur Deuja's 2003 *Muda Madan*. Based on a classic Nepalese love story, in scale and ambition it attempts to challenge India's dominance of Nepalese movie theaters, and was submitted as the country's official Oscar entry, though it failed to secure a nomination.

PAKISTAN

Carved from western India and established as a Muslim state in 1947, Pakistan has been embroiled in conflicts for almost its entire history. It has fought three wars with India, and tensions remain high over the disputed Kashmir region. Bangladesh, formerly East Pakistan, won the right to become a nation in its own right after a war in 1971. Lately, Pakistan, which shares a border with Afghanistan, is embroiled in the so-called War on Terror.

Despite all these troubles, Pakistan maintains a fairly successful film industry. Just as Nepal has Kollywood, Pakistan has Lollywood, named for the city of Lahore, where most film production takes place. Popular Pakistani cinema resembles India's Bollywood movies, with singing, dancing, and melodrama, but the films are geared to local tastes and sensibilities.

The only Pakistani film thus far to make an international impression is Sabiha Sumar's *Silent Waters* (2003). The winner of several awards at the 2003

Locarno Film Festival, it channels the currents of history through the daily lives of a group of villagers facing the rise of Islamic fundamentalism in Pakistan in 1979.

THE PHILIPPINES

Like much of Southeast Asia, the Republic of the Philippines, an archipelago of over seven thousand islands on the edge of the Pacific Ocean, is a melting pot, its history crisscrossed with Eastern and Western influences. The Spanish explorer Ferdinand Magellan landed there in 1521, marking the beginning of Spain's influence in the region. The Philippines remained a Spanish colony until the United States defeated Spain in the Spanish-American War of 1898. A long-running nationalist movement culminated in the Philippine-American War of 1899–1913, after which it became a U.S. colony and then, in 1935, an official commonwealth of the United States. Japan invaded and occupied the Philippines during World War II, and after their defeat, the United States granted the Philippines full independence.

The American colonial presence brought films to the Philippines quite early on. Pre–World War II Philippine films combined Hollywood conventions with local theater and literary traditions. The Japanese invasion during the war brought filmmaking to a halt, as the industry's resources were harnessed to produce propaganda, and many performers were forced to return to the theater to earn a living. With the departure of the Japanese, the film industry rebounded in the 1950s. Manuel Conde's *Genghis Khan* (1952) was invited to the Venice Film Festival. Gerardo De Leon, considered one of the Philippines' greatest directors, used his gifts for narrative construction to make films like *Sanda Wong* (1955) and *Noli Me Tangere* (1961), which often combined social consciousness with popular appeal. His protégé Eddie Romero worked with equal success in a similar vein with

SOUTH AND SOUTHEAST ASIA

films such as *A Shrimp's Life* (1952), *The Final Battle* (1957), and *The Walls of Hell* (1964), an action movie set during World War II.

It is a sign of the Philippine cinema's 1960s decline that both of these directors found themselves having to make ends meet by directing low-budget horror flicks aimed at both Filipino and American audiences. But the creative flair they brought to their work turned many of these films into enduring cult favorites. Romero's drive-in vampire movies, among them *Mad Doctor of Blood Island* and *Brides of Blood* (both 1968), as well as *Black Mama, White Mama* (1972), a blaxploitation movie he made in Hollywood, are considered classics among connoisseurs and are, for better or worse, more widely seen than his other films. The same can be said of De Leon films like *The Blood Drinkers* (1966) and *Blood of the Vampires* (1971). While both directors would later disavow these works-for-hire, they did lead foreign critics to finally see and appreciate their more serious work.

In 1972, Philippine leader Ferdinand Marcos declared martial law, introducing strict censorship that put an end to the low-budget sexploitation movies, known as *bomba*, that dominated the industry at the time. Marcos's oppressive policies touched off a political awakening among Filipino filmmakers and the emergence of a movement of independent directors making films addressing the issues of everyday life—a return to realism and social commentary not seen since the 1950s. Spearheading the movement was the prolific Lino Brocka, who would make over fifty films in his career. In his most revered films, among them *You Have Been Judged and Found Wanting* (1974) and *Manila in the Claws of Light* (1975), he created social realist works that powerfully and sensitively showed the lives of the Philippines' rural and urban poor.

There are other major figures in this 1970s renaissance, which continued into the following decade. The eccentric Mario O'Hara, who acted in and wrote films with Brocka, most notably the classic *Insiang* (1976), mixes mysticism with social themes in his work, at times blurring the line between reality and fantasy. *Demon* (2000) and *Woman of the Breakwater* (2005) are two prime examples of his unique filmmaking approach. *Breakwater* lopes along with a breezy style in its seaside location, punctuated by a Greek-chorus-like singer commenting on the action. Mike De Leon, whose films regularly appear in festivals around the world, is best known for the biting sociopolitical content of works like *Batch '81* (1982), *Sister Stella L.* (1984), and *Third World Hero* (2000). Also emerging in

the 1970s was Kidlak Tahimik, who in 1977 made a wonderfully strange cinematic essay on the colonial mind-set called *Perfumed Nightmare*, which kicked off an experimental film and video movement in the Philippines and became a favorite of German director Werner Herzog.

Filipino popular cinema—horror movies, love stories, thrillers, and the like—are surprisingly easy to find on DVD, but seem to fly under the general cultural radar. Erik Matti traffics in sex and violence with stylistic flare, from the bizarre *Gagamboy* (2004), featuring a superhero wielding orange goo, to *Pedro Penduko 2: Return of the Comeback* (2000), an action movie with appropriately heavy doses of violence. Chito Rono, director of *Yamashita: The Tiger's Treasure* (2001), *Spirit Warriors* (2000), and *Feng Shui* (2004), among others, specializes in fantasy and adventure. Other movies putting a Filipino spin on the gangster flick, the romantic comedy, and other genres are also widely available.

SRI LANKA

An island nation located in the Indian Ocean off the southeastern tip of India, Sri Lanka is populated mainly by people from the Sinhalese ethnic group, who arrived around 500 BC, apparently from northwest India. During the age of European exploration, Sri Lanka was occupied by the Portuguese, the Dutch, and eventually became a colony of England in 1802. Known for centuries as Ceylon, Sri Lanka declared independence in 1848, but remained a British protectorate until 1972, when it finally became an autonomous state and took its current name. For deades there has been almost continuous strife in Sri Lanka between the majority Sinhalese and minority Tamil ethnic groups. These tensions boiled over into all-out civil war in 1983, and although things have calmed somewhat since, the conflict does continue.

Sri Lanka's most revered director is Lester James Peries, who occupies a place in Sri Lankan culture similar to that of Satyajit Ray in India. His first two films, *Line of Destiny* (1956) and *The Changing Village* (1965), marked the establishment of a truly Sri Lankan cinema, dealing with the island's culture, history, and indigenous population in ways reminiscent of Ray's Apu Trilogy.

The Sri Lankan Freedom Party, which came into power in 1970, took steps to establish and preserve a national film culture, which led to a rise in serious film criticism, exposure to important European and Asian films, and a new

crop of filmmakers interested in experimenting with form and content. Among the important directors of the 1970s are Mahagama Sekera, Ranjit Lal, D. B. Nihalsinghe, and Dharmasena Pathiraja, with Dharmasiri Bandaranaike and Tissa Abeysekera coming along in the 1980s.

This flowering of film culture in Sri Lanka never quite made it to the world at large (although there have been retrospectives of Lester James Peries in Europe and the United States). But this may change. In 2005, Vimukthi Jayasundara's *The Forsaken Land* won the prestigious Camera d'Or at the Cannes Film Festival. Conjured with still, painterly compositions and minimal dialogue, Jayasundara's film is a sort of allegory of Sri Lanka's ongoing civil war, though it doesn't allude to the conflict directly. Rather, it takes place in a no-man's-land where the daily interactions of its characters, including a band of bored and aimless soldiers, take on the aura of mythology. As Jayasundara puts it, his film seeks to convey "the suspended state of being simultaneously without war and without peace . . . a world where war, peace, and God have become abstract notions."

Other recent Sri Lankan films also point to a thriving and quite varied film industry. Satyajit Maitipe's *Scent of the Lotus Pond* (2004) infuses high melodrama reminiscent of the films of Douglas Sirk into Buddhist mythology to tell the story of a group of factory girls falling in and out of love. Asoka Handagama's *Flying with One Wing* (2002) is an at times brutal story of a woman who disguises herself as a man to get a job as a mechanic and ends up getting deeper into her new life than she expected. These recent successes point to a deeply rooted film culture that may someday find its way to greater exposure in the world beyond the island where it flourishes.

THAILAND

Because of a combination of enlightened leadership and the fact that it served as a buffer between English and French interests, Thailand is the only country in Southeast Asia never colonized by any European power. This is a source of great pride in Thailand, a country of many ethnic groups, with Buddhism the most prominent religion, and a culture influenced by both Chinese and Indian sources.

Much of Thailand's cinematic history remains murky. It is estimated that over 75 percent of the films produced there are lost for one reason or another.

There is a general agreement that director Rattana Pestonji was Thai cinema's first pioneer. His films, such as *Country Hotel* (1957) and *Black Silk* (1961), show a knack for experimentation within budgetary limitations and a flair for vibrant color. There was a modernist, politically aware cinema movement in the 1970s, led by Prince Chatreechalerm Yukol, a member of the royal family educated at UCLA alongside Francis Ford Coppola and Roman Polanski, who made socially conscious films, such as *Dr. Karn* (1973), *The Elephant Keeper* (1987), and *Daughter* (1996), throughout the next two decades. Yukol's family has a past both in royalty and the cinema. His grandfather assisted Merian C. Cooper and Ernest B. Schoedsack (who made the original *King Kong*) on the landmark 1927 documentary *Chang: A Drama of the Wilderness*, which was filmed in Thailand. In 2001, with the help of his old classmate Coppola, Yukol completed his dream project, *The Legend of Suriyothai*, an extravagant historical epic about the life of a sixteenth-century Thai queen, full of meticulous period detail and up-to-the-minute special effects, that became Thailand's first big-budget blockbuster.

Suriyothai is part of a virtual stampede of films that have come out since the late 1990s that have turned Thailand into a world-cinema hotspot. These films range from the decidedly mainstream to the delightfully weird. On the mainstream side, there are the films of Nonzee Nimbutr. His *Nang Nak* (1999) is a romantic ghost story drenched in Thai superstition and legend. He followed that with *Jan Dara* (2001), an overheated soap opera based on a famous erotic novel. Nimbutr has also worked as a producer on some of the most high-profile recent Thai releases, including Wisit Sasanatieng's zany, candy-colored ode to westerns and 1950s Thai movies *Tears of the Black Tiger* (2000). He also produced *Bangkok Dangerous* (1999), by the Hong Kong–born Pang brothers, Danny and Oxide. Propulsive, nasty, and loud, it looks into Bangkok's teeming underworld of hit men, strippers, and gangsters with a slick, MTV-influenced style. Their next film, *One Take Only* (2001), is more of the same stylistically, but this time wrapped around an interesting theme of youthful longing in the mean streets of Bangkok. The Pangs split their time between Bangkok and Hong Kong, and have found a successful niche for themselves making slick horror movies with intriguing premises such as *Bangkok Haunted* (2001) and *The Eye* (2002), about a blind woman who starts seeing ghosts after a cornea transplant.

Pen-Ek Ratanaruang, another frequent collaborator with Nimbutr, is fast becoming an auteur of international standing. His 2003 film, *Last Life in the*

Universe, featuring the talents of Japanese actor Tadanobu Asano and the much-in-demand cinematographer Christopher Doyle, is a deliberately meandering story, done in glowing pastel light, about a suicide-obsessed librarian with a shady past in Japan and the pothead bargirl he becomes entangled with after he escapes to Thailand. The three have also worked together on a follow-up, *Invisible Waves* (2006), a witty karma-themed film-noir-like adventure with doses of absurdist comedy. Before these two films, Ratanaruang established his reputation with the engrossing comedy thriller *6ixty9* (1999) and *Monrak Transistor* (2001), a love story about a music-obsessed young man.

An eccentric in a land of eccentrics, Apichatpong Weerasethakul got his start with the unclassifiable *Mysterious Object at Noon* (2000), a travelogue of sorts that takes him and his crew around the Thai countryside, stopping in villages to have the locals add to an evolving narrative. Think of it as a cinematic combination of the children's story "Stone Soup" and the Surrealist "exquisite corpse" game, in which participants each contribute sections to a story. Two recent films, *Blissfully Yours* (2002) and *Tropical Malady* (2004), are oddball love stories, one straight and one gay, that are drenched in the atmosphere of the jungle. No one can sustain the pure bliss of simply hanging out the way Weerasethakul can. The sounds and images of nature in these two films, the delicately hushed voices, combined with subtly rendered characters and, in *Malady*'s rapturous second half, a surprising supernatural element out of Thai folklore, give them an atmosphere like nothing else. They verge on becoming almost nonnarrative and are less like dreams than like extended, lazy afternoon daydreams. This dreamlike atmosphere also pervades his 2006 film *Syndromes and a Century*, which treats questions of life, death, love, and reincarnation with wit, whimsy, and cinematic inventiveness.

It's becoming clear that Thai cinema has room for everything. One of the more popular releases of the past few years has been *The Iron Ladies* (2001), Youngyooth Thongkunthun's charmingly told true story of a volleyball team made up of several transvestites and one transsexual, who played in the national tournament. Its popularity spawned a sequel, *Iron Ladies 2: The Early Years* (2003). Also based on a true story, Ekachai Uekrongtham's *Beautiful Boxer* (2003) is about Parinya Charoenphol, Thailand's most famous boxer, who entered the brutal world of prizefighting to earn money for a sex-change operation. It must certainly be due in part to the rise of Thai cinema that Thailand's indigenous martial art, Muay Thai (Charoenphol's specialty), is enjoying a bit of a vogue right now. *Ong-Bak: Muay Thai Warrior* (2003), directed by Prachya Pinkaew, introduced Muay Thai specialist Tony Jaa to the world, using a fairly standard action plot to showcase his athletic prowess.

Thai comedies tend to be broad, ribald, and satisfyingly bawdy, full of dirty jokes and a permissive attitude toward bodily functions. Pornchai Hongrattanaporn's *Bangkok Loco* (2004) is an irreverent pop culture riot about sex and rock music, replete with naughty wordplay that parodies everything from the Beatles to *Star Wars* to kung fu flicks. Youngyooth Thongkunthun, who made both *Iron Ladies* films, also directed *M.A.I.D.* (2004), which takes a bevy of maids (staples of Thai TV shows) and turns them into undercover agents. Its star, Pornchita Na Songkhla, attacks her role with relish, displaying split-second comic timing and effortless charm. *Hello Yasothorn* (2005), directed by and starring the popular Thai comedian Petchthai Wongkamlao, is a worthy companion piece to *Tears of the Black Tiger* with its retina-scorching colors and unspeakably tacky costumes. Like *Tears*, it

pays tribute to the Thai cinema of the past with its deliberately cheap-looking sets and hammy acting, but it's completely up-to-date in its tasteless jokes and goofy performances. Other recent films have looked to Thailand's past for inspiration. Thanit Jitnukul's *Bang Rajan* (2000) uses a famous series of eighteenth-century battles between Thai natives and Burmese invaders as fodder for a bloody war epic, and was released in the United States in 2004 thanks to the efforts of Oliver Stone. *The Overture* (2004), by Ittisoontorn Vichailak, is a biopic about the life of one of Thailand's most revered musicians, Luang Pradit Pairoh, and is filled with riveting performances of traditional music.

The sheer variety and consistently high artistic standards of this recent harvest of Thai movies is good news for film buffs, and a harbinger of more good things to come from Thailand's consistently surprising moviemakers.

TIBET

Long a land of mystery in the Western imagination, the land of the fabled Shangri-la, Tibet is the traditional center of Tibetan Buddhism and nicknamed the "rooftop of the world" for its location high in the Himalayas. China has claimed Tibet as its own since the early twentieth century and refuses to let go of it, despite pressure from governments and activists around the world. Tibetan Buddhism's spiritual leader, the Dalai Lama, currently lives in exile in India.

There is certainly no shortage of movies about Tibet. The Dalai Lama's cause is very popular in the West, as is the spiritual allure of Tibet's version of Buddhism. Among the many American and European movies about Tibet are Martin Scorsese's *Kundun* (1997), Jean-Jacques Annaud's *Seven Years in Tibet* (1997), Bernardo Bertolucci's *Little Buddha* (1993), and Werner Herzog's documentary *Wheel of Time* (2003). Bhutanese director Khyentse Norbu's *The Cup* and *Travellers and Magicians* both draw on Tibetan religion and culture. Films by Tibetan directors are just starting to become a presence. *Dreaming Lhasa* (2005), directed by Ritu Sarin and Tenzing Sonam and executive-produced by Richard Gere, focuses on the Tibetan exile community in India of which the directors are a part. It may be too soon to tell, but this and two other new features—Pema Dhondup's *We Are No Monks* (2006), about four Tibetan friends living in exile, and Neten Chokling's *Milarepa: Revenge* (2006), the life story of the revered eleventh-century sage—signal the possibility of a new wave of Tibetan filmmaking.

VIETNAM

Vietnam, a country of awe-inspiring natural beauty, has a long history of both fighting and absorbing foreign influence. China sporadically ruled Vietnam from 207 BC to the tenth century AD, when Chinese forces were driven out. France colonized the country in the eighteenth century and, after Japan took and then lost control of much of Vietnam during World War II, attempted to reassert their rule, but were defeated by the Vietnamese at the famous battle of Dien Bien Phu in 1954. That same year, the Geneva Accords, aimed at settling the conflicts going on there and in Korea, divided Vietnam into

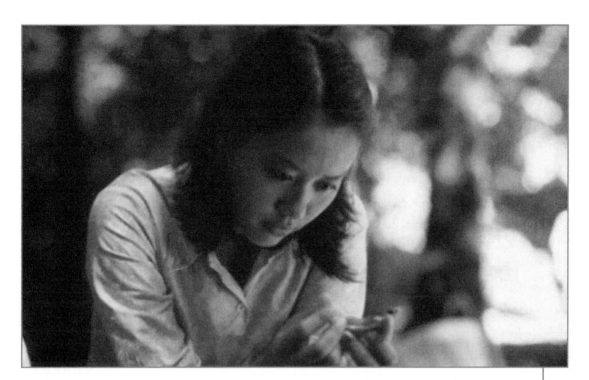

Soviet-backed Communist North Vietnam and South Vietnam, supported by the United States. This led to the Vietnam War, then the eventual withdrawal of the United States and the establishment of a unified Communist Vietnam.

While the United States viewed the conflict as an important fight against the spread of Communism, Vietnam has always seen it as yet another attempt at colonization by a foreign power. Today Vietnam is one of the few Communist countries left, but one that is beginning to experiment with capitalism as well. Reforms over the past couple of decades—and a modernization campaign known as *doi moi*—are creating a growing economy and a changing society, and opening up Vietnam more and more to the rest of the world.

Because it is a Communist state, film production is tightly controlled in Vietnam. Official filmmakers work for the state, make their films in state-run studios, and must submit their scripts and movies for review and censorship. As might be expected in a country that spent so much of the twentieth century at war, development of a film industry was spotty and film production has often been yoked to propaganda. *On the Same River* (1959), codirected by Nguyen Hong Nghi and Pham Ky Nam, is considered the first Vietnamese feature film

(not counting those made by the French and Japanese during their occupations). It attacks what was viewed as American imperialism around the time of the Geneva Accords through a story of two lovers separated by the river that divided North and South Vietnam.

Given the regulations on content and relatively bare-bones production facilities that don't allow for much in the way of special effects, Vietnamese filmmakers, like those in Iran, have to use these limitations to their advantage, telling their stories economically and sometimes slipping a dash of protest under the censors' noses. Dang Nhat Minh, one of Vietnam's most respected directors, often addresses the changes in Vietnamese society—from traditional culture to an emerging market economy, from decades of war to a time of peace. In films ranging from *When the Tenth Month Comes* (1984), about a war widow taking care of her sick father-in-law, to *Nostalgia for the Countryside* (1995), about a peasant family adjusting to modernization, Dang compassionately chronicles Vietnam's social changes.

These state-produced films are rarely shown in the West, except for occasional museum or repertory screenings. The films of Dang, Pham Nhue Giang (whose 2002 drama about teachers in the countryside, *Deserted Valley*, is well worth seeking out), Vuong Duc (whose deliberately absurd 2003 film *Lost and Found* was shown in the Tribeca Film Festival), and other talented directors remain relatively unknown to the outside world. Instead, Tran Anh Hung, who was born in Vietnam but whose films are produced mostly with French money, has served as Vietnamese cinema's ambassador. Tran's films are lush, soaked in color, and move with lazy rhythms that allow the viewer to linger over visual details and become absorbed in their tropical atmospheres. Both nostalgic and sensual, *The Scent of Green Papaya* (1993) evokes the Vietnam of the 1950s through the story of a domestic servant and the unhappy family she works for. It received the Camera d'Or at Cannes and was nominated for an Academy Award for Best Foreign Language Film. *Cyclo* (1995), the story of a Ho Chi Minh City bicycle-taxi driver who becomes entangled with organized crime, is set in a seamier milieu but is equally sensuous and steeped in color, and features a soulful performance by Hong Kong movie star Tony Leung as a poetry-quoting gangster. A tale of three sisters, two married, the other devoted to her brother, *Vertical Ray of the Sun* (2000) glides on the beauty of Vietnam summer light and mellow Velvet Underground tunes.

Part of Vietnam's modernization is a new openness to independent filmmaking and international coproductions. Its awe-inspiring landscape is put to great use in two recent films. Nguyen Vo Minh's U.S.-Vietnam coproduction *Buffalo Boy* (2004) is set in the Mekong Delta during the 1930s and is infused with the traditions of the area's rural culture and the tensions brought on by French colonialism. The river and its lush green banks feature prominently in a *Bride of Silence* (2004), about a peasant girl who chooses not to speak rather than reveal the man who impregnated her. Hailed as the first feminist Vietnamese film, it was directed by the brother-and-sister team of Doan Minh Phuong and Doan Thanh Nghia.

On the independent front, a spate of new films have popped up in the past five years that take a breezy, pop cinema approach to Vietnam's changing society. Two of these, *Long Legged Girls* and *Bar Girls*, are notable for their depictions of contemporary sexual mores and lifestyles, which, it turns out, are not so different in Ho Chi Minh City than in any other hip metropolis.

Vietnam's film industry is modernizing as quickly as its population. A new dialogue is opening up between Vietnamese directors and the rest of the world, which means we can look forward to discovering the previously hidden cinema of this changing country.

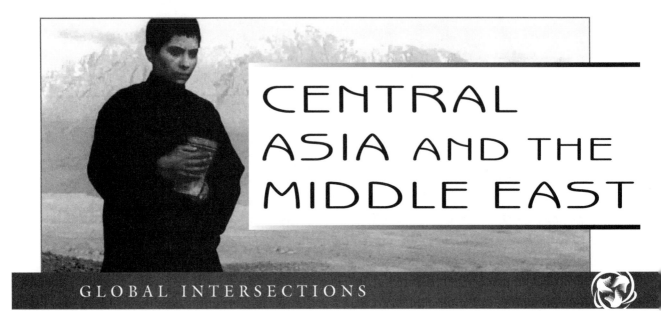

CENTRAL ASIA AND THE MIDDLE EAST

THE FORMER SOVIET REPUBLICS, AFGHANISTAN, AND MONGOLIA

The vast deserts, treeless, grassy steppes, and rugged mountains of central Asia occupy a special place in the popular imagination. This is the land of Genghis Khan and the Mongols, of Tashkent, Bukhara, Ulan Bator, and Samarkand—cities whose names alone evoke visions of history and adventure. It was through the daunting landscape of central Asia that the famed Silk Road ran for thousands of years, connecting China to the Mediterranean Sea, carrying trade goods, travelers, and the seeds of cultural exchange between East Asia, Europe, and the Middle East. Central Asia was and is one of the great crossroads of the world, at times peaceful, and at times bloody.

The core of central Asia is formed by the five former Republics of the Soviet Union known colloquially as "the stans": Turkmenistan, Tajikistan, Kyrgyzstan, Kazakhstan, and Uzbekistan. In 2003, filmgoers in a few American cities were able to see a traveling retrospective of these countries' cinemas, an eye-opening look at a part of the world formerly hidden to us. During the Soviet era, directors from these

regions would often go to the famed All-Union State Institute of Cinematography (VGIK) then return to their homelands to make movies about their local cultures, using their rigorous training in the great Soviet cinema tradition. Foremost among these directors is certainly Tolomush Okeev, director of *The Fierce One* (1973) and *The Sky of Our Childhood* (1967), among other films. A supreme poet of the beauty and violence of nature and of the rough lives of the hunters and herdsmen of the Kyrgyz frontier, Okeev is a kindred spirit to American writer Cormac McCarthy, whose novels do the same for the American west. Made just before the fall of the Soviet Union, *The Fall of Otrar* (1990), by Kazakhstan's Ardak Amirkulov, is one of the true masterpieces of central Asian cinema. An epic cascade of political intrigue and hallucinatory violence, it chronicles the buildup to Genghis Khan's conquest and destruction of the ancient East Asian Otrar civilization.

SOVIET CINEMA • When the Soviet Union was established in 1922, its leaders quickly saw cinema as a useful propaganda tool, and so they built the foundations of a strong film industry, which introduced technological and aesthetic advancements to the growing medium and produced master directors such as Sergei Eisenstein, V. I. Pudovkin, and Dziga Vertov. A rigorous film-education system developed, centered on the All-Union State Institute of Cinematography (known as VGIK), providing Soviet directors with a solid background in filmmaking technique. Many directors in what are now the former Soviet Republics came through this system, and its influence shows in the strength and quality of their work.

After the Soviet Union's fall, these newly independent countries went through the necessary, sometimes troubled period of adjustment, and their filmmakers found new freedom to treat previously banned subjects (and even to make films in their own languages, instead of dubbing them in state-mandated Russian), along with new social conditions to confront in their art. Darezhan Omirbaev, the most well-traveled Kazakh filmmaker on the international festival circuit, has said that the hero's profession of hitman in his 1998 *Killer* only came into existence with Kazakhstan's independence, when organized crime took the place of the Soviet state as a way out of poverty. With its hushed aura and tense plotting, Omirbaev's film recalls the work of both Robert Bresson and Alfred Hitchcock, two of his influences. Crime and its consequences also play a part in *Angel on the Right* (2002), by Tajikistan's Jamshed Usmonov, a dark comedy about an ex-con released from a Russian jail trying to readjust to life among the cantankerous inhabitants of his hometown, with Usmonov's actual hometown of Asht, as well as his friends and family, playing principal roles.

The Fierce One

In *Schizo* (2004), her debut feature, Kazakhstan's Guka Omarova portrays the grasslands of the eastern region of her country as a hardscrabble place where a fifteen-year-old boy with an innate sense of honor becomes involved in an illegal bare-knuckle-boxing operation. When one of the competitors is killed, he takes it upon himself to take the dead man's prize money to his wife. One gets the sense of characters lost in life, and lost in a vast, flat landscape, punctuated only by lines of utility poles stretching to the distant horizon. Stylistically very different from *Schizo*, *Luna Papa* (1999), by Tajikistan's Bakhtiar Khudojanazarov, also addresses the lawlessness and confusion of post-Soviet life in central Asia, but in a tone that

can best be described as dark whimsy. A young woman in a surreal fictional city by the Caspian Sea becomes pregnant, she believes by a supernatural force, and her unborn baby narrates the efforts of her eccentric family to find the father, an adventure culminating in a road trip through an oddly imagined Tajik landscape. A coproduction among some seven countries, *Luna Papa* may be a hopeful sign for the future of central Asian cinema.

The Soviet Union never conquered Afghanistan, but not for lack of trying. The ultimately futile war they fought against the U.S.-backed mujahideen rebels between 1979 and 1989 has been compared to the Vietnam War in the toll it took on the men unfortunate enough to have fought it. A contested land since the time of Alexander the Great, Afghanistan once had a small film industry that made a mere forty-odd movies between the early 1950s and the rise of the Taliban in the late 1990s. Under the Taliban's policy of banning and destroying all images of living things, they razed movie theaters and torched some two thousand films in the collection of Afghan Film, a state-run archive. One thousand films survived hidden in a back room.

After the Taliban's fall, it was Iranian filmmakers, especially Mohsen Makhmalbaf, who stepped in to try to resurrect Afghan cinema. Makhmalbaf had already made the feature *Kandahar* and the documentary *An Afghan Alphabet* (2002) while the Taliban were still in power. After they were gone, he assisted his daughter Samira in her sorrowful *At Five in the Afternoon,* made in the wrecked country the Taliban left behind, and he began using the Afghan Children Education Movement, an organization he founded in Iran for Afghan refugees, to educate future Afghan filmmakers. He also helped fund Siddiq Barmak's *Osama* (2002), the first post-Taliban Afghan feature film.

Barmak is a veteran of the Afghan film industry and headed Afghan Film until 1996. *Osama* is an angry indictment of the Taliban's treatment of women, told through the eyes of a girl forced to disguise herself as a boy in order to feed her family, since women weren't allowed to hold jobs. Her plight becomes even more dangerous when she is kidnapped into the army and her secret is discovered. Its moving story and political relevance earned it a Golden Globe for Best Foreign Language Film, but besides tapping into current concerns, it reveals Barmak to be a skilled and committed filmmaker. Although his is the only film thus far to gain attention internationally, the slowly reviving Afghan film industry has produced more films, from shorts to documentaries to features aimed at the local populace,

Osama

and more directors will surely emerge to tell Afghanistan's stories to the rest of the world.

From Genghis Khan to the unique gutteral harmonies of the Tuvan throat singers, Mongolia's history and culture have for centuries been a source of fascination. It is believed that nomadic tribes in some remote areas of the country still live a traditional way of life very similar to that of people believed by archeologists to have lived there some five hundred thousand years ago. This general fascination naturally extends to cinema, and Mongolia (one of the world's oldest countries) and its history have been the subject of films since the silent era. Soviet director V. I. Pudovkin's *Storm Over Asia* (1928) harnessed authentic locations and cultural traditions to a story of local resistance to British colonialism led by an heir to Genghis Khan. John Wayne and Omar Sharif have each taken turns playing Genghis Khan, in, respectively, Dick Powell's *The Conquerer* (1955) and Henry Levin's *Genghis Khan* (1964). German filmmaker Ulrike Ottinger's eight-hour documentary *Taiga* (1992) is an exhaustive and sensitive portrayal of traditional nomadic life. In her more whimsical fiction feature *Joan of Arc of*

Mongolia (1989), seven European women are kidnapped by a Mongolian warrior-princess and forced to spend a summer in deep cultural immersion.

The products of Mongolia's indigenous directors rarely make it to foreign movie screens. Until more of them do, we can well content ourselves with *The Story of the Weeping Camel* (2004), a documentary/narrative blend that centers on an actual nomadic ritual in which a song is played to encourage a recalcitrant mother camel to bond with her baby. It was made by Byambasuren Davaa, who is of the first generation of a traditionally nomadic family to grow up in the city, and Luigi Falorni, her fellow film student at the Munich Film School. Aside from its anthropological interest, it is a genuinely endearing film that also provides an authentic look at Mongolian rural life and the changes brought on by modernization. Davaa's follow-up, *The Cave of the Yellow Dog* (2005), uses the same technique in its story of the hard life of a family on the steppes, whose daughter wants to adopt a wild puppy.

Zaman, the Man from the Reeds

THE MIDDLE EAST

No Middle Eastern nation's films have had the worldwide impact that Iran's have, and for a variety of reasons, from political instability to lack of financing. Syria has a small state-supported film industry with apparently quite a few talented directors trained in the Soviet style, but lacks the funds to promote its products overseas. Lebanon's movie industry was decimated by a fifteen-year-long civil war that began in 1975. Public movie screenings were outlawed in Saudi Arabia from the early 1980s until late 2005, when a single theater opened to show animated films, but only to women and children. This, however, is the exception. Even under Saddam Hussein, Iraq had a movie industry—albeit yoked to his propaganda apparatus—that produced at least one film that has been hailed as a masterpiece by those who've seen it: Muhammad Shukri Jamil's *The Thirsty Ones* (1972). Aside from foreign-made documentaries, few films have emerged since Saddam's fall. Amer Alwan's *Zaman, the Man from the Reeds* (2004) was made on the eve of the American invasion. Alwan, who moved to France from Iraq in 1980, sets his film

among the "marsh Arabs," a little-known ancient culture inhabiting the swamps at the confluence of the Tigris and Euphrates rivers. The plot, about an old man traveling to the city to obtain medicine for his sick wife, takes us into the heart of Iraq on the eve of war.

The development of cinema in Israel paralleled that of the nation, consistently reflecting the dominant concerns of the times. Thorold Dickinson's *Hill 24 Doesn't Answer* (1955) and Baruch Dinar's *They Were Ten* (1960) recount the heroic deeds of soldiers and settlers around the time of the establishment of Israel and the 1948 Arab-Israeli War. Uri Zohar's 1965 *Hole in the Moon* deals humorously with the problem of settling so many diverse groups of immigrants into the still-new nation, while in Ephraim Kishon's Oscar-nominated *Sallah Shabbati* (1964), a charming Moroccan immigrant subverts government bureaucracy to try to secure decent housing for his family. Also nominated for an Oscar was Menahem Golan's *Operation Thunderbolt* (1977), a fact-based account of a 1975 hijacking that has become an Israeli cinema classic. Golan and his producing partner Yoram Globus would later become one of the top producing teams in Hollywood.

The aftermath of the 1967 Six-Day War brought great changes to Israeli society, and cinema changed along with it. *Bourekas* films (named after a type of pastry)—light comedies designed to distract audiences from the tensions of the day—became the dominant popular genre. A prime example is Assi Dayan's *Hill "Halfon" Doesn't Answer* (1975), a very broad parody of Dickinson's war film of twenty years before. On the other hand, an art-film movement also developed, drawing on the innovations of the French *nouvelle vague* combined with Jewish literary tradition. Uri Zohar's *Three Days and a Child* (1967), based on a short story by A. B. Yehoshua, and Dan Wolman's *My Michael* (1975), based on an Amos Oz novel, are two of the best-known films to come out of the movement. Zohar, one of Israel's most popular entertainers, was able to deftly balance art with commerce. For every serious film like *Three Days and a Child*, there were several *bourekas* displaying his comic talents, among them *Mezizim* (1972), *Big Eyes* (1974), and *Save the Lifeguard* (1977).

In 1979, Israel's government moved to support artistic filmmaking by establishing the Fund for the Promotion of Quality Films (later renamed The Israeli Film Fund), which helped establish the careers of, among others, Daniel Waxman (*Transit*, 1979) and Uri Barabash, whose *Beyond the Walls* (1984), a political allegory of Arab-Israeli relations set in a maximum security prison, won

him a International Critics Prize at the Venice Film Festival. The most prominent of Israel's auteurs, however, is Amos Gitai, whose training as an architect and background in documentary filmmaking can be seen in the carefully constructed long takes that dominate his features. Informed by a ten-year self-imposed exile in Paris following a dispute with Israeli censors, the European cinema tradition and the currents of Israeli and Jewish history merge in his many features and documentaries. An early feature, *Berlin Jerusalem* (1989), chronicles the lives of two Jewish women, friends in the Berlin of the 1920s who immigrate to Palestine after the rise of the Nazis. A trilogy—*Birth of a Golem* (1991), *Golem: The Spirit of Exile* (1992), and *Golem: The Petrified Garden* (1993)—are contemporary variations on the golem figure from Jewish folklore—a living being made from inanimate material. *Kippur* (2000), one of his most praised films, is a fictionalized account of his own experiences in the Yom Kippur War, when his helicopter was shot down by a Syrian missile. It is an unsentimental portrayal of the realities of modern warfare, the forces that drive it, and the young men who carry it out on the battlefield. Gitai, who has in the past worked with such diverse performers as Annie Lennox and Sam Fuller, cast Natalie Portman as one of two women in 2005's *Free Zone* who become unlikely traveling partners on a road trip through the eponymous region of Jordan.

Throughout much of its history, Israeli cinema returned obsessively to the Israeli-Palestinian conflict. This began to change in the 1990s. With an expanding population and a stronger economy, Israeli society became less insular, and cinema along with it. The conflict began to take a backseat as filmmakers broadened their subject matter. A kind of breakthrough happened in 2001, when Dover Koshashvili's *Late Marriage* became an international hit. A story of generational conflict, family feuds, and hot sex, it impressed audiences and critics with its ornate set pieces and bold bawdiness. It was quite a different view of Israel, as was Eitan Gorlin's *The Holy Land*, released the same year. In this exploration of the rift between Orthodox Judaism and secular Israeli life, a rabbinical student sent to a brothel to sow his wild oats becomes smitten with a prostitute and abandons his studies to plunge into Jerusalem's seedier locales. Gidi Dar's *Ushpizin* (2004), a broad comedy in the Yiddish tradition, is groundbreaking in its depiction of ultra-Orthodox Judaism. It was written by and stars Shuli Rand, an actor who is himself Orthodox, as a man who finds some unwelcome guests showing up at an important celebration.

Israel's new cinema foregrounds the struggles and accomplishments of simply living; they investigate Israeli society from the inside out. The death of a family patriarch sets in the motion the unraveling, and eventual healing, of a family in Nir Bergman's *Broken Wings* (2002). Keren Yedaya's Camera d'Or–winning debut feature, *Or (My Treasure)* (2004), depicts, with brutal realism, the relationship between a prostitute and the daughter trying to save her from herself. An offbeat, melancholy comedy, *Nina's Tragedies* (Savi Gabizon, 2003) features a very different family with a host of sexual and emotional hang-ups. The picaresque fable *James' Journey to Jerusalem* (2003), by Ra'anan Alexandrowicz, is a seriocomic send-up of Israeli attitudes toward foreigners, with, as its hero, an innocent South African Christian whose pilgrimage to the holy land is derailed by an unscrupulous contractor who offers him a job. Although its milieu is the Israel Defense Forces, Eytan Fox's *Yossi & Jagger* (2002) eschews political statements on the Palestinian question and instead focuses on a secret affair between two gay soldiers. Originally intended as a TV drama, it became a surprise hit both in Israel and abroad. Fox's follow-up, *Walk on Water* (2004), is a thriller about a Mossad agent on the trail of a Nazi war criminal that takes on terrorism, homophobia, Israeli nationalism, and the legacy of the Holocaust.

Yossi & Jagger

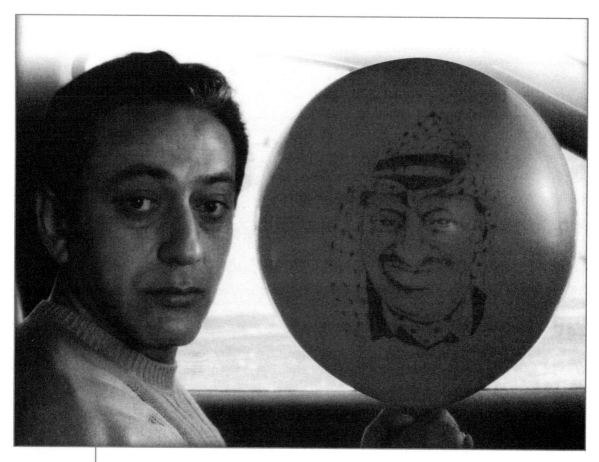

Divine Intervention

Palestinian filmmakers are also starting to make their mark. Elia Suleiman, after spending over a decade in self-imposed exile in New York, returned to his homeland to make *Chronicle of a Disappearance* (1996), a series of disjointed, grimly funny vignettes documenting his conflicted feelings about himself, his family, and the inescapable political situation in which they live. His films owe a debt to the deadpan, artful sight and sound gags of Jacques Tati, put to the service of trying to remain sane in an insane part of the world. *Divine Intervention* (2002), which won prizes at Cannes and the European Film Awards, employs the same structural style in an even more pointedly absurd manner. Santa Claus is stabbed by a gang of kids outside Nazareth, a sexy woman hypnotizes the troops at a security checkpoint with a supermodel-style runway walk, a huge balloon

decorated with a picture of Yasser Arafat drifts through the sky, and through all the comedy runs a sad story about two lovers who live on either side of a security checkpoint. Suleiman's films turn the tragedy of Israeli-Palestinian relations into a macabre theater of the absurd, crackling with characters on the brink of losing their minds, and suggest that laughter might be at least a temporary cure.

Suleiman's fellow Palestinian and sometime collaborator Hany Abu-Assad constructs his films along more conventional lines, but shares with him an instinct for finding dark humor in the everyday difficulties of life under occupation. In *Rana's Wedding* (2002), a young woman, determined to marry her secret boyfriend, has to confront not only the disapproval of her family but an obstacle course of checkpoints, roadblocks, and suspicious Israeli soldiers. Even more controversial, his 2005 *Paradise Now* has as its central characters two affable mechanics who are also suicide bombers in training. Abu-Assad's savvy plotting sidesteps the darkest implications of the story and sacrifices realism for action, but its trajectory is believable, and it becomes, in the end, a surprisingly powerful film. Suleiman's *Divine Intervention* was denied an Oscar nomination on the grounds that the nation of Palestine doesn't exist, but an exception was made for *Paradise Now*, a more Hollywood-ready film that nonetheless carries real sting.

TURKEY

It's fitting that we should end with Turkey, a nation that straddles Europe and Asia and combines cultural influences from the East and West, from the Byzantine Empire to the Ottoman Empire, from old Constantinople to modern Istanbul. Modern Turkey begins with Mustafa Kemal Ataturk, founder and first president of the Republic of Turkey, which was established in 1923 after the Allied forces, who had defeated the Ottoman Empire in World War I, were driven out during the Turkish War of Independence. Ataturk set out to modernize the new nation. He considered cinema an important invention, but with so much talent lost to decades of war, the entire Turkish film industry was entrusted to one man, Muhsin Ertugrul, a popular entertainer, who began by filming his stage shows and then gradually moved into more sophisticated cinematic forms. For some seventeen years, he was essentially Turkey's only director.

The industry grew up during the 1940s and 1950s, but it wasn't until the 1960s, after a military coup that led to a new constitution and more freedom

for artists, that it came into its own. Domestic films gained popularity at the box office, and increasingly in intellectual circles as well. Turkish filmmakers self-consciously set out to create a national cinema based on the qualities that made Turkey different from the West. Thus, *Time to Love* (1966), to take one example, tells what director Atif Yilmaz considered to be a distinctly Asian sort of love story using images inspired by Turkish miniature paintings. Yilmaz, along with Halit Refig, Metin Erksan, and Duygu Sagiroglu formed the core of a movement that captured audiences' interest with these uniquely Turkish films.

The movement fell off in the latter part of the 1960s, partly because of the introduction of color film, which came quite late to Turkey. Faced with increased costs of making movies in color, producers became reluctant to take risks on serious, challenging films and instead threw their funds behind popular genre pictures, which were more likely to earn them a return on their investment. Ironically, it was from this world that Turkey's most revered director emerged. In the 1960s, Yilmaz Güney was a beloved movie star. Known as "the ugly king" for his unconventional looks, he played the oppressed everyman who, by the end of the movie, inevitably wrought vengeance on the bad guys who held him down.

Güney had higher aspirations, though. He moved into directing in the late 1960s, and made the biggest impression with his 1970 film *Hope*, in which a poor horse-cart driver's quest to find buried treasure in the desert becomes a journey into madness brought on by desperation and greed. Its gradually more hallucinatory images and refusal to cater to popular convention were the flipside of the films he had once starred in. Güney's commitment to social and economic justice—which is quite evident in *Hope*—soon got him into trouble, and he spent much of the 1970s in prison, until he escaped to France in 1981.

When the Ankara Cinema Association conducted a poll to determine the ten greatest Turkish films, *Hope* was joined on the list by *Yol* (Serif Gören, 1982) and *The Herd* (Zeki Ökten, 1979), two films Güney is said to have directed from his prison cell by relaying his instructions to Gören and Ökten. *The Herd* is the story of a family from the country who go on a train journey to Ankara to sell their sheep. Overflowing with local color, culture, and traditional music, it is at once intimate and epic. In the Palm d'Or–winning *Yol*, five convicts on a weeklong leave from prison find themselves on journeys of enlightenment, but also journeys of discovery about themselves and their nation.

Yol

The ghosts of Güney, and the meditative aesthetics of Andrei Tarkovsky, and Theo Angelopoulos seem to hover over much recent Turkish cinema. Ömer Kavur, in films such as *Motherland Hotel* (1986) and *Secret Face* (1991), and Erden Kiral, in *Hunting Time* (1988), *The Blue Exile* (1993), and other films, show an abilty to use time and images to draw viewers into their characters' interior lives and raise larger questions about existing in the world. Zeki Demirkubuz is another master of pacing and imagery. In his *Innocence* (1997), about an ex-con who becomes involved with a dysfunctional family, one character tells his life story in one ten-minute take. It's as if the film has stopped to give him space, and his speech is at least as mesmerizing as what surrounds it.

Turkish cinema found itself back at the center of world cinema when Nuri Bilge Ceylan's *Distant* (2002) won the Grand Prize at the 2002 Cannes Film Festival. A deadpan, seriocomic riff on loneliness, the film's icy, pristine images of Istanbul in the wintertime seem to haunt its characters as they try to make sense of their lives and relationships. He followed it with *Climates* (2006), which stars him and his wife as a couple whose relationship is disintegrating. Ceylan, a perfectionist who writes, produces, shoots, and edits his films, previously displayed his considerable gifts in two other features, *The Small Town* (1997) and *Clouds of May* (2000). Perhaps his success will lead to more exposure for Kavur, Kiral, Demirkubuz, and Turkey's other talented auteurs.

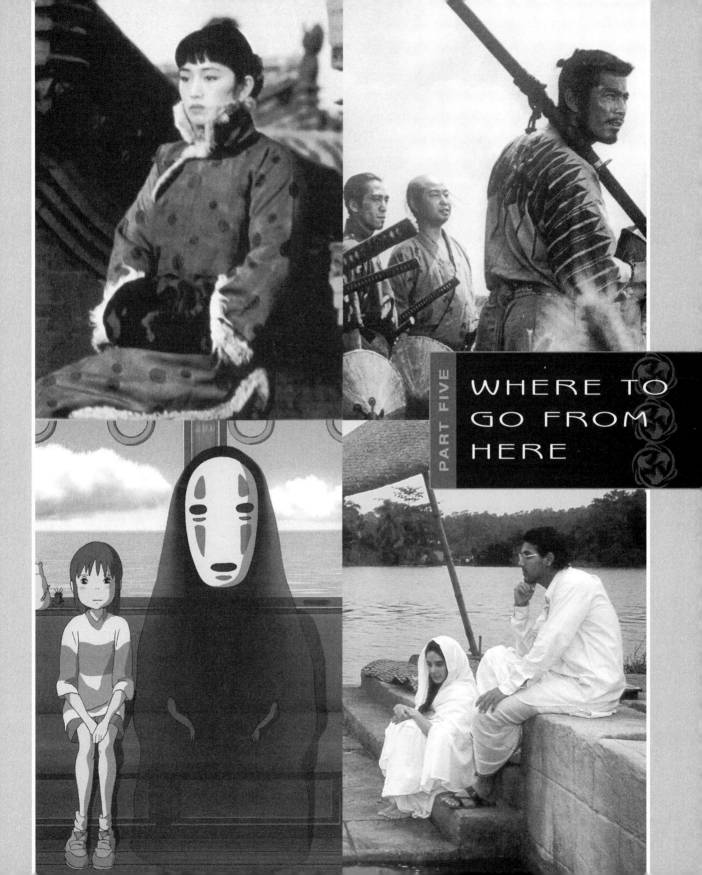

I f this book has done its job, you now have a desire to delve more deeply into Asian cinema. Here is a list of recommended books, magazines, and Web sites for further investigation.

A FEW CHOICE WEB SITES

The Internet Movie Database: www.imdb.com
The largest online source for movie information and links.

GreenCine Daily: daily.greencine.com
Comprehensive source of film news from around the world, plus links to just about every movie site there is. The perfect place for a film buff to start the day.

Variety Asia Online: www.varietyasiaonline.com
Up-to-the-minute coverage of Asian movie industry news.

Senses of Cinema: www.sensesofcinema.com
Australia-based online film journal "devoted to the serious and eclectic discussion of world cinema."

Film Comment Magazine: www.filmlinc.com/fcm/fcm.htm
New York-based magazine for serious cinephiles, with some Web content.

Cinemaya: The Asian Film Quarterly: www.cinemaya.net/abtcine.asp
The only magazine in the world devoted exclusively to Asian cinema.

Cinema Scope: www.cinema-scope.com
Canadian print and online magazine with lots of articles about Asian cinema.

Firecracker Magazine: www.firecracker-magazine.com
Online magazine devoted to all things Asian cinema.

MonkeyPeaches: www.monkeypeaches.com
Obsessive, up-to-the-minute coverage of film news from China, Hong Kong, and Taiwan.

Midnight Eye: www.midnighteye.com
"The latest and best on Japanese cinema."

Koreanfilm.org: www.koreanfilm.org
Just about everything you need to know about Korean cinema past, present, and future, courtesy of Seoul-based writer Darcy Paquet.

CinemaIran: www.cinemairan.com
"News and reviews of Persian films."

Criticine: www.criticine.com
"Elevating discourse on Southeast Asian cinema."

YesAsia.com: www.yesasia.com
One-stop shopping for Asian DVDs not released in the United States.

Eros Entertainment: www.erosentertainment.com
Excellent source for classic and contemporary Indian films on DVD, at very reasonable prices.

GENERAL ASIAN CINEMA

Bowyer, Justin (ed.). *The Cinema of Japan and Korea*. London: Wallflower Press, 2004.

Ciecko, Anne Tereska (ed.). *Contemporary Asian Cinema: Popular Culture in a Global Frame*. Oxford: Berg Publishing, 2006.

Lent, John A. *The Asian Film Industry*. Austin: University of Texas Press, 1990.

Server, Lee. *Asian Pop Cinema: Bombay to Tokyo*. San Francisco: Chronicle Books, 1999.

Thomas, Brian. *VideoHound's Dragon: Asian Action and Cult Flicks*. Detroit: Visible Ink Press, 2003.

Vasudev, Aruna, et al. (eds.). *Being and Becoming: The Cinemas of Asia*. New Delhi: Macmillan, 2002.

CHINA, HONG KONG, AND TAIWAN

Anderson, John. *Edward Yang*. Chicago: University of Illinois Press, 2005.

Berry, Chris (ed.). *Chinese Films in Focus: 25 New Takes*. Berkeley: University of California Press, 2004.

Berry, Chris (ed.). *Perspectives in Chinese Cinema*. London: British Film Institute, 1993.

Berry, Michael. *Speaking in Images: Interviews with Contemporary Chinese Filmmakers*. New York: Columbia University Press, 2005.

Bordwell, David. *Planet Hong Kong: Popular Cinema and the Art of Entertainment*. Cambridge, MA: Harvard University Press, 2000.

Browne, Nick (ed.). *New Chinese Cinemas: Forms, Identities, Politics*. Cambridge, MA: Cambridge University Press, 1994.

Brunette, Peter. *Wong Kar-wai*. Chicago: University of Illinois Press, 2005.

Chan, Jackie. *I Am Jackie Chan: My Life in Action*. New York: Ballantine, 1999.

Cornelius, Sheila: *New Chinese Cinema: Challenging Representations*. New York: Columbia University Press, 2002.

Dannen, Fredric, and Barry Long. *Hong Kong Babylon: An Insider's Guide to the Hollywood of the East*. London: Faber and Faber, 1997.

Fu, Poshek. *Between Shanghai and Hong Kong: The Politics of Chinese Cinemas*. Stanford, CA: Stanford University Press, 2003.

Fu, Poshek, and David Desser (eds.). *The Cinema of Hong Kong: History, Arts, Identity*. Cambridge: Cambridge University Press, 2000.

Gateward, Frances (ed.). *Zhang Yimou: Interviews*. Jackson: University Press of Mississippi, 2001.

Hammond, Stefan, and Mike Wilkins. *Sex and Zen and a Bullet in the Head: The Essential Guide to Hong Kong's Mind-bending Films*. New York: Fireside, 1996.

Hunt, Leon. *Kung Fu Masters*. London: Wallflower Press, 2003.

Kar, Law, and Frank Bren. *Hong Kong Cinema: A Cross-Cultural View*. Lanham, MD: Scarecrow Press, 2004.

LaLanne, Jean-Marc, et al. *Wong Kar-wai*. Paris: Dis Voir, 1997.

Logan, Bey. *Hong Kong Action Cinema*. New York: Overlook TP, 1996.

Meyers, Richard. *Great Martial Arts Movies: From Bruce Lee to Jackie Chan and More*. Sacramento, CA: Citadel Press, 2000.

Palmer, Bill, et al. *The Encyclopedia of Martial Arts Movies.* Lanham, MD: Scarecrow Press, 1995.

Rehm, Jean-Pierre, et al. *Tsai Ming-liang.* Paris: Dis Voir, 1999.

Reynaud, Berenice. *A City of Sadness (BFI Modern Classics).* London: British Film Institute, 2002.

Rovin, Jeff. *The Essential Jackie Chan Source Book.* New York: Pocket Books, 1997.

Semsel, George Stephen. *Chinese Film.* New York: Praeger Publishers, 1987.

Silbergeld, Jerome. *China into Film: Frames of Reference in Contemporary Chinese Cinema.* London: Reaktion Books, 2000.

Stokes, Lisa Odham, and Michael Hoover. *City on Fire: Hong Kong Cinema.* New York: Verso, 1999.

Tam, Kwok-kan, and Wimal Dissanayake. *New Chinese Cinema.* Oxford: Oxford University Press, 1998.

Teo, Stephen. *Hong Kong Cinema: The Extra Dimensions.* Berkeley, CA: University of California Press, 1998.

Teo, Stephen. *Wong Kar-wai: Auteur of Time.* Berkeley, CA: University of California Press, 2005.

Wood, Miles. *Cine East: Hong Kong Cinema Through the Looking Glass.* Eureka, CA: Firebird Distributing, 1998.

Yang, Jeff. *Once Upon a Time in China.* New York: Atria Books, 2003.

Yau, Esther C.M. (ed.). *At Full Speed: Hong Kong Cinema in a Borderless World.* Minneapolis: University of Minnesota Press, 2001.

Zhang, Yingjin. *Chinese National Cinema.* New York: Routledge, 2004.

Zhang, Yingjin. *Encyclopedia of Chinese Film.* London: Routledge, 1998.

Zhen, Ni. *Memoirs from the Beijing Film Academy: The Genesis of China's Fifth Generation.* Durham, NC: Duke University Press, 2002.

JAPAN

Anderson, Joseph L., and Donald Richie. *The Japanese Film.* Princeton, NJ: Princeton University Press, 1983.

Andrew, Dudley, and Carole Cavanaugh. *Sansho Dayu (BFI Film Classics).* London: British Film Institute, 2000.

Bordwell, David. *Ozu and the Poetics of Cinema.* London: British Film Institute, 1988.

Burch, Noel. *To the Distant Observer: Form and Meaning in Japanese Cinema.* Berkeley, CA: University of California Press, 1979.

Clements, Jonathan, and Helen McCarthy. *The Anime Encyclopedia.* Berkeley, CA: Stone Bridge Press, 2001.

Desjardins, Chris. *Outlaw Masters of Japanese Film.* London: I.B. Tauris, 2005.

Desser, David. *Eros Plus Massacre: An Introduction to the New Wave Japanese Cinema.* Bloomington, IN: University of Indiana Press, 1988.

Desser, David (ed.). *Ozu's Tokyo Story.* Cambridge, MA: Cambridge University Press, 1997.

Drazen, Patrick. *Anime Explosion! The What? Why? and Wow! of Japanese Animation.* Berkeley, CA: Stone Bridge Press, 2003.

Galbraith IV, Stephen. *The Emperor and the Wolf: The Lives and Films of Akira Kurosawa and Toshiro Mifune.* New York: Faber and Faber, 2001.

Galloway, Patrick: *Stray Dogs and Lone Wolves: The Samurai Film Handbook.* Berkeley, CA: Stone Bridge Press, 2005.

Goodwin, James. *Akira Kurosawa and Intertextual Cinema*. Baltmore, MD: Johns Hopkins University Press, 1994.

Hirano, Kyoko. *Mr. Smith Goes to Tokyo: Japanese Cinema under the American Occupation, 1945–1952*. Washington, DC: Smithsonian Books, 1994.

Hunter, Jack. *Eros in Hell: Sex, Blood and Madness in Japanese Cinema*. New York: Creation Books, 1999.

Kurosawa, Akira. *Something Like an Autobiography*. New York: Vintage Books, 1983.

Le Fanu, Mark. *Mizoguchi and Japan*. London: British Film Institute, 2005.

Levi, Antonia. *Samurai from Outer Space: Understanding Japanese Animation*. Peru, IL: Carus Publishing Company, 1996.

Macias, Patrick. *TokyoScope: The Japanese Cult Film Companion*. San Francisco: VIZ Media, 2001.

McCarthy, Helen. *Hayao Miyazaki: Master of Japanese Animation*. Berkeley, CA: Stone Bridge Press, 1999.

McDonald, Keiko. *Reading a Japanese Film: Cinema in Context*. Honolulu: University of Hawaii Press, 2005.

Mcroy, Jay (ed.). *Japanese Horror Cinema*. Edinburgh, UK: Edinburgh University Press, 2005.

Mellen, Joan. *In the Realm of the Senses (BFI Film Classics)*. London: British Film Institute, 2004.

Mellen, Joan. *Seven Samurai (BFI Film Classics)*. London: British Film Institute, 2002.

Mellen, Joan. *Voices from the Japanese Cinema*. New York: Liveright, 1975.

Mellen, Joan. *The Waves at Genji's Door: Japan Through Its Cinema*. New York: Pantheon Books, 1976.

Mes, Tom. *Agitator: The Cinema of Takashi Miike*. Surrey, UK: Fab Press, 2004.

Mes, Tom. *Iron Man: The Cinema of Shinya Tsukamoto*. Surrey, UK: Fab Press, 2005.

Mes, Tom, and Jasper Sharp. *The Midnight Eye Guide to New Japanese Film*. Berkeley, CA: Stone Bridge Press, 2005.

Napier, Susan J. *Anime from Akira to Princess Mononoke: Experiencing Contemporary Japanese Animation*. New York: Palgrave, 2001.

Nolletti, Arthur, and David Desser (eds.). *Reframing Japanese Cinema: Authorship, Genre, History*. Bloomington, IN: Indiana University Press, 1992.

Phillips, Alistair, and Julian Stringer. *Japanese Cinema: Texts and Contexts*. London: Routledge, 2006.

Poitras, Gilles. *The Anime Companion: What's Japanese in Japanese Animation*. Berkeley, CA: Stone Bridge Press, 1999.

Poitras, Gilles. *Anime Essentials: Every Thing a Fan Needs to Know*. Berkeley, CA: Stone Bridge Press, 2001.

Prince, Stephen. *The Warrior's Camera: The Cinema of Akira Kurosawa*. Princeton, NJ: Princeton University Press, 1991.

Richie, Donald. *The Films of Akira Kurosawa*. Berkeley, CA: University of California Press, 1999.

Richie, Donald. *A Hundred Years of Japanese Film*. Tokyo: Kodansha International, 2005.

Richie, Donald. *Japanese Cinema: An Introduction*. Oxford: Oxford University Press, 1990.

Richie, Donald. *Ozu*. Berkeley: University of California Press, 1977.

Sato, Tadao. *Currents in Japanese Cinema*. New York: Kodansha America, 1987.

Schilling, Mark. *The Yakuza Movie Book: A Guide to Japanese Gangster Films*. Berkeley, CA: Stone Bridge Press, 2003.

Silver, Alain. *The Samurai Film*. New York: Overlook Press, 2005.

Standish, Isolde. *A New History of Japanese Cinema: A Century of Narrative Film*. New York: Continuum International Publishing Group, 2005.

Turim, Maureen Cheryn. *The Films of Nagisa Oshima: Images of a Japanese Iconoclast*. Berkeley, CA: University of California Press, 1998.

Weisser, Thomas, and Yuko Mihara Weisser. *Japanese Cinema Essential Handbook*. Miami: Vital Books, 1998.

Yoshimoto, Mitsuhiro. *Kurosawa: Film Studies and Japanese Cinema*. Durham, NC: Duke University Press, 2000.

INDIA

Biswas, Moinak (ed.) *Satyajit Ray*. London: Seagull Books, 2006.

Chatterjee, Gayarti. *Mother India (BFI Film Classics)*. London: British Film Institute, 2002.

Chopra, Anupama. *Dilwale Dulhania Le Jayenge (BFI Modern Classics)*. London: British Film Institute, 2002.

De Vos, Marijke, and Johan Manschot (eds.). *Behind the Scenes of Hindi Cinema: A Visual Journey Through the Heart of Bollywood*. Amsterdam: Koninklijk Instituut Voor de Tropen, 2005.

Desai, Jigna. *Beyond Bollywood: The Cultural Politics of South Asian Diasporic Film*. New York: Routledge, 2004.

Dudrah, Rajinder Kumar. *Bollywood: Sociology Goes to the Movies*. Thousand Oaks, CA: SAGE Publications, 2006.

Dwyer, Rachel. *Cinema India: The Visual Culture of Hindi Film*. London: Reaktion Books, 2002.

Dwyer, Rachel. *Filming the Gods: Religion and Indian Cinema*. London: Routledge, 2006.

Dwyer, Rachel. *100 Bollywood Films*. London: British Film Institute, 2005.

Ganguly, Suranjan. *Satyajit Ray: In Search of the Modern*. Lanham, MD: Scarecrow Press, 2000.

Ganti, T. *Bollywood: A Guidebook to Popular Hindi Cinema*. New York: Routledge, 2004.

Ghatak, Ritwikkumar. *Rows and Rows of Fences: Ritwik Ghatak on Cinema*. London: Seagull Books, 2000.

Gokulsing, K. Moti, and Wimal Dissanayake. *Indian Popular Cinema: A Narrative of Cultural Change*. Staffordshire, UK: Trentham Books, 1998.

Gopalan, Lalitha. *Bombay (BFI Modern Classics)*. London: British Film Institute, 2005.

Gopalan, Lalitha. *Cinema of Interruptions: Action Genres in Contemporary Indian Cinema*. London: British Film Institute, 2002.

Hood, John W. *Essential Mystery: The Major Filmmakers of Indian Art Cinema*. Hyderabad, India: Orient Longman, 2000.

Jain, Madhu. *The Kapoors: The First Family of Indian Cinema*. London: Penguin Global, 2006.

Jha, Shubhash K. *The Essential Guide to Bollywood*. New Delhi: Roli Books, 2005.

Joshi, Lalit Mohan (ed.). *Bollywood: Popular Indian Cinema*. London: Dakini Books, 2001.

Kabir, Nasreen Muni. *Bollywood: The Indian Cinema Story*. London: Channel 4 Books, 2002.

Kabir, Nasreen Munni. *Guru Dutt: A Life in Cinema*. New York: Oxford University Press USA, 2006.

Kaur, Raminder, and Ajay J. Sinha (eds.). *Bollyworld: Popular Indian Cinema Through a Transnational Lens*. Thousand Oaks, CA: SAGE Publications, 2005.

Mishra, Vijay. *Bollywood Cinema: Temples of Desire*. New York: Routledge, 2001.

Muir, John Kenneth. *Mercy in Her Eyes: The Films of Mira Nair*. New York: Applause, 2006.

Narwekar, Sanjit. *Directory of Indian Film-makers and Films*. Westport, CT: Greenwood Press, 1994.

Nyce, Ben. *Satyajit Ray: A Study of His Films*. New York: Praeger Press, 1988.

Raheja, Dinesh, and Jitendra Kothari. *The Bollywood Saga: Indian Cinema*. New Delhi: Roli Books, 2004.

Rajadhyaksha, Ashish, and Paul Willemen. *Encyclopedia of Indian Cinema*. Berkeley, CA: University of California Press, 1999.

Ray, Satyajit. *My Years with Apu: A Memoir*. New Delhi: Penguin Books India, 1996.

Robinson, Andrew. *Satyajit Ray: The Inner Eye*. London: I.B. Tauris, 1989.

Robinson, Andrew. *Satyajit Ray: A Vision of Cinema*. London: I.B. Tauris, 2005.

Saltzman, Devyani. *Shooting Water: A Memoir of Second Chances, Family and Filmmaking*. New York: Newmarket Press, 2006.

Torgovnik, Jonathan. *Bollywood Dreams*. London: Phaidon Press, 2003.

Van der Heide, William. *Bollywood Babylon: Interviews with Shyam Benegal*. Oxford: Berg Publishers, 2006.

Vasudevan, Ravi S. *Making Meaning in Indian Cinema*. New Delhi: Oxford University Press, 2000.

KOREA

James, David E., and Kim, Kyung Hyun. *Im Kwon-taek: The Making of a Korean National Cinema*. Detroit: Wayne State University Press, 2002.

Kim, Ki-duk, et al. *Kim Ki-duk*. Paris: Dis Voir, 2006.

Kim, Kyung Hyun. *The Remasculinization of Korean Cinema*. Durham, NC: Duke University Press, 2004.

Lee, Hyangjin. *Contemporary Korean Cinema: Culture, Identity and Politics*. Manchester, UK: Manchester University Press, 2000.

Lee, Young-il, and Choe, Young-chol. *The History of Korean Cinema*. Seoul: Jimoondang International, 1998.

Leong, Anthony. *Korean Cinema: The New Hong Kong*. Ojai, CA: Black Dot Publications, 2003.

McHugh, Kathleen, and Nancy Abelmann (eds.). *South Korean Golden Age Melodrama: Gender, Genre and National Cinema*. Detroit: Wayne State University Press, 2005.

Min, Eungjun, et al. *Korean Film: History, Resistance and Democratic Imagination*. New York: Praeger Press, 2003.

Rayns, Tony. *Seoul Stirring: 5 Korean Directors*. Bloomington, IN: Indiana University Press, 1996.

Shin, Chi-yun, and Julian Stringer. *New Korean Cinema*. New York: New York University Press, 2005.

IRAN

Andrew, Geoff. *10 (BFI Modern Classics)*. London: British Film Institute, 2005.

Dabashi, Hamid. *Close Up: Iranian Cinema, Past, Present and Future*. London: Verso, 2001.

Dabashi, Hamid. *Masters and Masterpieces of Iranian Cinema*. Washington, DC: Mage Publishers, 2007.

Egan, Eric. *The Films of Makhmalbaf: Cinema, Politics and Culture in Iran*. Washington, DC: Mage Publishers, 2006.

Elena, Alberto. *The Cinema of Abbas Kiarostami*. London: Saqi, 2005.

Issa, Rose, and Sheila Whitaker (eds.). *Life and Art: The New Iranian Cinema*. London: British Film Institute, 1999.

Kiarostami, Abbas. *Walking with the Wind*. Boston: Harvard Film Archive, 2002.

Mirbakhtyar, Shahla. *Iranian Cinema and the Islamic Revolution*. Jefferson, NC: McFarland & Co., 2006.

Saeed-Vafa, Mehrnaz, and Jonathan Rosenbaum. *Abbas Kiarostami*. Chicago: University of Illinois Press, 2003.

Tapper, Richard (ed.). *The New Iranian Cinema: Politics, Representation and Identity*. London: I.B. Tauris, 2004.

SOUTH AND SOUTHEAST ASIA

Gazdar, Mushtaq. *Pakistan Cinema 1947–1997*. New York: Oxford University Press USA, 1998.

Sen, Krishna. *Indonesian Cinema: Framing the New Order*. London: Zed Books, 1994.

Sukwong, Dome, and Sawasdi Suwannapak. *A Century of Thai Cinema*. London: Thames and Hudson, 2001.

Van der Heide, William. *Malaysian Cinema, Asian Film: Border Crossings and National Cultures*. Amsterdam: Amsterdam University Press, 2002.

CENTRAL ASIA AND THE MIDDLE EAST

Abdel-Malek, Kamal. *Arab-Jewish Encounters in Contemporary Palestinian Literature and Film*. New York: Palgrave MacMillan, 2005.

Donmez-Colin, Gonul. *Cinemas of the Other: A Personal Journey with Film-makers from the Middle East and Central Asia*. Bristol, UK: Intellect Ltd., 2006.

Kronish, Amy, and Costel Safirman. *Israeli Film: A Reference Guide*. Westport, CT: Praeger Publishers, 2003.

Loshitzky, Yosefa. *Identity Politics on the Israeli Screen*. Austin: University of Texas Press, 2002.

Shohat, Ella. *Israeli Cinema: East/West and the Politics of Representation*. Austin: University of Texas Press, 1989.

Willemen, Paul (ed.). *The Films of Amos Gitai: A Montage*. London: British Film Institute, 1994.

Yosef, Raz. *Beyond Flesh: Queer Masculinities and Nationalism in Israeli Cinema*. Piscataway, NJ: Rutgers University Press, 2004.

ACKNOWLEDGMENTS

I am very grateful to Sandra Choron, Jeffrey Cunard, Julian Raby, and Jim Ulak for helping to shepherd this book to publication. Without them, it might not have made it. I'd also like to thank the following people who, through their writing and/or conversation, provided helpful insights and advice: Florence Almozini, Max Alvarez, Thom Andersen, Ian Birnie, Travis Crawford, Lalitha Gopalan, Grady Hendrix, Denise Hwang, Shelly Kraicer, Cheng-sim Lim, Sheila Meehan, Hyunjun Min, Darcy Paquet, James Quandt, Berenice Reynaud, Jonathan Rosenbaum, and Maria Ruggieri. Finally, thanks to my colleagues at the Freer and Sackler Galleries for their encouragement.

PHOTO CREDITS

Abbreviations: t—top; **c**—center; **b**—bottom; **l**—left; **r**—right

i Photofest; **ii** Photofest; **iv** courtesy of Strand Releasing; **vi** Photofest; **ix** Photofest; **xi** Photofest; **xii** Photofest; **1t** Photofest; **1c** Photofest; **1b** Photofest; **2** Photofest; **8** Photofest; **13** Photofest; **16** Photofest; **20** courtesy of Kino International (U.S.), Bejing Film Studio (world); **25** Photofest; **27** courtesy of Strand Releasing; **29** Photofest; **33** Photofest; **35** courtesy of Kino International (U.S.), Tag Spledour (world); **37** Photofest; **40** Photofest; **44** Photofest; **47** Photofest; **48** Photofest; **50** Photofest; **54** Photofest; **57** Photofest; **59** Photofest; **62** Photofest; **65** Photofest; **68** Photofest; **70** courtesy of Vitagraph; **72** Photofest; **75** Photofest; **76** Photofest; **79** courtesy of Milestone Film & Video/www.milesonefilms. com (U.S.), Celluloid Dreams (world); **81** courtesy of Strand Releasing; **83** Photofest; **85** Photofest; **87** Photofest; **91** Photofest; **95l** courtesy of Manu Savani; **95r** courtesy of Manu Savani; **97** Photofest; **100** courtesy of Adoor Gopalakrishnan; **103** Photofest; **105** courtesy of Muzaffar Ali; **107** Photofest; **108** courtesy of Madras Talkies; **109** courtesy of Madras Talkies; **110** Photofest; **113t** Photofest; **113b** Korean Film Archive; **114** Photofest; **119** Photofest; **121** courtesy of Pathfinder Pictures; **124** Photofest; **127** Photofest; **132** Photofest; **134** Photofest; **135** courtesy of Strand Releasing; **136** Photofest; **138** Photofest; **140** courtesy of Strand Releasing; **141** Photofest; **143** Photofest; **146** Korean Film Archive; **147** Korean Film Archive; **148** Korean Film Archive; **149** Korean Film Archive; **150** Korean Film Archive; **151** Korean Film Archive; **154** courtesy of Kino International (U.S.), CJ Entertainment (world); **159** CJ Entertainment; **160** courtesy of Magnolia Pictures (U.S.), Cineclick Asia (world); **162** courtesy of Kino International (U.S.), CJ Entertainment (world); **163** CJ Entertainment; **165** Photofest; **167** Photofest; **169** CJ Entertainment; **170** Cineclick Asia; **171** courtesy of Kino International (U.S.), Cinemaservice (world); **173t** Photofest; **173b** Photofest; **174** Photofest; **178** Photofest; **181** Photofest; **185** First Run Features; **188** Photofest; **191** courtesy of Magnolia Pictures (U.S.); Sheherazad Media (world); **192** First Run Features; **193** courtesy of Kino International (U.S.), Sheherazad Media (world); **195** Photofest; **198** Photofest; **205** Photofest; **207** Photofest; **210** Photofest; **212** courtesy of Strand Releasing; **214** Homegreen Films; **215** courtesy of Strand Releasing; **217** Photofest; **219t** courtesy of Strand Releasing; **219b** courtesy of the Ankara Cinema Association; **220** Photofest; **221** courtesy of Tareque Masud; **224** courtesy of Nan Achnas; **226** Working Man Films; **234** courtesy of Apichatpong Weerasethakul; **235** courtesy of Strand Releasing; **237** Photofest; **239** courtesy of the Vietnam Cinema Department; **241** courtesy of the Vietnam Cinema Department; **242** Photofest; **244** courtesy of Seagull Films; **246** Photofest; **247** courtesy of Pathfinder Pictures; **249** courtesy of Magnolia Pictures (U.S.), Celluloid Dreams (world); **251** courtesy of Strand Releasing; **252** Photofest; **255** courtesy of the Ankara Cinema Association; **257tl** Photofest; **257tr** Photofest; **257bl** Photofest; **257br** Photofest.

INDEX

NOTE: *Italic page numbers* indicate photographs